IMAGES
of America
GILROY

IMAGES
of America

GILROY

Claudia Salewske

ARCADIA
PUBLISHING

Published by Arcadia Publishing
Charleston, South Carolina

Library of Congress Catalog Card Number: 2003110955

For all general information contact Arcadia Publishing at:
Telephone 843-853-2070
Fax 843-853-0044
E-Mail sales@arcadiapublishing.com
For customer service and orders:
Toll-Free 1-888-313-2665

Visit us on the Internet at www.arcadiapublishing.com

CONTENTS

ACKNOWLEDGMENTS

I am indebted to the following for their researched works from which I have gleaned many particulars used in this text: Adams-Chitactac Heritage County Park, Elizabeth Barratt, Chuck Catánia, Patricia Baldwin Escamilla, Loyola Fortaine, Walt Glines, Marion Ketchum, Malcolm Margolin, Nancy McCarthy, Chuck Myer, Ralph Pillman, Marjorie Pierce, Alan Porcella, Carroll Pursell, Eugene Sawyer, Christine Tognetti, James Williams, and Angela Woollacott.

Warm thanks to Gilroy Historical Society President Connie Rogers, for encouraging this project, and to my many friends in the Society, Connie included, who have shared their knowledge and treasured family photos with me. Thank you also to others with deep roots in this community who have provided many leads and answers. My appreciation for the gracious assistance I was given by Kirsten Carr, director of the Gilroy Visitors Bureau, Christine Filice, administrative support manager for the Gilroy Garlic Festival Association, and Pat DeStasio at the Christopher Ranch.

To Cathy Mirelez, Cultural Arts and Museum supervisor for the City of Gilroy, my heartfelt appreciation for your support and for the support of the museum staff. This book, with its emphasis on archival graphics, would not have been possible without the invaluable assistance and expertise of Gilroy Museum Coordinator Lucy C. Solórzano Jr. and her assistant, Susan Voss. Museum aide Tom Howard also assisted my research. Thank you to my friend and former colleague, Carol Peters, for the gift of your original art that has enhanced this project, and to Robin McGinnis and Kai Lai for the contributions your artistic visions have made.

My gratitude to Mick Crouch, my editor at Arcadia Publishing, for his guidance, patience, and serene demeanor that never failed to ease the stressful moments.

And finally to my husband, Mike, thank you for your faith in me that is the light of my life.

INTRODUCTION

"Ever heard of Gilroy?"

"Gilroy? Oh—*that* place. About half way between Carmel and San Francisco, right? Can be hotter than a pistol in the summer and reeks of garlic. Sure, I know Gilroy."

"How about you?"

"Gilroy? Of course I know where it is—it's awesome. I've seen it on TV and in all sorts of magazines. Tons of cool factory outlets—and people come from all over the world when have this fabulous Garlic Festival thing every July. Who *doesn't* know about Gilroy?"

There's some truth in all of the above comments, but the essence of Gilroy is far deeper than either response suggests. The Gilroy Garlic Festival celebrated its Silver Jubilee in 2003, and, without a doubt, the global media attention this event showers on the city has enhanced Gilroy's image. Further, native son Jeff Garcia is often in the national limelight as an NFL quarterback. All of this could make us too big for our britches, but that's really not the case. Celebrity status hasn't altered Jeff's values. He adheres to principles that prevail in this community as well: work hard, take pride in what you have to offer, remember there's always room for improvement, and give back to those who made it possible for you to move forward.

Gilroy has a rich and diversified past that is as exciting and worthy of exploration as its present claims to fame. Dating back thousands of years, the Ohlone culture was a tranquil yet highly inventive one. The era of the Spanish and Mexican jurisdictions created deep and lasting Latino influences, which continue to enrich the community. The disillusionment that awaited so many newcomers in the mining camps was frequently dispelled when these individuals found their way to this valley and discovered the wealth of a different nature that it has to offer. They brought with them their languages, their recipes, their sacred traditions, their farming expertise, their knowledge of making music, wine, cheese, beer, and of raising prime livestock. Above all, they exhibited their willingness to share these skills with their neighbors—to create a new life from the old.

Spend some time exploring the kaleidoscopic elements that have been shaping Gilroy in colorful, distinctive ways from its beginnings. Catch our spirit and consider how vital it is for any community to study its past and to maintain a degree of pioneer spirit that welcomes challenges and new ways of expression. Rather than rest on our laurels, may we commit ourselves to bettering life in and around the place that we call home.

—Claudia Salewske-

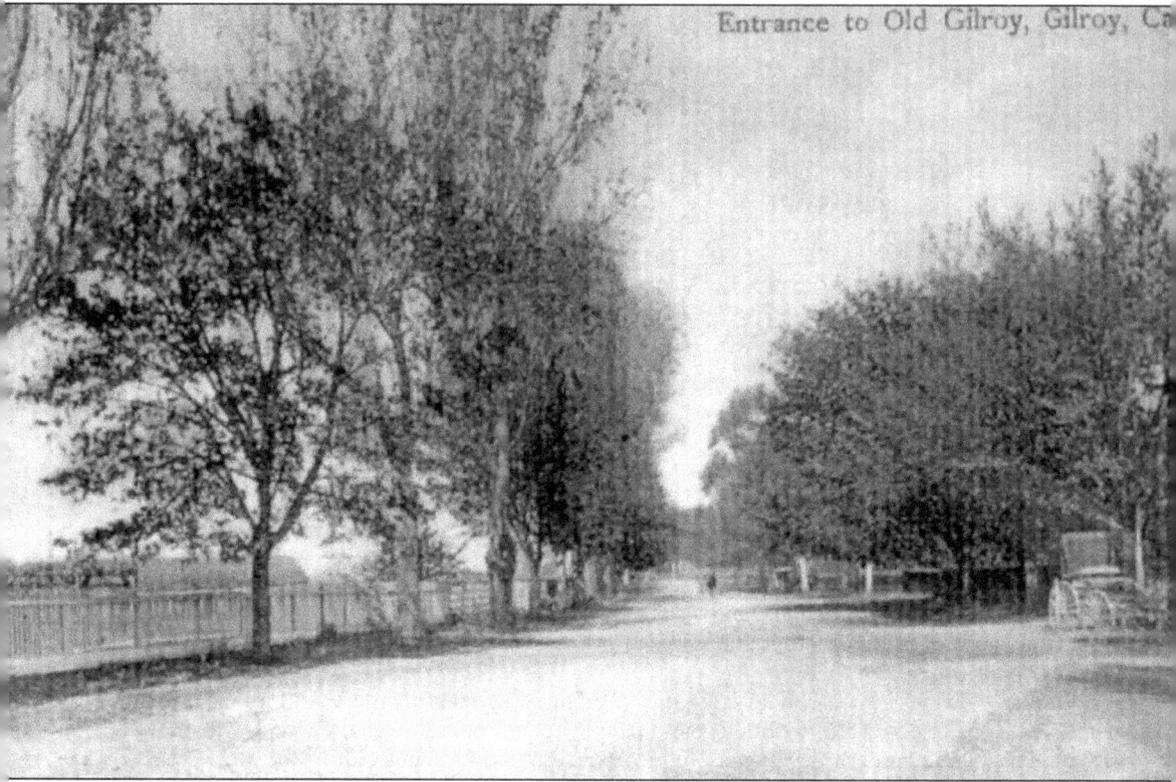

In sharp contrast to its present-day, bustling state highway status, this vintage postcard depicts the tranquil thoroughfare the Pacheco Pass Road once was. It meandered through the village of San Ysidro and intersected with the El Camino Real—the King's Highway—some three miles west of this point. The town of Pleasant Valley, which developed near that intersection, incorporated many decades later as Gilroy, California. (Courtesy Jack and Dorothy Sturla.)

One

THE FIRST PEOPLE AND THE RANCHO ERA

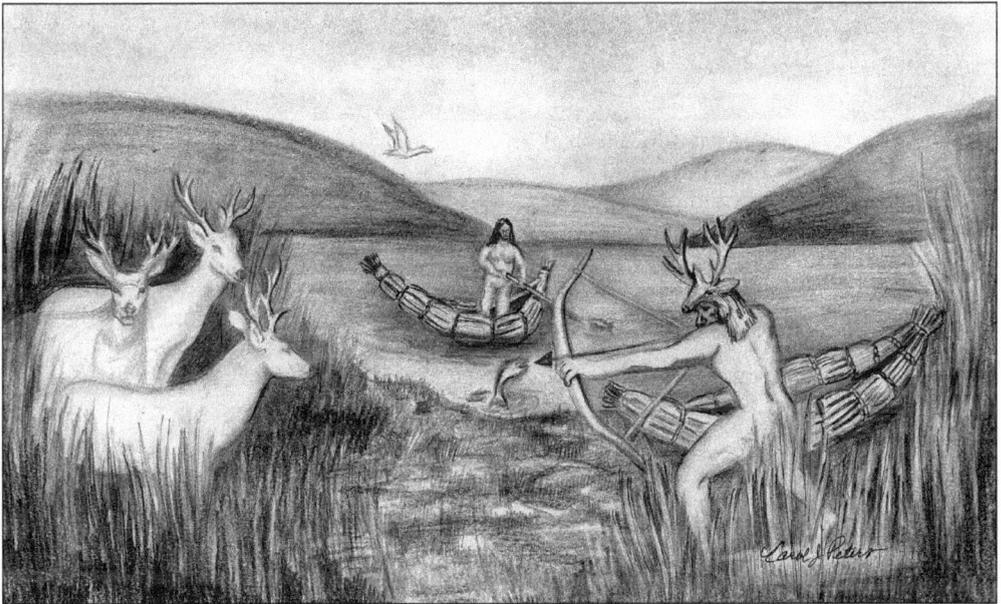

It was the Native Americans who formed the first trail between this valley and the vast San Joaquin Valley to the east. Anthropologists estimate the Ohlone, who were given their name meaning "people to the west" by central valley tribes, located here at least 5,000 years ago. Ohlone villages stretched from north of San Francisco to Salinas. With no written language, we depend upon the journals and letters of the Spanish explorers and missionaries for specifics. The men prepared for a hunt in a *temescal*, or sweat house, where the chants sung and stories told summoned the spiritual power for success with their weapons. They donned deer-head masks, which allowed them to move within close range of their quarry. Boats created from tule rushes facilitated navigation of the inland marshlands and ponds. They fished with spears, used clever decoys to lure game birds, and caught small animals in artful snares. (Artwork by Carol Peters.)

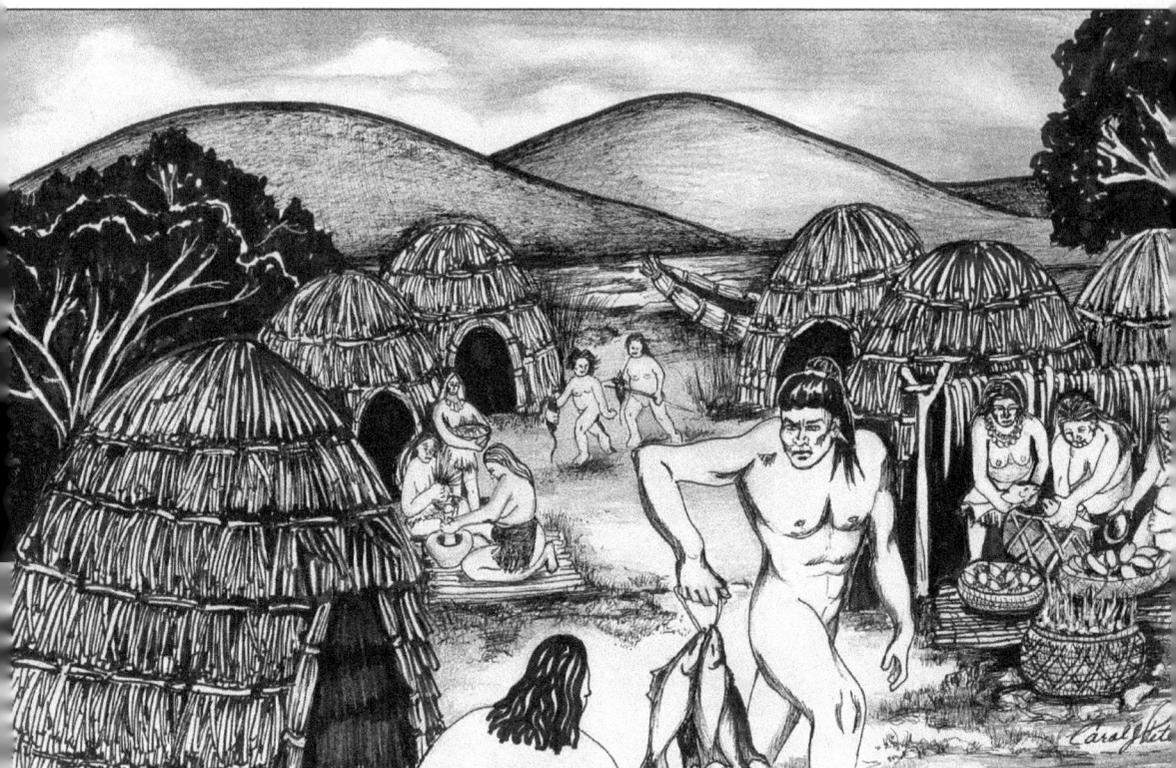

Recent research suggests the Ohlone had an organized system of growing, harvesting, and storing food. Villages averaged 250–1,000 inhabitants. Cooking was a communal activity for the women. Acorns and grains were ground with a rough-hewn mortal and pestle, and the flour was rinsed to purge it of its bitterness. Hot rocks were placed in watertight baskets and a kind of soup was made with this flour and additional water. Meats and fish were roasted in underground pit ovens. Scant clothing was common for either sex. The men pierced their noses and ears and wore ornamental shells or bones in those piercings, whereas the women chose to tattoo their chins, and fashion necklaces from abalone and clamshells. The shells were practical as well: as the women gathered food in the tall grasslands the clatter and reflection of the shells scared off rattlesnakes. (Artwork by Carol Peters.)

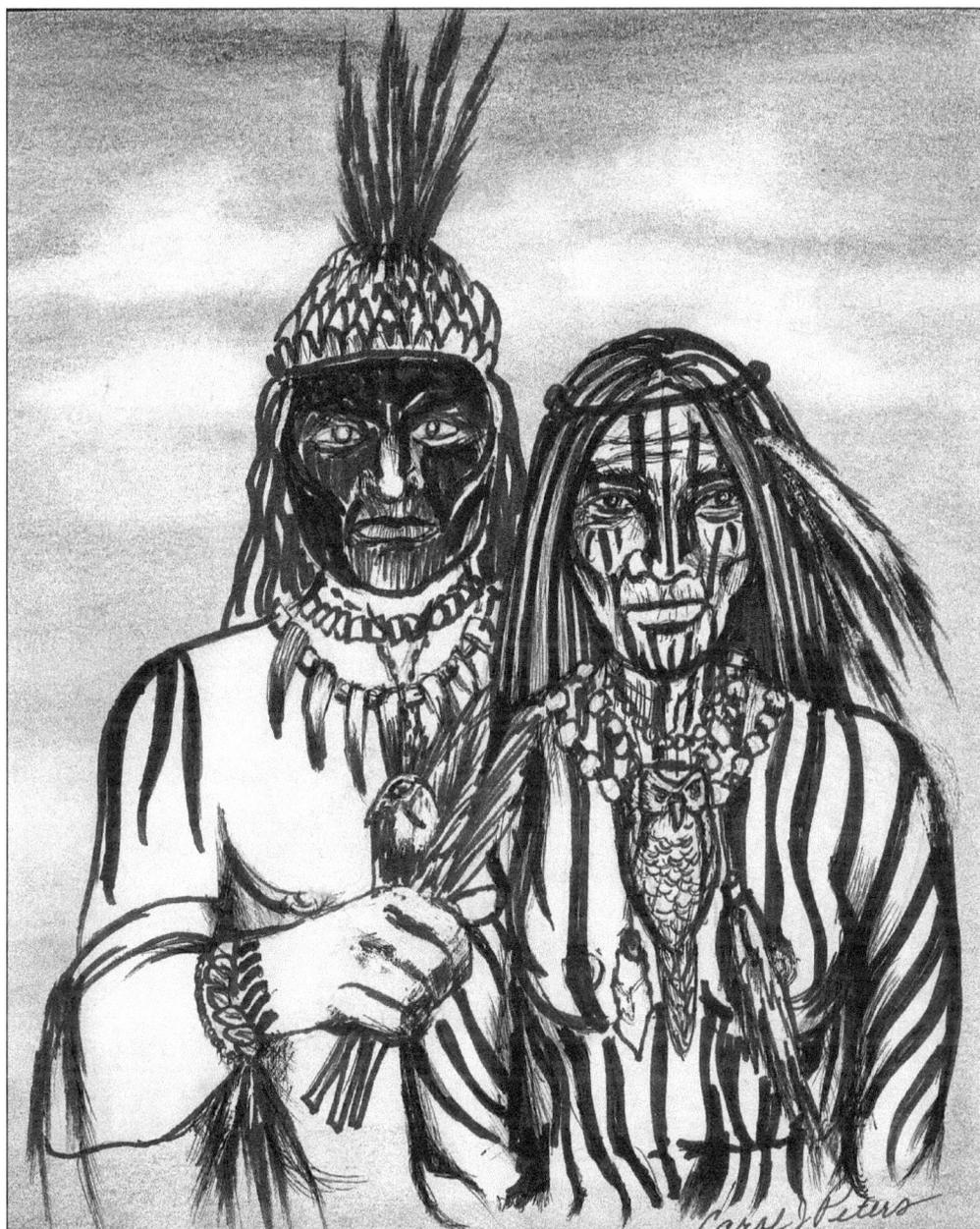

Records indicate the Ohlone set bones by fabricating casts of bark or appropriately shaped baskets secured with leather straps. Bleeding was controlled with animal-hair compresses, and common ailments such as stomach upsets and colds were treated with roots and herbs. But if severe aches and pains persisted, the Shamans were consulted, and most worked in male-female teams. The man danced and chanted around the victim until he had a vision of the precise location of the ailment. Then, the woman (who was most often a widow), after making a small incision, inserted a bone tube and literally sucked the malignancy from the patient. The ritual was a precise one. This drawing depicts the meticulous face and body painting and special accouterments each shaman used to enhance his or her powers. Gifts were given for such services, but returned if the patient died or if the affliction was not cured. (Artwork by Carol Peters.)

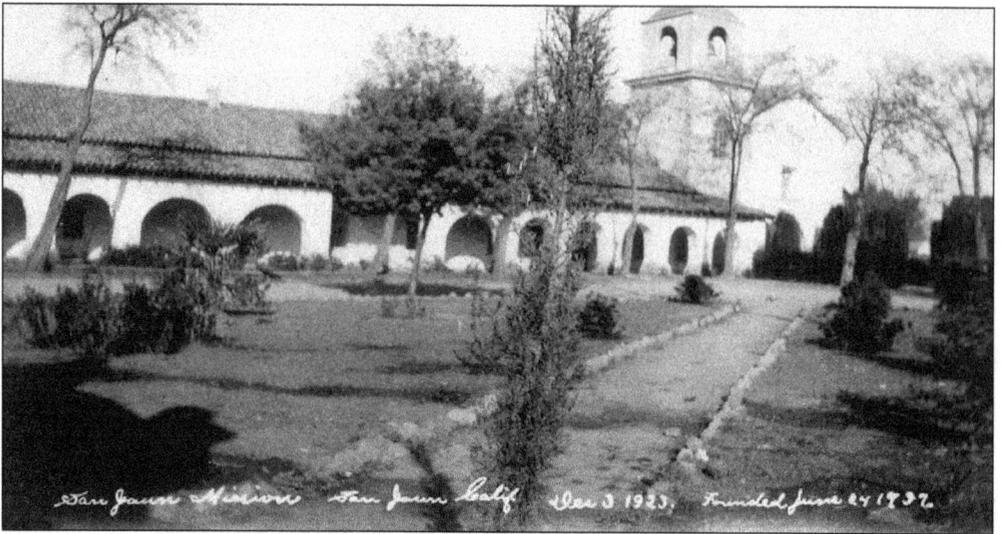

San Juan Mission San Juan Calif. Dec 3 1923. Founded June 24 1797.

In 1768, on orders from the King of Spain, Franciscan friars under Father Junipero Serra's direction began a slow journey northward, establishing sites along the El Camino Real where they could live among the indigenous people, teaching them Christianity and the three R's. Mission San Juan Bautista was dedicated on June 24, 1797. Soon after, most of the area's Unijaima, Ausaima, and Huris-tak clans of the Ohlone tribe were moved here to work as communal farm laborers. Members of the Chicac-tak clan were relocated for the same purpose to Mission Santa Cruz. (Courtesy Gilroy Museum.)

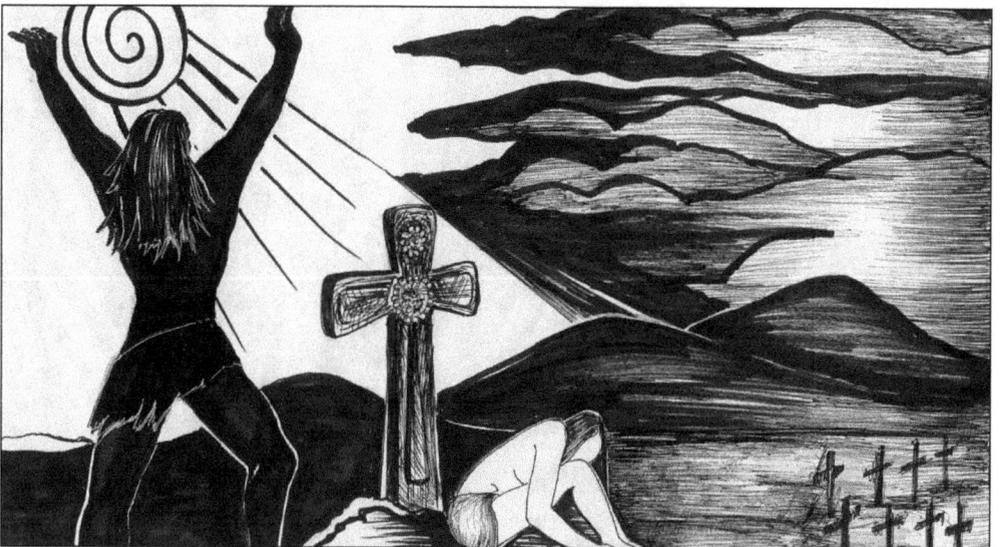

Life at a mission compound was devastating for most natives. The Ohlone way was to rise before dawn and shout greetings eastward to encourage the sun's arrival. They felt a kinship and believed the sun's rising was a sign that it heeded their pleas. The missionaries tried to eliminate such practices, considering them idolatrous. They further exposed the Ohlone to European diseases for which the natives had no defenses. -Though well intentioned, the padres' control of the Ohlone decimated the majority of these people in body and spirit. Between 10,000–20,000 Ohlone were here before the Spanish explorers came. Within 50 years their numbers had dwindled to 2,000. (Artwork by Carol Peters.)

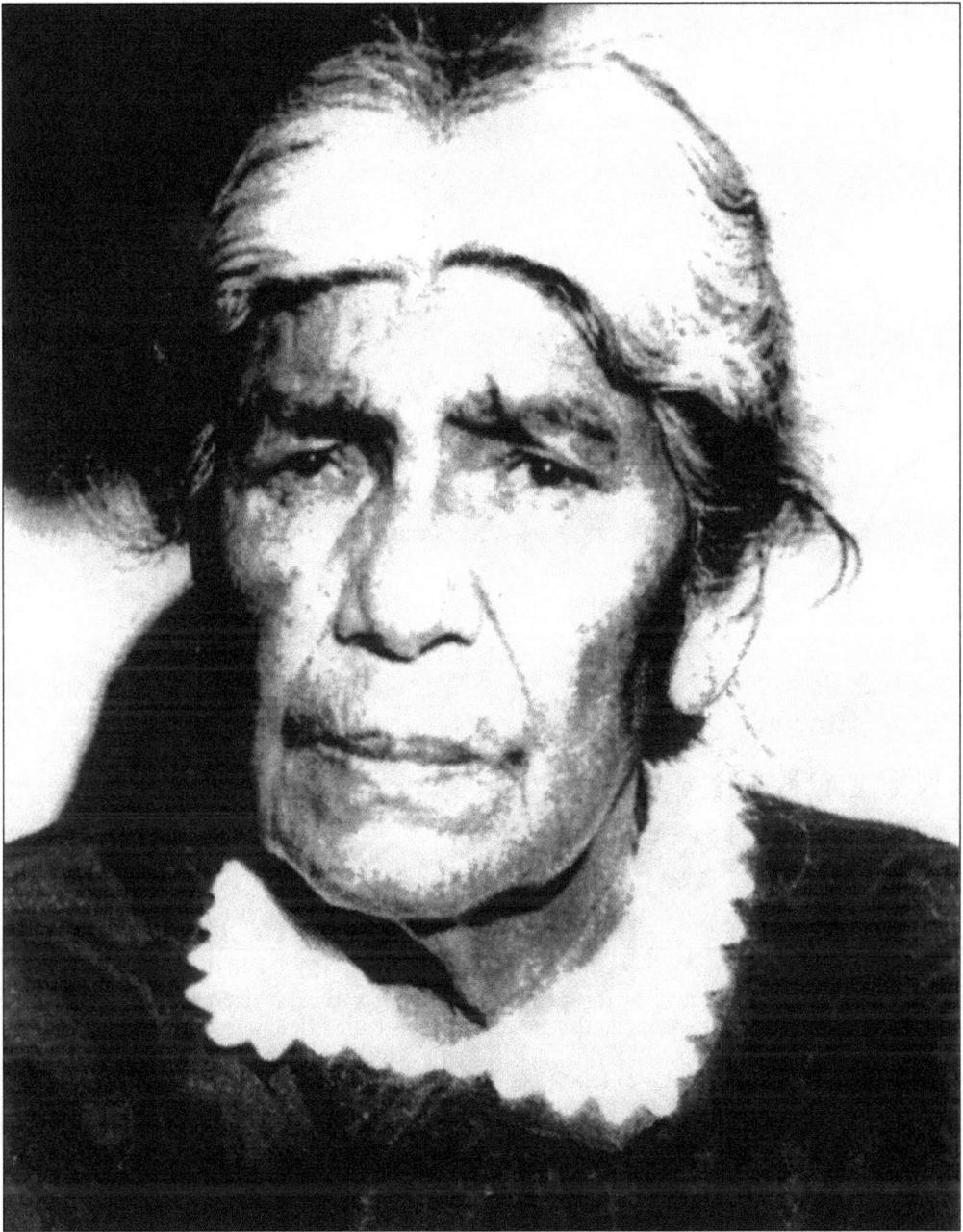

Ascencion Solorsano de Cervantes of the Amah clan was born on the mission grounds at San Juan Bautista in 1846, and lived in Gilroy much of her life. She had knowledge of the healing powers of myriad plants. For years she tirelessly dispensed her remedies from her home on Rosanna Street. As the last full-blooded Mutsun Ohlone speaker, doctora was also keeper of the tribal memories, stories, and language. Fortunately an ethnology expert from the Smithsonian came to record all that she had to share shortly before her death in 1930. Gilroy's third middle school, which opened in September, 2003, is named in her honor. Many descendants of Gilroy's first people wish to revitalize their cultural traditions, and some are seeking restoration for the Mutsun Ohlone as a federally recognized tribe. (Courtesy Loyola Fortaine and Gilroy Museum.)

13

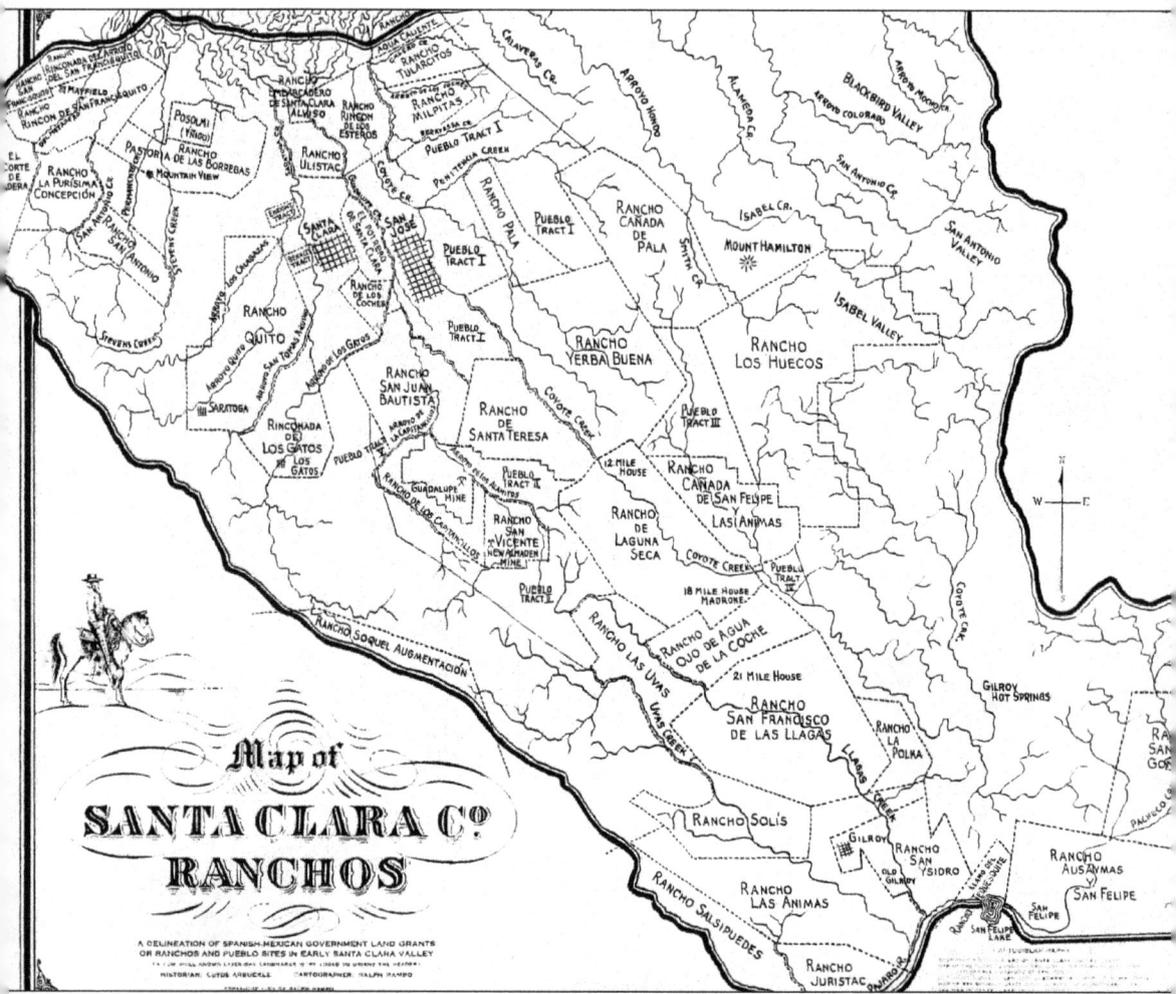

Spanish domination gave way to Mexican jurisdiction in 1822 and that lasted until the United States gained control of the region at the end of the Mexican War in 1848. The governors in charge divided the landscape into parcels called ranchos. The city's namesake, Scottish seaman John Cameron Gilroy, left his ship when it docked in Monterey and made his way here. He eventually settled on Rancho San Ysidro, marrying a daughter of the owner, Don Ignacio Ortega, in 1821. These parcels varied in size from 200 to 40,000 acres. (Courtesy the late Ralph Rambo.)

Two

SETTLERS FROM AROUND THE WORLD

Mathew Fellom, a Dane, came to California on a whaling ship in 1822. Upon arriving here the following year, he took a job as a soap maker for John Gilroy. Eventually he purchased part of the Rancho San Ysidro acreage, married Manuela Briones, and had a large, colorful family. Fellom was a renowned livestock raiser, and this fine home, built in 1861, may be the oldest in the south county. Grandson James Fellom was a popular writer whose stories highlighted western life. (Courtesy Gilroy Museum.)

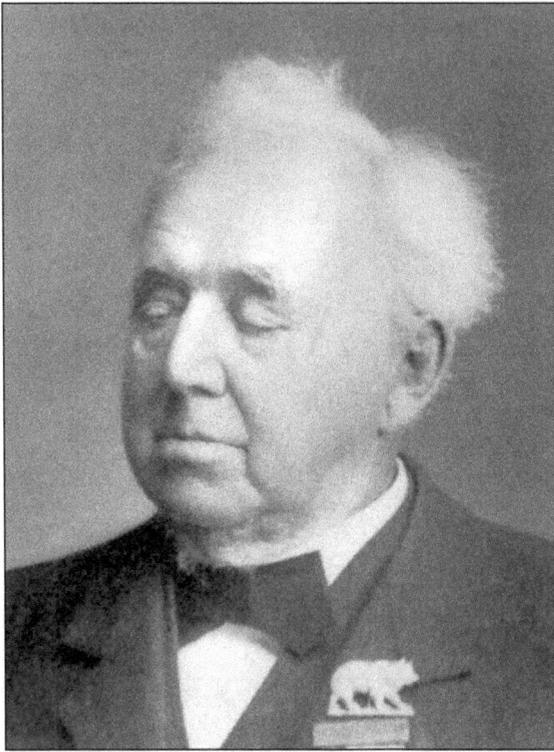

Julius Martin is considered to be the first American settler here, coming from the east by the overland route, arriving in December of 1843. Martin served as a captain with the American Scouts under General Fremont and was at Sonoma when the Bear Flag was raised (notice the bear insignia he's wearing). After a successful trip to the gold fields in 1849, he returned with enough bounty to purchase 1,220 acres of Rancho San Ysidro from John Gilroy. There he built a flour mill and raised cattle. Blinded in 1861, his neighbors marveled that he could nonetheless walk to town, make his business rounds, and return home without a hitch. (Courtesy Gilroy Museum.)

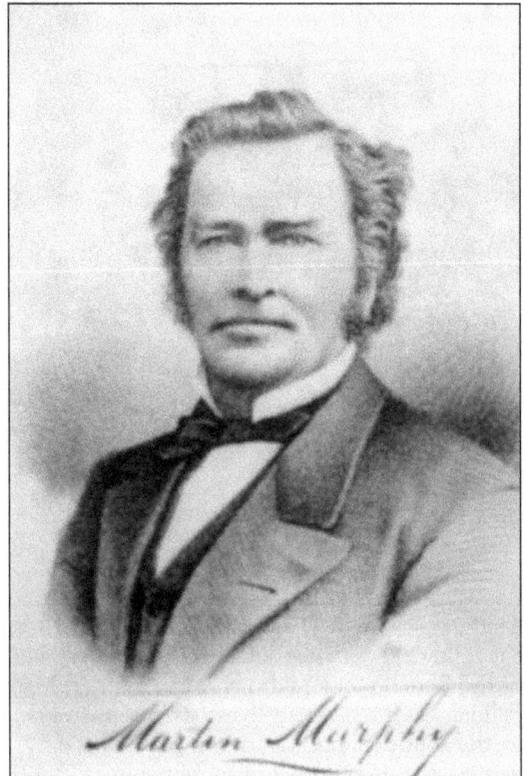

Martin Murphy was part of the first wagon train of immigrants to cross the Sierra Nevadas in 1844. Coming south from Sacramento, he purchased Rancho Ojo de Agua de la Coche. The family's adobe home was known for its warmth and hospitality. As a devout Catholic, Murphy was concerned that the distance to the missions south and north was too far for regular worship. He gave four acres, and with the assistance of the archbishop in San Francisco, a country chapel was built to serve the parish until St. Mary Church was founded in 1865. (Courtesy Gilroy Museum.)

16

Massey Thomas was among the first to come west with gold fever. Unlucky at mining, for a time he outfitted other prospectors. In 1851 he returned to Missouri and then came west again two years later, driving 300 head of cattle—another first. A successful livestock breeder and orchardist, he was later part of a lawsuit against Henry Miller that sought to clear the titles to many early citizens' lands that had been previously designated as Rancho Las Animas holdings. He and wife Phoebe (Bane) were on the founding committee for the Christian Church, one of the first Protestant congregations in the area. (Courtesy Gilroy Museum.)

At age 19 Heinrich Kreiser came alone from Germany to New York in 1846. Several years later, using the ticket and passport of an acquaintance, Henry Miller, he ventured west via the Isthmus of Panama. Finding temporary work in San Francisco as a butcher, Kreiser decided to keep his new name and had it legally changed some years later. (Courtesy Gilroy Museum.)

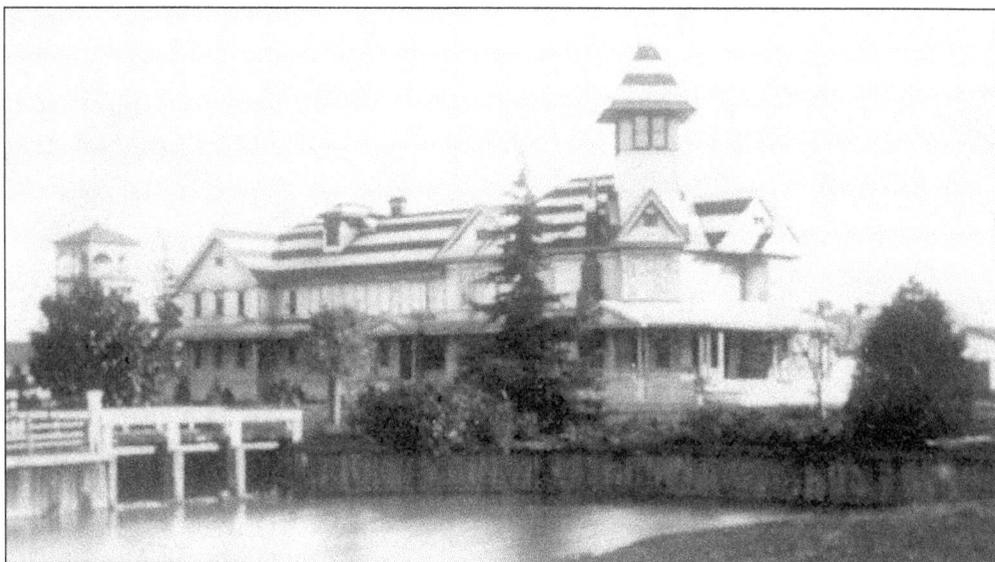

Miller went into private enterprise—the cattle business—by purchasing a portion of the successful operation on the vast Rancho Sanjon de Santa Rita near Los Banos. The deal included the rights to the prestigious Hildreth & Hildreth (HH) brand. In the ensuing years, cattle by the hundreds of thousands bore this mark. In 1857 Miller formed a partnership with Charles W. Lux that was headquartered at Bloomfield Ranch just south of Gilroy. This 44-room mansion was built in 1888. The ranch property was a self-contained community: livery stables, a blacksmith shop, poultry houses, granaries, a general store, and its own railroad shipping station. (Courtesy Gilroy Museum.)

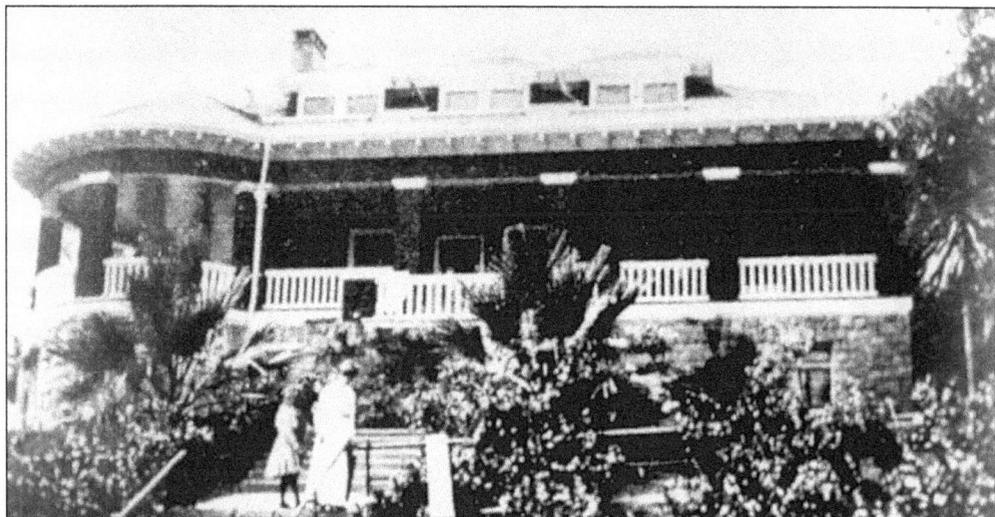

Miller's personal favorite of the nearly 1.5 million acres he ultimately owned was this property high atop Mount Madonna, west of town. His savvy as a butcher may have contributed to his reputation as "Father of the Barbecue." Miller rejoiced in hosting lavish cookouts on the grounds of this gracious home completed in 1901. Frank Schmitt, foreman of this ranch, supervised the building of roads and the planting of orchards and a vineyard, and the women of Schmitt's family did most of the grocery buying and cooking—all of which contributed to making this haven in the redwoods so pleasant. (Courtesy Gilroy Museum.)

Some still refer to this west side area, once part of Miller's Glen Ranch, as Indian Camp. The stone for Old City Hall, at the corner of Monterey and Sixth Streets, was quarried here. Notice the grinding holes in some of these rocks that were created centuries ago by the Ohlone women as they prepared food for their families. In the early 1920s this 475-acre ranch was purchased from Miller & Lux by a great-nephew of Massey Thomas. (Courtesy Gilroy Museum.)

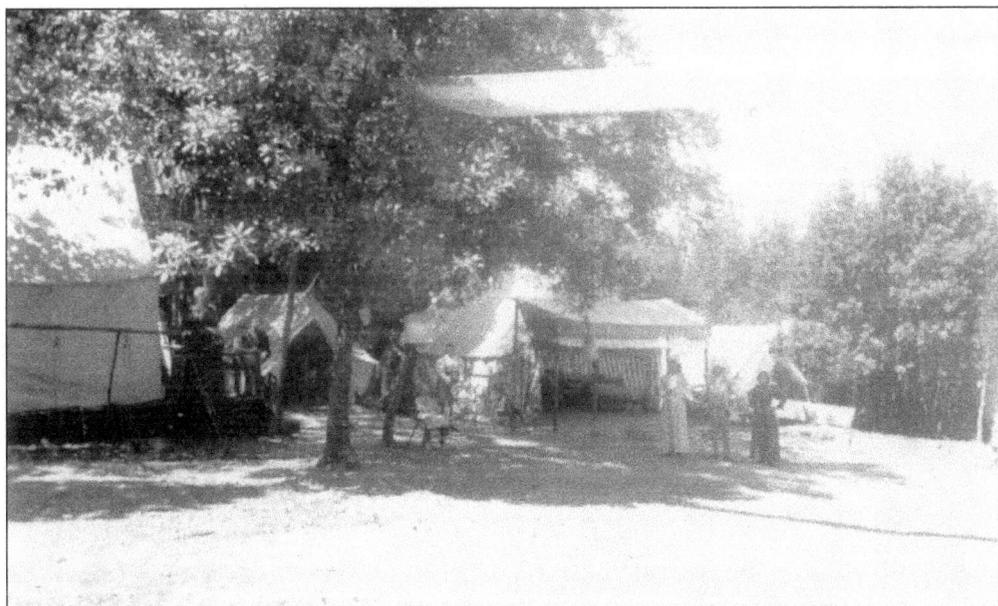

The Millers had a modest redwood cabin on this property in the 1890s. For those years, and later when there were large groups staying at the Mount Madonna retreat, Miller provided these spacious tents for his guests, complete with inn-like amenities. Apparently there was a hierarchy: the higher the social status of the guest, the fancier the tent and its accommodations.

Decked out in a sunbonnet here is Dr. Clarence Weaver, center right, who had a dental practice in town. (Courtesy Gilroy Museum.)

19

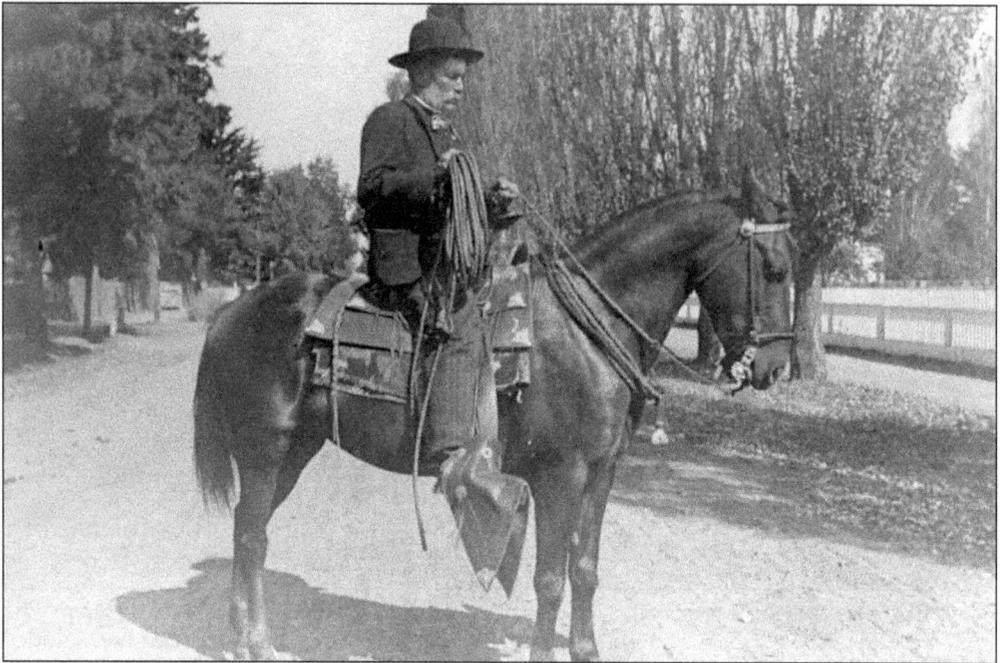

Miller was a hard taskmaster but a fair boss according to most. He had numerous capable, loyal employees like Santa Cruz-born Andrew Rodriguez, pictured here c. 1896, who was Miller's head vaquero for many years. The Miller & Lux empire covered parts of three states, and Miller spent the majority of his time traveling on horseback from one site to another, often accompanied by Rodriguez. (Courtesy Gilroy Museum.)

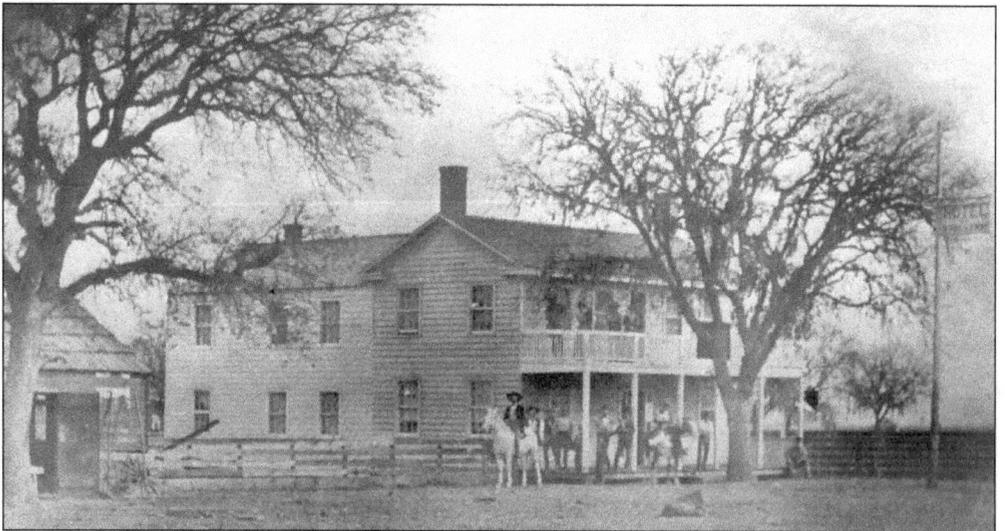

The gold rush changed California forever. David Holloway ventured west in 1853 and settled here in Pleasant Valley as it was called by that time. During his first winter here Holloway built this large structure on Monterey Street, complete with a veranda, intending it to be his family's home. In the spring, however, he converted it to Gilroy's first hotel. He opened a blacksmith's shop as well, which he operated with his sons. The Holloways had much to offer individuals traveling up and down the central coast, and theirs was a popular stopping place. (Courtesy Gilroy Museum.)

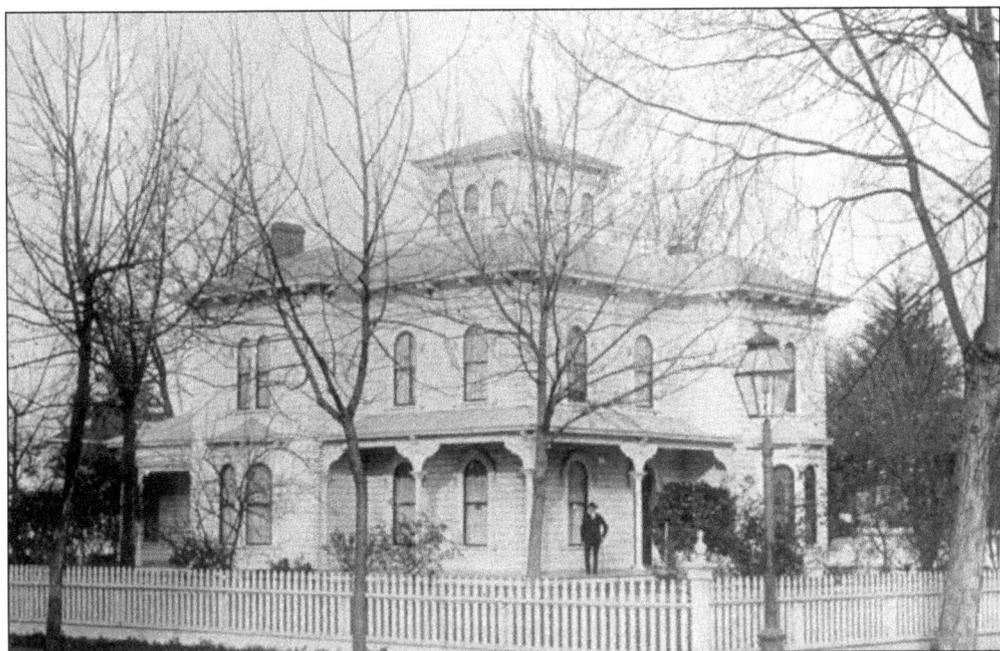

Thomas Rea first settled on part of Rancho Solis and started a dairy enterprise, which grew to 935 acres. In 1871 he sold the business to his son and built this stately home at Sixth and Alexander Streets. He was an initial stockholder in the Bank of Gilroy and its president for a time. Civic-minded, Rea was also mayor, served on the City Council, and was a state assemblyman. (Courtesy Gilroy Museum.)

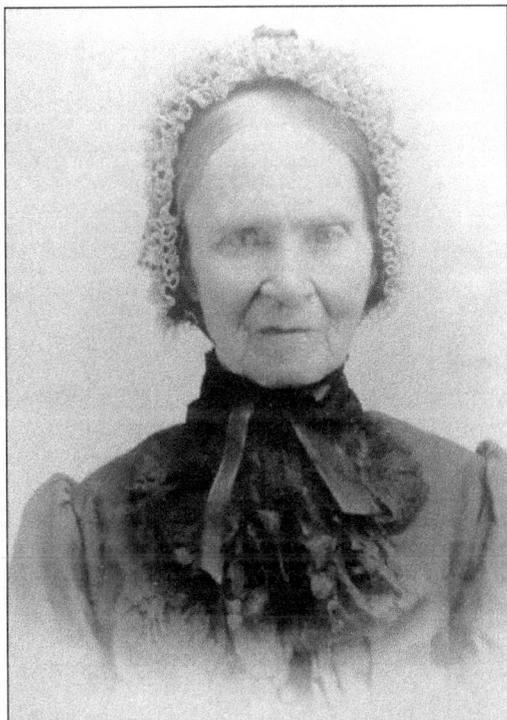

Electa Ousley was one strong woman. In 1852–53, while pregnant with her ninth child, she and her husband Samuel, along with their eight children, came across the plains and settled on former Rancho Solis land west of town. Samuel was killed in a farming accident in 1856 as she awaited their tenth child. Electa persevered and, with her children's help, recorded land in her own name—a rarity for a woman in those days—and ran a profitable cattle ranch. Years later two of her daughters gifted part of the family's land to the city, designating its use as a municipal golf course. (Courtesy Gilroy Museum.)

The early railroad line that connected Gilroy and San Jose was called the Santa Clara & Pajaro Valley Company. When it was completed in 1869, most of the town turned out, complete with a brass band, to welcome the first train. A branch line to Hollister came in the next year. (Courtesy Gilroy Museum.)

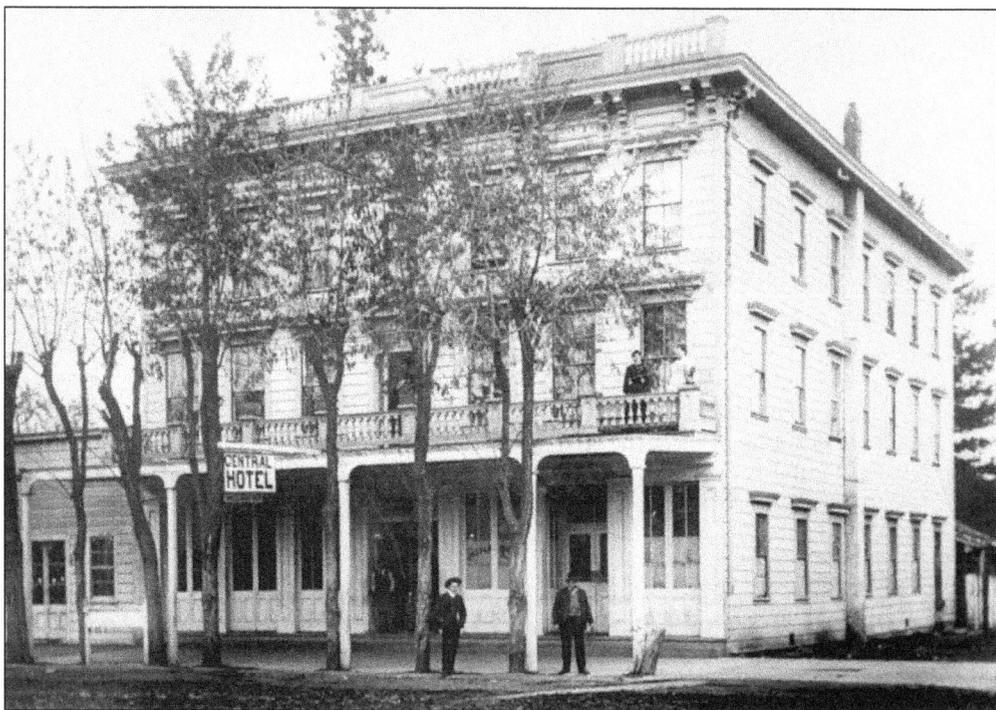

The advent of the railroad accelerated the city's growth and the need for more lodging for travelers. The William's House was built on the east side of Monterey Street near Fifth Street in 1872 and later became the Central Hotel, a favorite with businessmen. (Courtesy Gilroy Museum.)

Three

SPECIAL FIRSTS

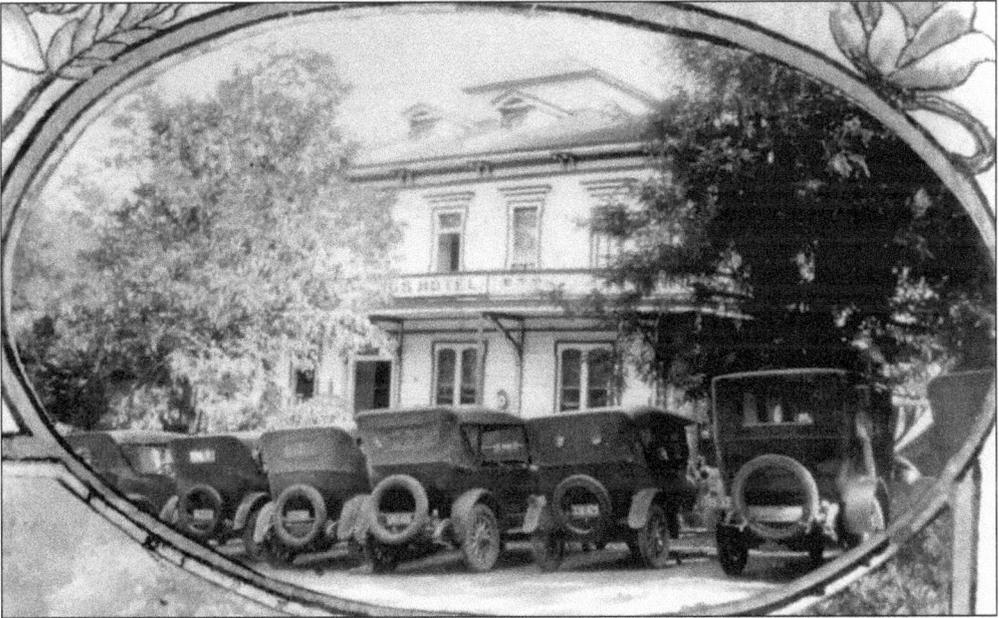

Depending on the source, discovery of the mineral springs in the eastern foothills is credited to either sheepherder Francisco Cantua or to Ignacio and Jose Ortega of the Rancho San Ysidro family. George Roop bought the land around the springs in the fall of 1866 and cleared a roadway to the site. He and a partner built cabins and opened for business in 1868. This three-story hotel, the first rural resort in the area, was completed in 1874 and could accommodate up to 170 guests. (Courtesy Gilroy Museum.)

The waters of these springs were regarded as a balm for many ailments. That belief, plus the splendid climate and recreation in the area and the excellent reputation of all three dining rooms, drew visitors from around the world to the resort. This kiosk provided shade over the cistern of the main spring, and ladles were provided so that guests could fill their room pitchers with "the freshest mineral water available." (Courtesy Gilroy Museum.)

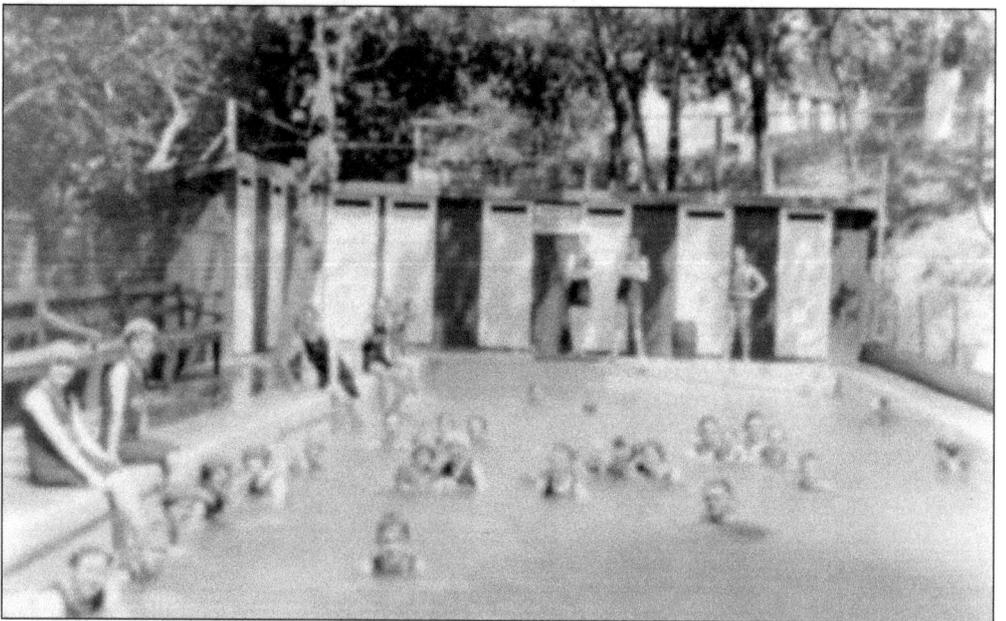

The mineral springs—even to this day—bubble out of the ground at an average temperature of 107 degrees. By the late 1880s the resort was in its heyday with 16 bathing rooms, fitted with cool-water sprinklers, separate mud baths, and two large swimming pools, called tanks, which were gender specific. This coed photo from 1926 shows that the separate-facilities policy of the Victorian era had been eliminated. (Courtesy Gilroy Museum.)

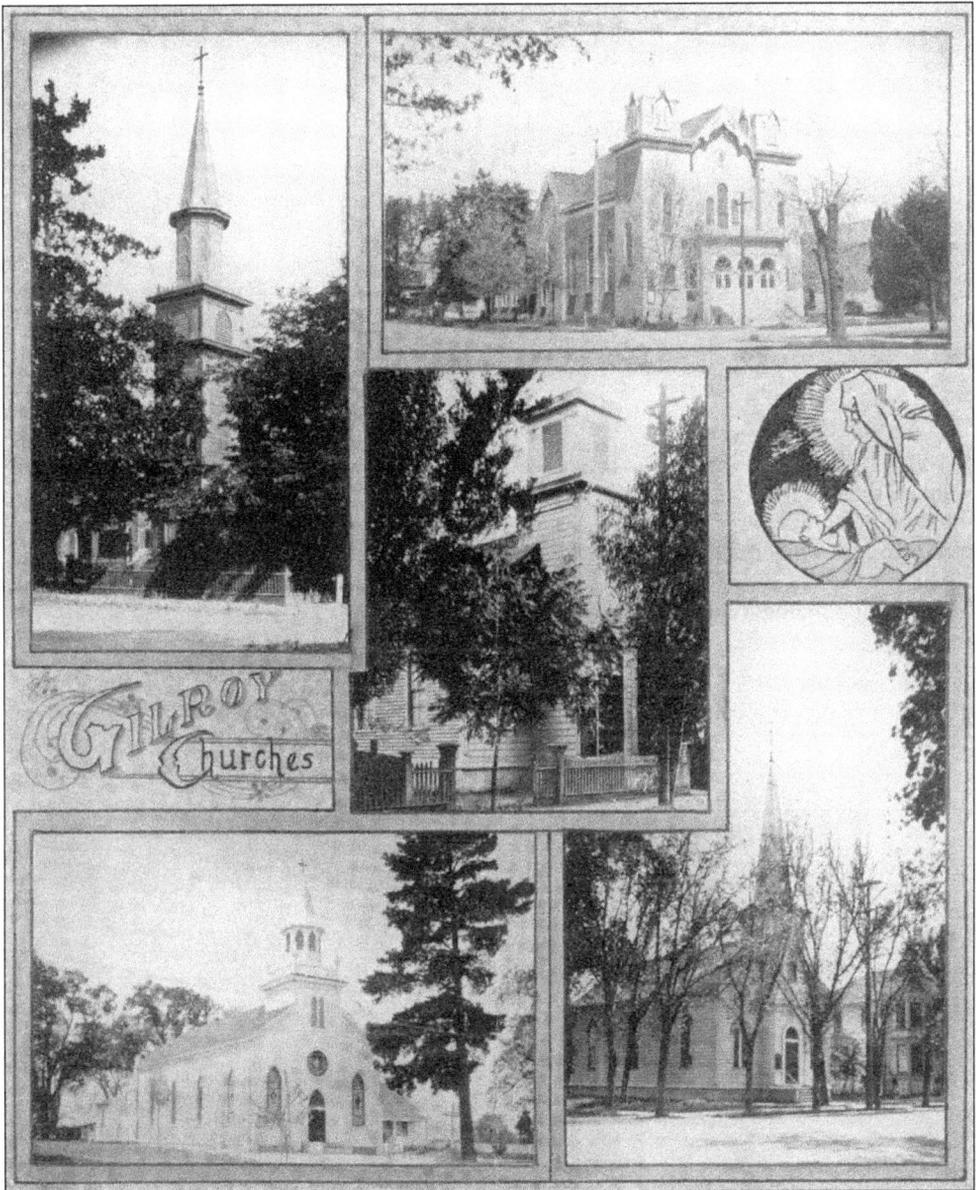

The first recorded Protestant services in the area were conducted in 1852 in the William Bane home by a circuit-riding minister of the Methodist Episcopal South church. The Methodist Church shown here (upper right) was gutted by fire in 1938 and replaced. The Christian Church's (center) congregation formed in 1855 and this building is considered the oldest structure in the city limits. The Presbyterians (lower right) built this, their first church, in 1869 at the corner of Fifth and Church Streets. The first in-town church for the Catholic congregation of St. Mary (lower left) faced Monterey Street at First Street and was built in 1864. The Episcopalian Church (upper left) was founded in the late 1860s as well. Constructed of local redwood it stood at the corner of Martin and Forest Streets. (Courtesy Gilroy Museum.)

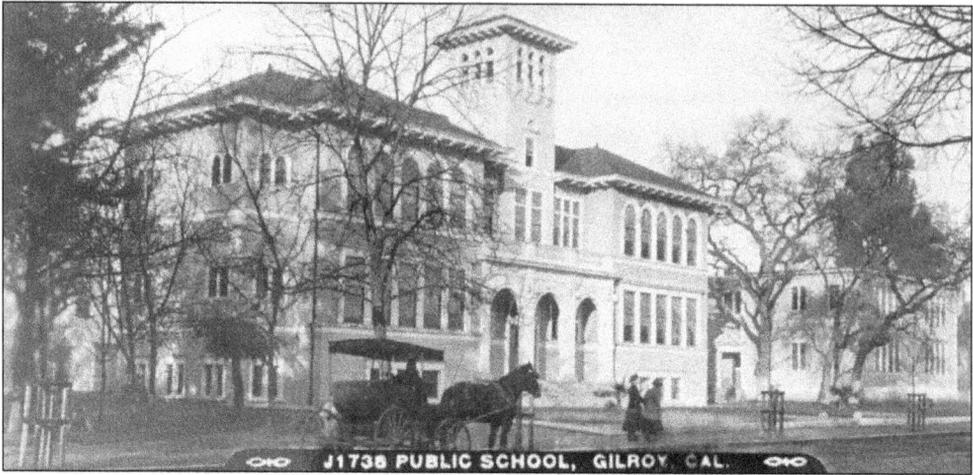

J1738 PUBLIC SCHOOL, GILROY CAL.

William Bane organized the first classes held in town for Gilroy's children in 1852. Years later, the Miss Sarah M. Severance Gilroy Seminary, a school for young ladies, opened on Railroad Street and was directed by Miss Severance and her sister for 17 years. This late 19th century public school on Church Street was named in Miss Severance's honor. To the right is the first high school building. (Courtesy Gilroy Museum.)

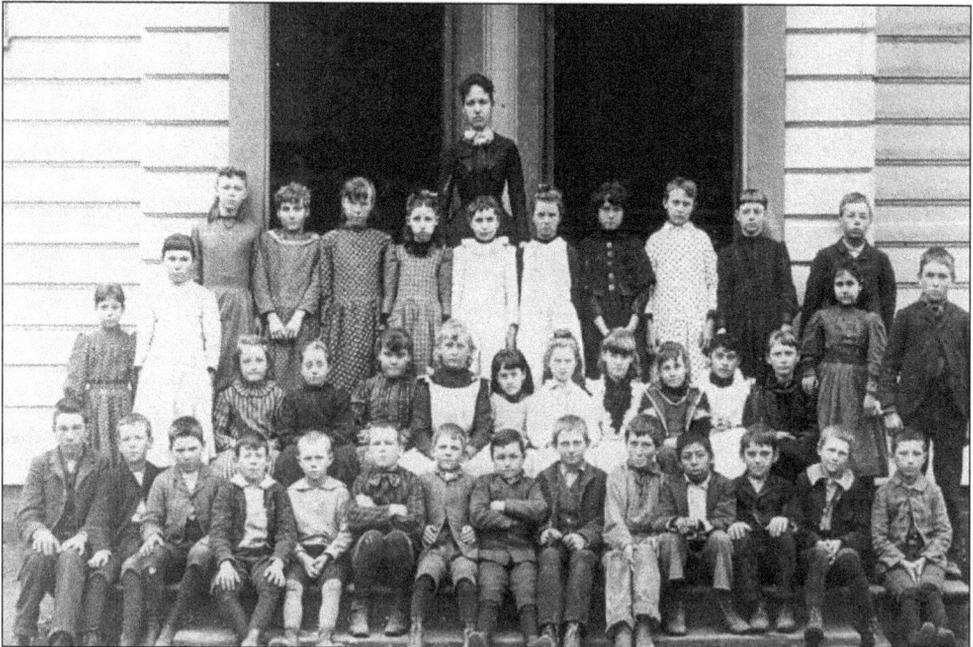

Pictured here is a class at Severance School, c. 1892. The young teacher doesn't appear to be very happy, but with the range of ages seen here and 38 children to plan for, every day must have been quite a challenge for her. (Courtesy Gilroy Museum.)

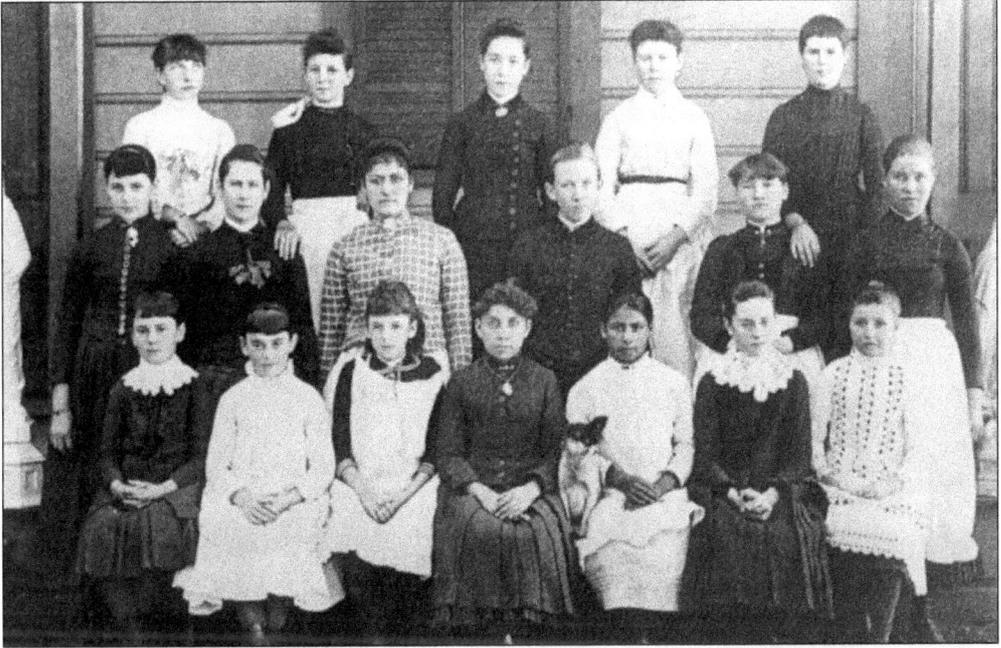

St. Mary Catholic Church founded its own school in 1870, run by the sisters of the Convent of the Immaculate Heart. Young ladies of Sister Vibiana's girls' class of 1888, from left to right, are: (bottom row) Evelyn Casey, Josephine Casey, Mamie Payne, Angelina Princevalle, Anita Torres, Mollie Casey, and Laura Dewart; (middle row) Frances Fitzgerald, Mamie Breen, unidentified, Edna Milne, Belle Costigan, and Mary White; (top row) Nellie Coche, Mamie Bruen, Carrie Costello, Frances Sullivan, and unidentified. (Courtesy Gilroy Museum.)

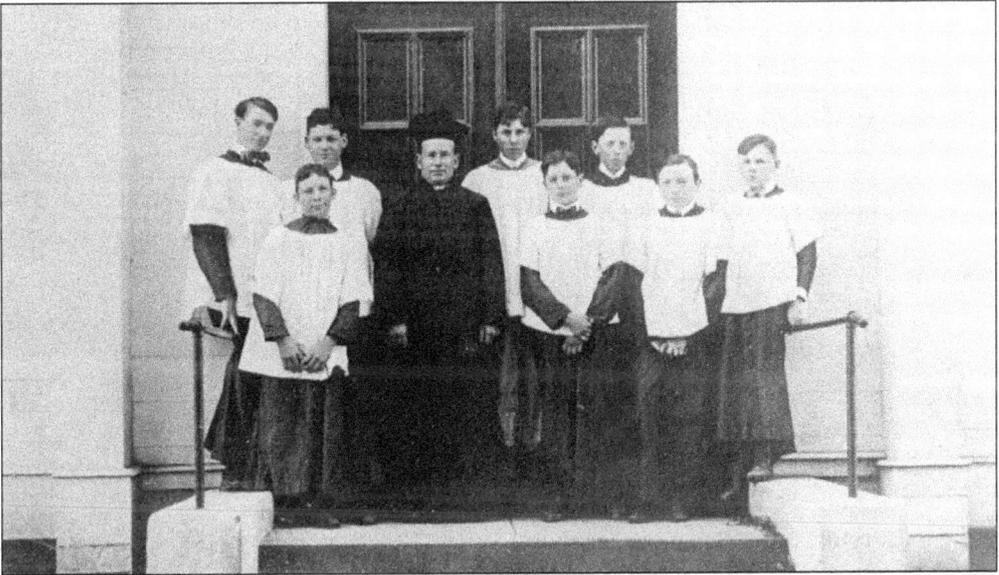

It has always been a special honor for young members of the St. Mary parish to serve as acolytes. Pictured in this 1909 photo in front of the original church, from left to right, are: (front row) Albert Fahey, Father P.J. Hennessey, Thomas Cullen, Herbert Fahey, and William Hines; (back row) John Hines, William Cullen, Thomas White, and George Klassen. (Courtesy Gilroy Museum.)

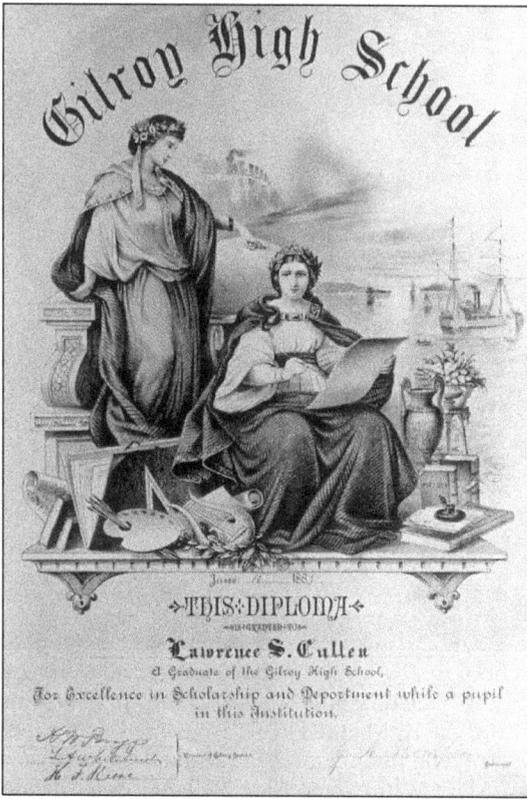

It is interesting to note the artwork on Lawrence S. Cullen's 1883 Gilroy High School diploma. It indicates that this graduate of a pioneer family has mastered the three R's and has also had an exposure to the fine arts—a well-rounded education, indeed. (Courtesy Gilroy Museum.)

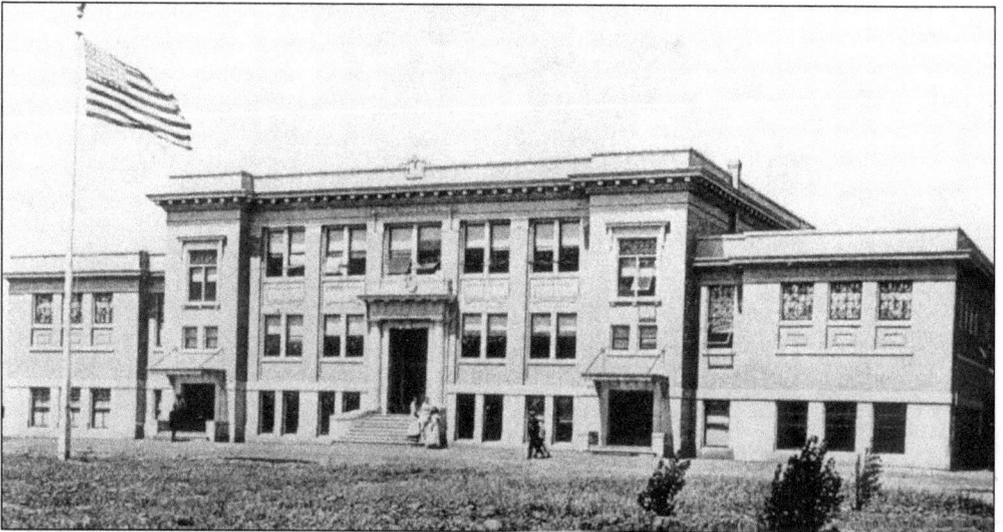

Designed by the noted architect William H. Weeks, this three-story, state-of-the-art high school was erected on I.O.O.F. Avenue in 1912. For the first time Gilroy's teenagers had a campus of their own—cause for celebration, no doubt. (Courtesy Gilroy Museum.)

Lumber! Lumber!

WILLIAM HANNA,

Church Street, bet. 6th and 7th. GILROY, CAL.

Is prepared to furnish all kinds of

LUMBER, BUILDING FINISH,

Doors, Window Sash and Frames,

OF EVERY VARIETY.

STAIR BUILDING,

Turning and Scroll Sawing, with Mouldings

OF EVERY DESCRIPTION.

(*above*) An act of the state legislature on March 12, 1870, transformed the town of Pleasant Valley into the incorporated city of Gilroy. Long before that, however, the bustling growth created a need for construction materials. The lush redwood forests west of town were the source. William Hanna claimed to be the first with both a logging and milling operation. In 1862 he sold part of the business to George Bodfish. Bodfish stayed only two years, but the name stuck, for it is Bodfish Creek that still runs alongside the area where the mill once stood. Hanna built and operated the Gilroy Planing Mill in town for a time, and frequently ran ads like the one above in the local paper of that era, *The Gilroy Advocate*. (Courtesy Gilroy Museum.)

(*right*) Hanna got out of the lumber business in the early 1870s and moved on to public service. He was both a city councilman and mayor. In 1877 he was elected by a large majority to represent Santa Clara County in the state legislature. Even in retirement Hanna continued work on various inventions. His descendants continue to contribute to the community just as their predecessor did. (Courtesy Gilroy Museum.)

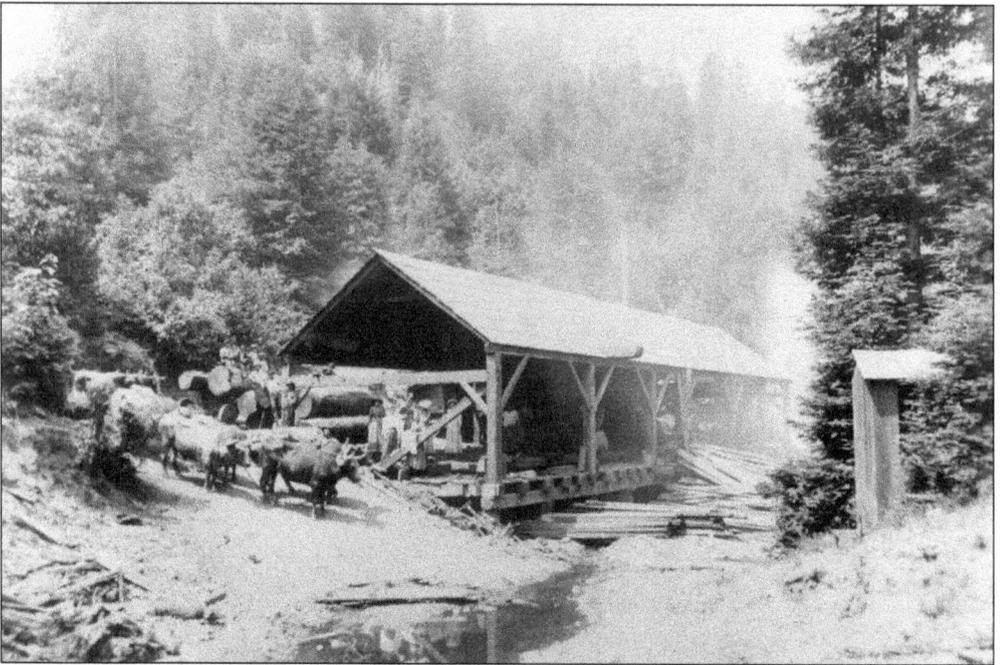

Partners Lyttleton A. Whitehurst and Pleasant Hodges purchased the major lumber holdings along Bodfish Creek in the early 1870s. They expanded the facilities and did a thriving business for several decades. Oxen pulled the heavy timbers from where they were felled to the sawmill pictured here. (Courtesy Gilroy Museum.)

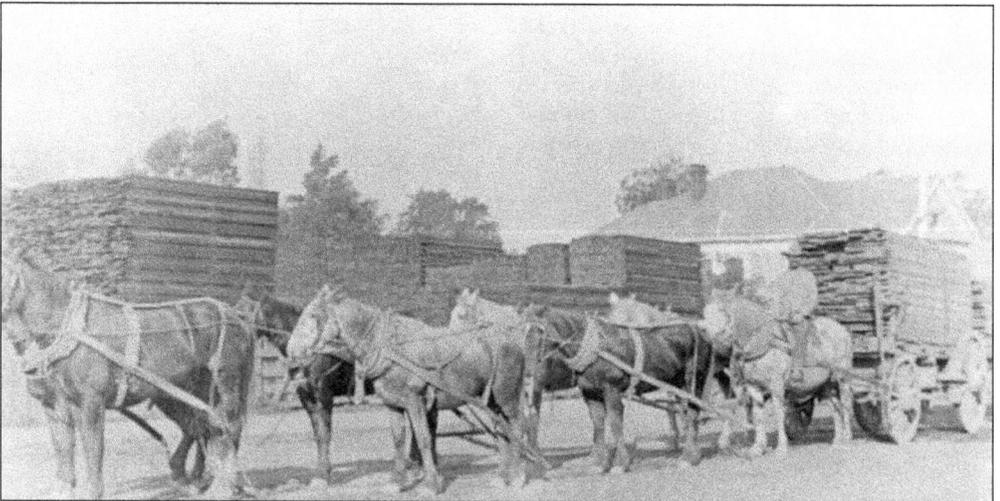

Whitehurst & Hodges also bought Hanna's planing mill in town. Horse teams brought the crude planks out of the mountains. The horses' bridles were outfitted with bells to warn other travelers that a heavy load was on its way downhill and along the city's streets. Here driver William Easton guides a team to the yard at Sixth and Church Streets, *c.* 1881. The firm made roofing and siding shingles and shakes and turned out millions of board feet of construction timber. Whitehurst & Hodges dominated the local market and were major suppliers to growing communities throughout the state. Many homes built of local redwood still stand in Gilroy today. (Courtesy Gilroy Museum.)

Mr. Whitehurst served Gilroy in numerous ways. He was president of the Bank of Gilroy for many years, was mayor for one term in the early 1890s, was elected to the state assembly for several terms, and followed that with a term in the state senate. A close inspection of the high school diploma on page 28 reveals that he also served as a trustee for the Gilroy schools. (Courtesy Gilroy Museum.)

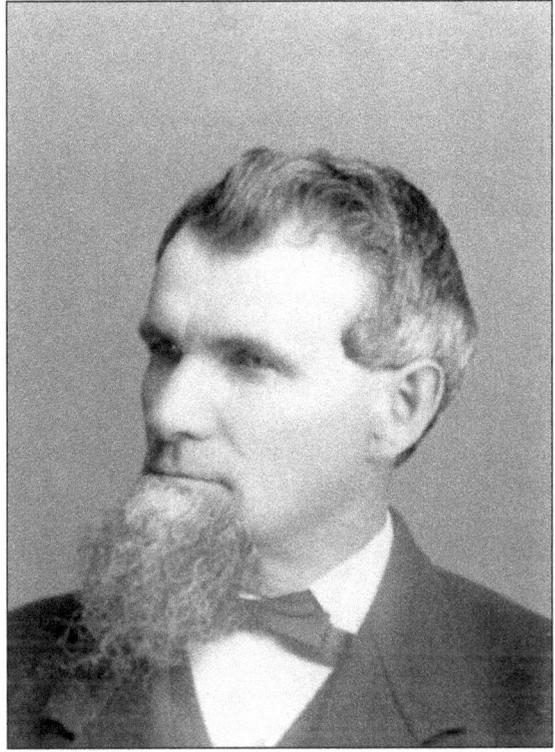

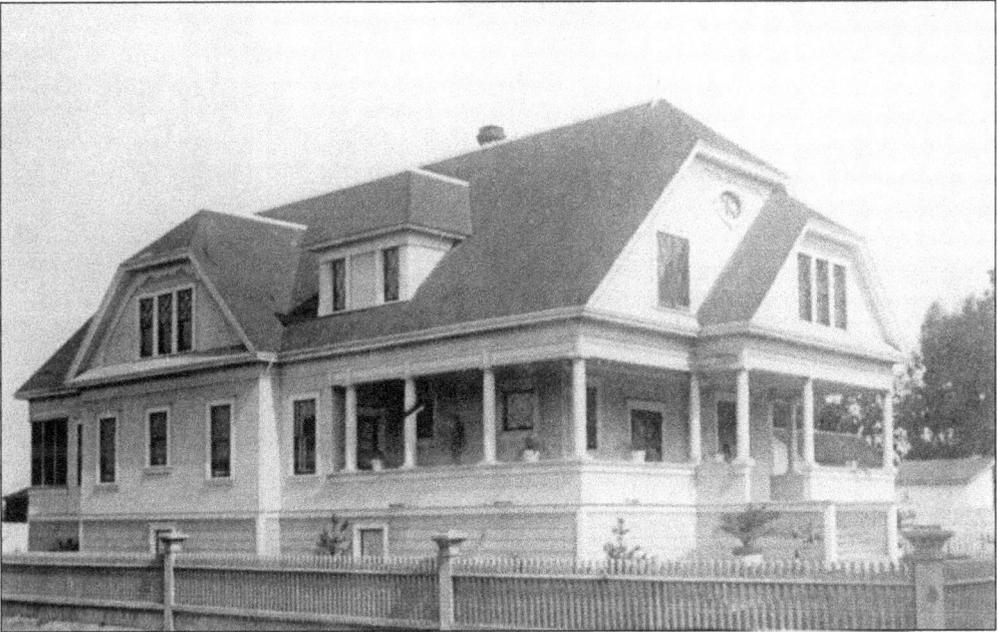

In 1909, Logan Whitehurst, son of Lyttleton, built this stately, 4,800 square-foot home along south Church Street for his bride. Logan, by then having managed the Whitehurst & Hodges enterprise for some 20 years, knew prime woods, and the fine workmanship in this home is stunning. After Whitehurst's death, the home was owned and occupied for many years by long-time city attorney, Sydney Johnson. (Courtesy Gilroy Museum.)

31

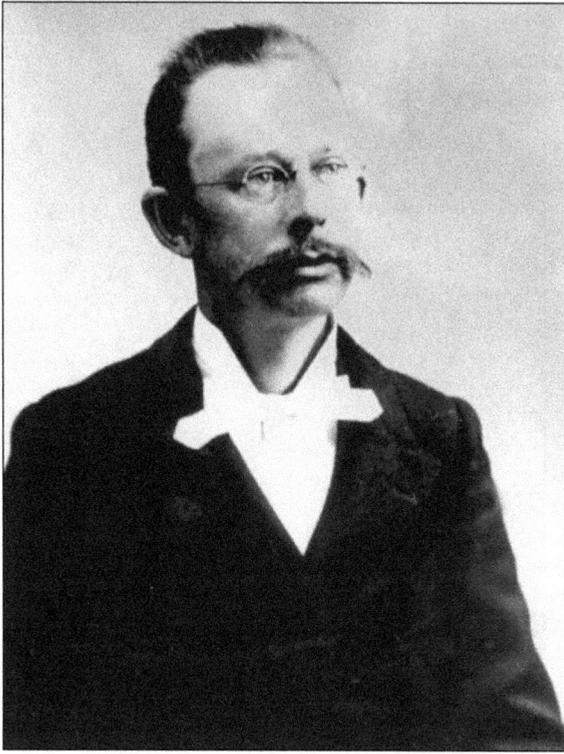

Dr. Jonas Clark was a 1875 graduate of Harvard Medical School and, seeking a warmer climate, came west to Gilroy in 1888. In the late 1890s, he set up a general and surgical practice and founded the Gilroy Private Hospital, the first in this area. He operated it at his own expense until it became a public enterprise in 1907. Dr. Clark was also the superintendent of the county hospital in San Jose from 1910–1913. His son John studied to be a physician as well, and eventually joined his father's practice. (Courtesy Gilroy Museum.)

Dr. Clark's daughter, Marie, was a trained surgical nurse and was her father's partner in a nurses' training school that was connected with the hospital. Marie Clark later became Gilroy's first school nurse and tended to Gilroy's children in that capacity for nearly 30 years. (Courtesy Gilroy Museum.)

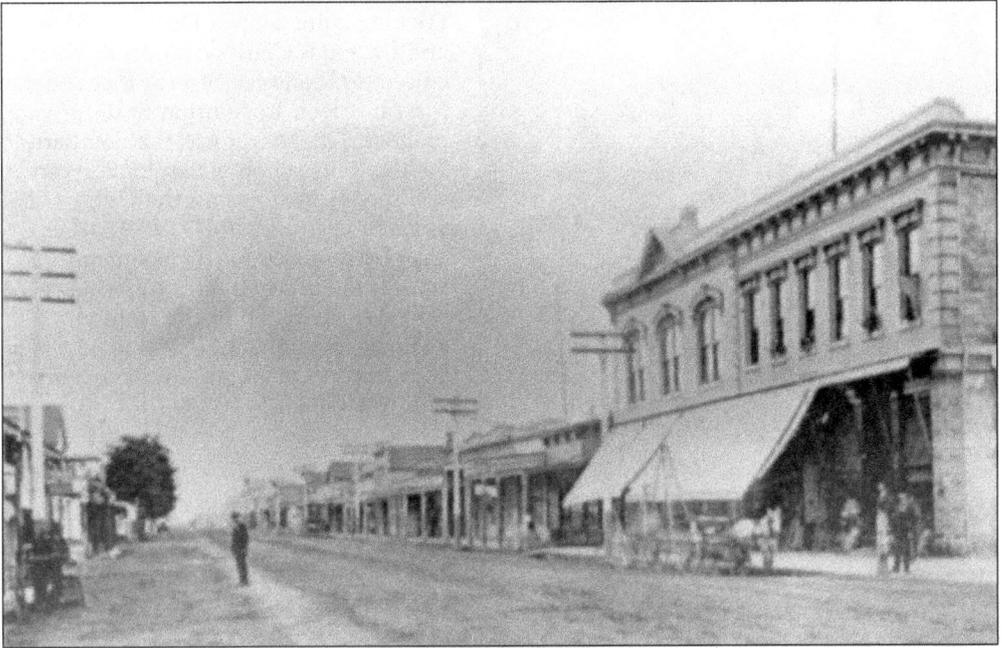

The two-story building featured on the right here is on the southwest corner of Monterey and Fifth Streets, c. 1902. Dr. Jonas Clark's hospital as well as a nurses' training school were on the second floor. The ground floor housed Henry Hecker's General Store. (Courtesy Gilroy Museum.)

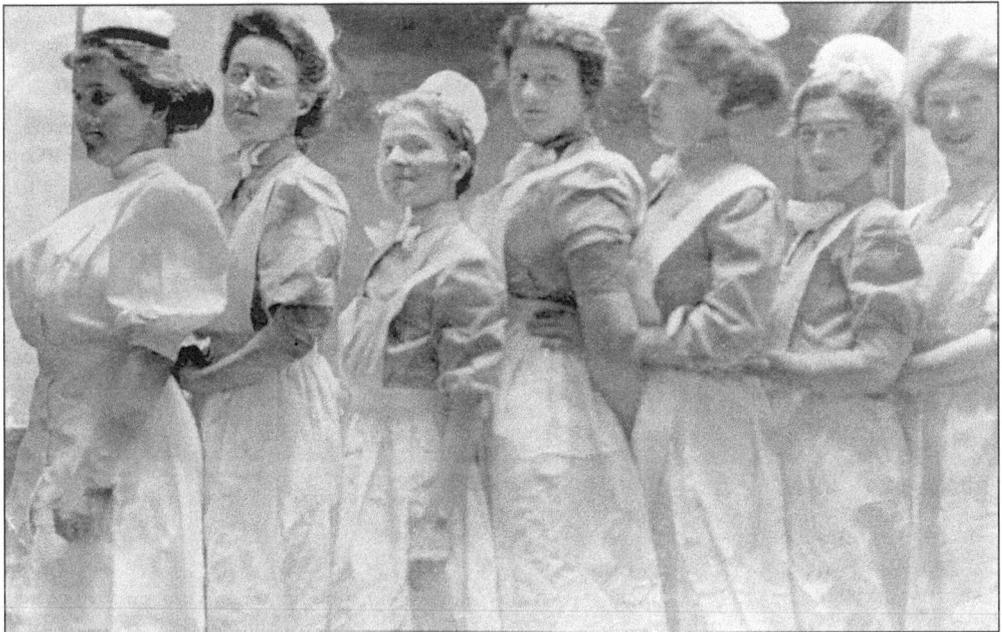

Before a rigid state control of nurses' training facilities was enacted, Dr. Jonas Clark and his daughter, Marie, trained those interested in a nursing career at the Gilroy Private Hospital. Pictured here, c. 1904, from left to right, are Frances Aston, unidentified, Georgia Tremaine, Thelma Whitehurst, unidentified, Hattie Holmes, and (obtusely identified) Mrs. Pyle's mother. (Courtesy Gilroy Museum.)

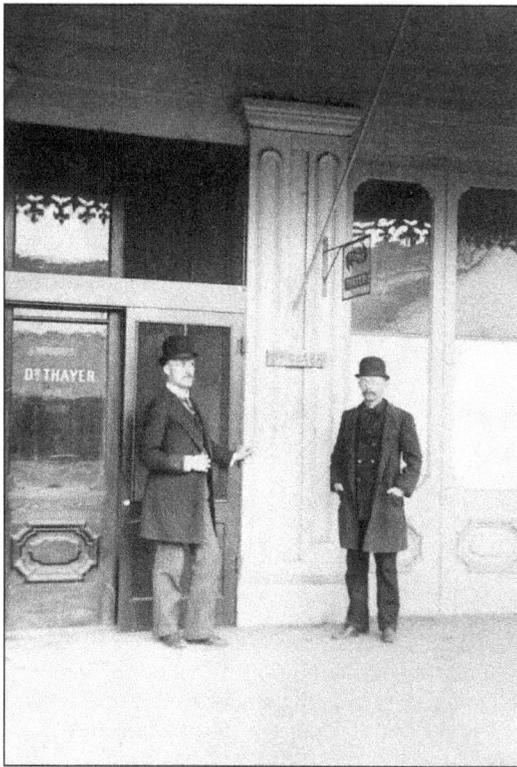

Looking quite dapper, Dr. James Thayer and Dr. Jonas Clark pose outside their adjoining Monterey Street offices near Martin Street. In addition to his private practice, Dr. Thayer was the Southern Pacific Railroad physician for 25 years and spent five terms on the Gilroy City Council beginning in 1892. Another asset he provided for the community was his fluency in Spanish, having served as physician to the Central Railroad in Chihuahua, Mexico, for four years before coming to Gilroy. (Courtesy Gilroy Museum.)

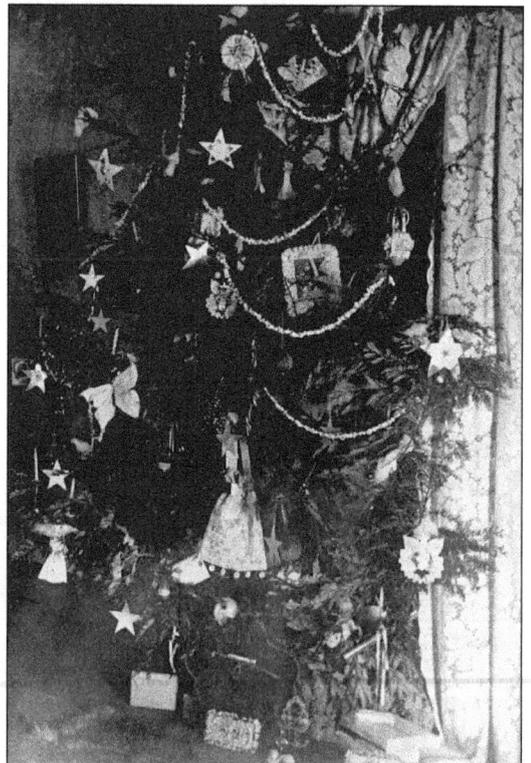

The Thayer residence was at the corner of Martin and Alexander Streets, just a short walk from the doctor's office. Every year the Thayer's Christmas tree, cut from the nearby redwood forests, was enjoyed by those who would partake of the yuletide hospitality extended to the community by the good doctor and his family. (Courtesy Gilroy Museum.)

Four

OUT AND ABOUT TOWN

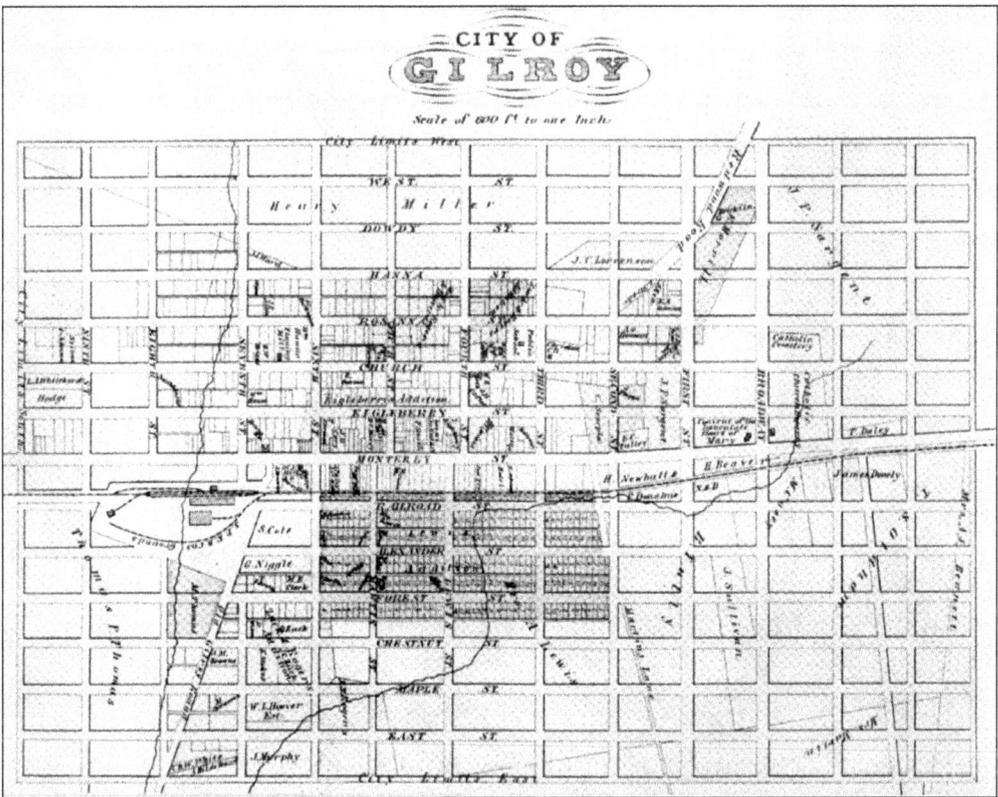

This map of Gilroy's city limits from the 1877 Thompson Atlas shows how intense the development was by then, particularly toward the center of town. Note that Henry Miller owned many blocks of the west side (top) in addition to the hundreds of acres that were a part of his rural Gilroy holdings. (Courtesy Gilroy Museum.)

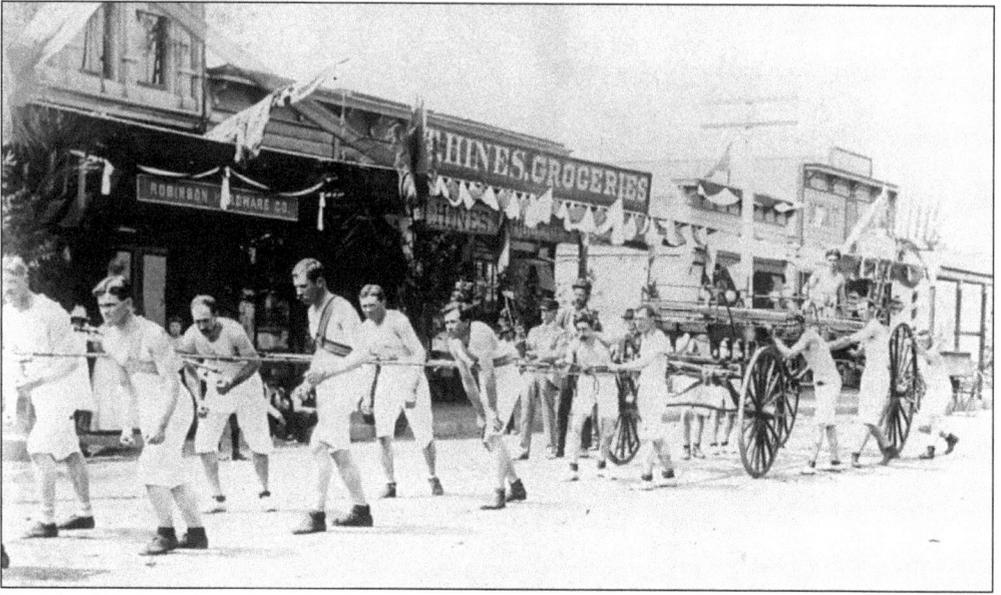

Most buildings in the city were constructed of wood and were lighted with candles and fuel lamps in the early days, making fire an ever-present threat. In July of 1869 the first official fire-fighting unit formed, calling themselves the Vigilant Engine Company. Two years later they joined forces with a second volunteer team, the Eureka Hook & Ladder Company. The men pulled the hoses and water tanks to the scene. To stay in shape for this strenuous activity, they practiced regularly, often in spirited competitions with one another. (Courtesy Gilroy Museum.)

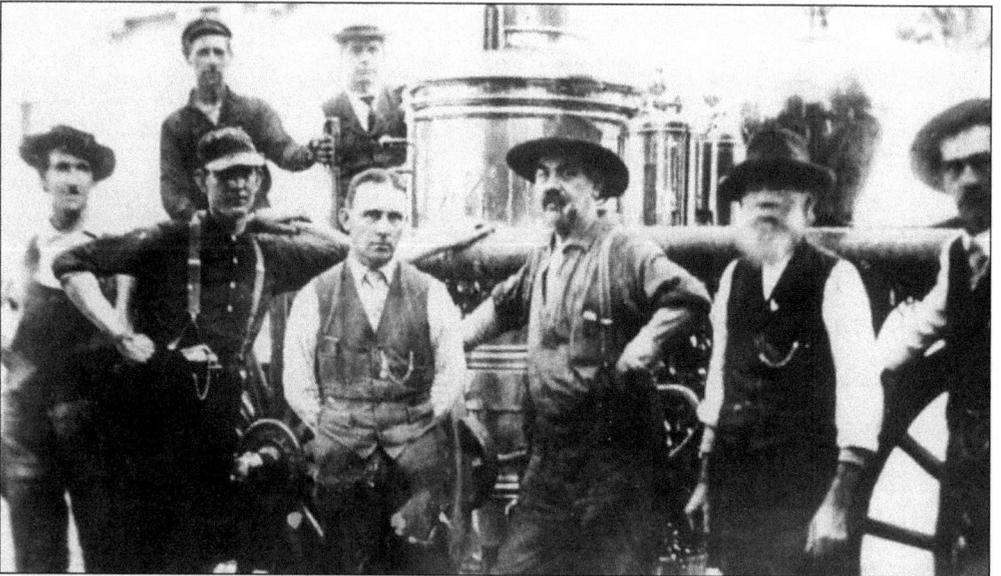

In this close-up some of the Vigilant volunteers proudly display their shiny Knickerbocker steam engine that increased pumping capacity for dousing flames. Pictured here, from left to right, are: (front row) Paul Demange, plumber; Frank Congable, tinner; Willis Eustice, assistant postmaster; Val Grodhaus, tinsmith and foreman for Robinson Hardware Company; Mr. Whitney, blacksmith; W. Stayton, horse trainer and trader; (back row) unidentified; and John M. Hoesch, water superintendent and engineer. (Courtesy Gilroy Museum.)

36

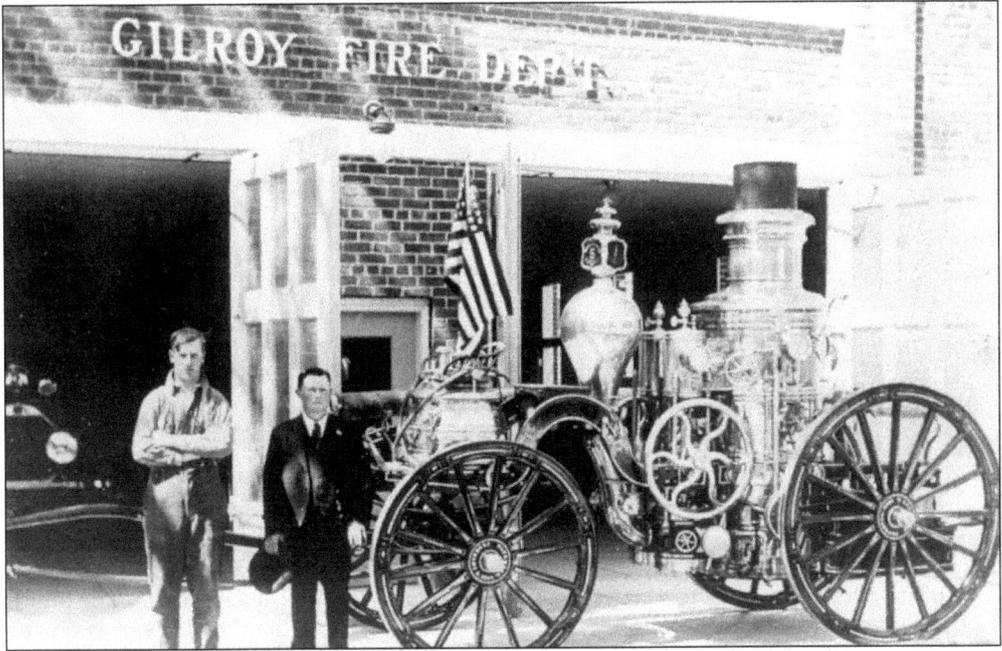

In 1916, a permanent firehouse—prudently, of brick—was built on Fifth Street by William Radtke Sr. It served Gilroy until 1978. Radtke first came to Gilroy in 1911 when he was hired by Henry Miller to construct the concrete silos at Miller's Bloomfield Ranch which can still be seen along Highway 101 near the intersection of Highway 25. Pictured here are Shirley Johnson, the first paid driver, on the left, and Hugo Hornlein, standing beside the department's spit-polished steam-pumped engine at right. (Courtesy Gilroy Museum.)

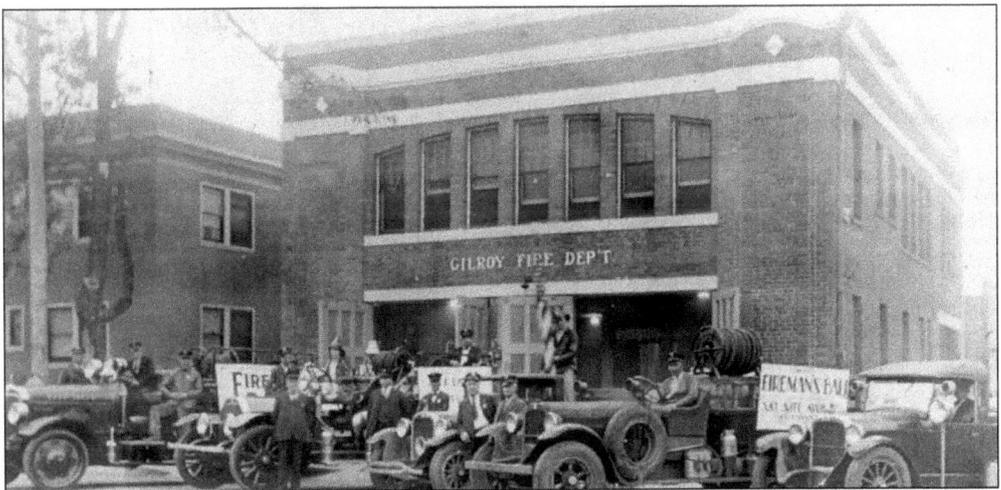

This photo, c. 1931, shows the combined forces of the city and rural fire units. Pictured here, from left to right, are: the Seagrave Pumper, American LaFrance, a Dodge pickup (the chief's car), a Dodge 800 gallon water tank truck (the first rural vehicle), and a 30-gallon chemical rural Dodge truck. Though difficult to distinguish, the firefighters pictured here, from left to right, are Al Robershotts, Charles Shields, Al Mercer, Charles Corbett, Marion Werner, John Hoesch, Bill Schiplick, Jess Rhodes, Lawrence Osborn, Chief, Will Wenslaben, Gus Cruse, James Mercer, George Pierce, and Irving Otto. (Courtesy Gilroy Museum.)

By the late 19th century there were at least two flour mills within the city limits. The Smith brothers' enterprise was on Monterey Street. The mill pictured here, c. 1894, was on the southwest corner of Railroad and Lewis Streets. It had the usual stone-ground capability and there was a steam-powered mill here as well, both under the supervision of Alexander Hay, one of the proprietors. In addition to flours this mill produced cornmeal and middlings. All products were available for both local trade and shipment. The flour, in particular, commanded a high price in San Francisco. Tom Weston, on horseback, is the owner of the rig shown here. (Courtesy Gilroy Museum.)

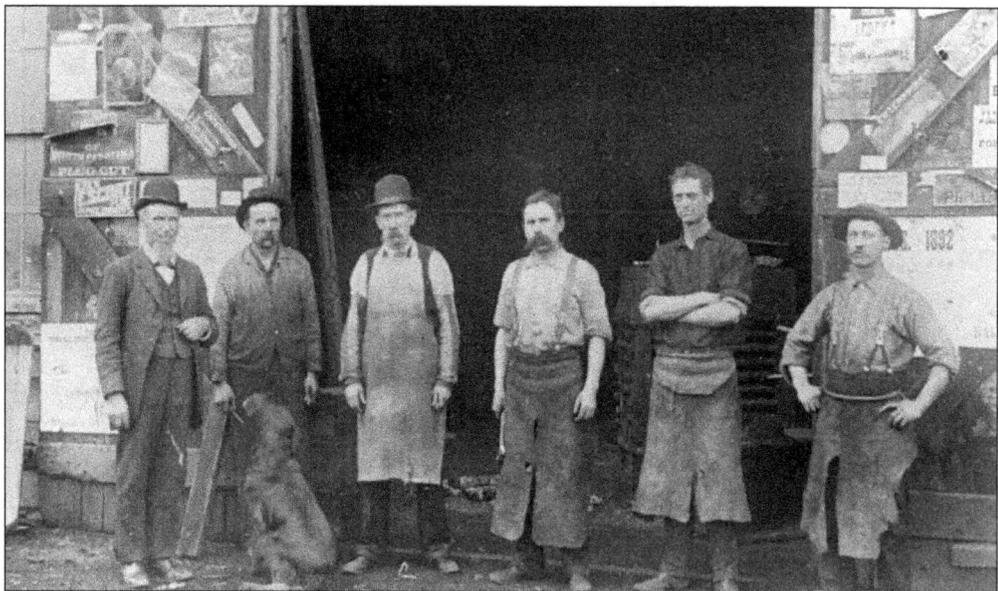

With all the horses and buggies in town and the building of homes with fences and gates, it's not surprising that Gilroy had many "village smithies." Here, c. 1884, Mr. Crews, his faithful dog, and his employees pose outside Crews' blacksmith shop on Monterey near Lewis Street. (Courtesy Gilroy Museum.)

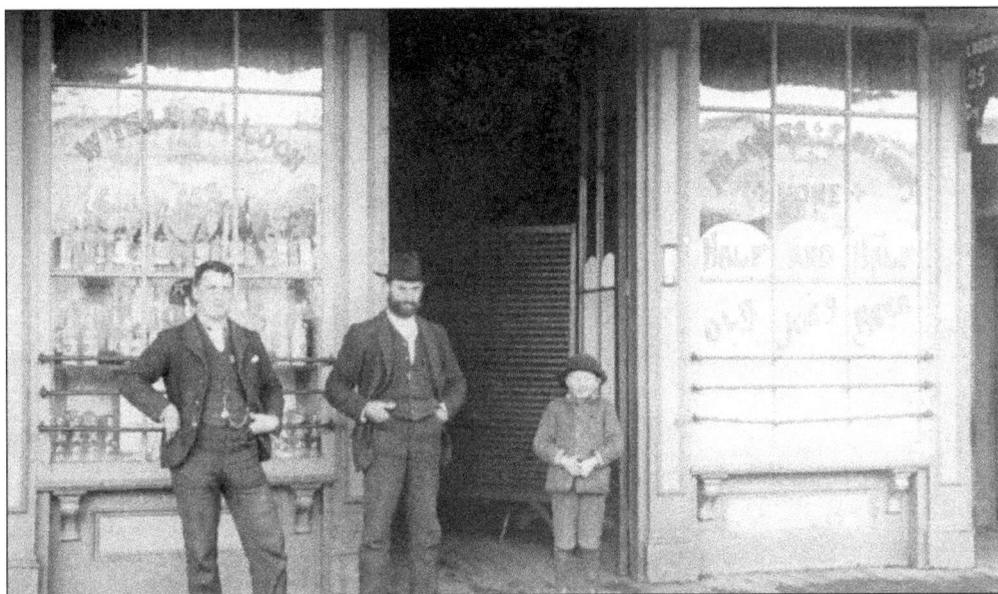

The William Tell House was a popular Monterey Street "watering hole." Pictured at left is young August Gubser. He'd lost both his parents in his native Switzerland by the time he was 17, and attracted by the knowledge of many Swiss immigrants living in Gilroy, settled here in 1888. He worked for Mr. Rea, center, at Rea's Swiss Hotel, and then learned the cheese-making trade. Later, his son Joseph became one of the first garlic growers in California. (Courtesy Gilroy Museum.)

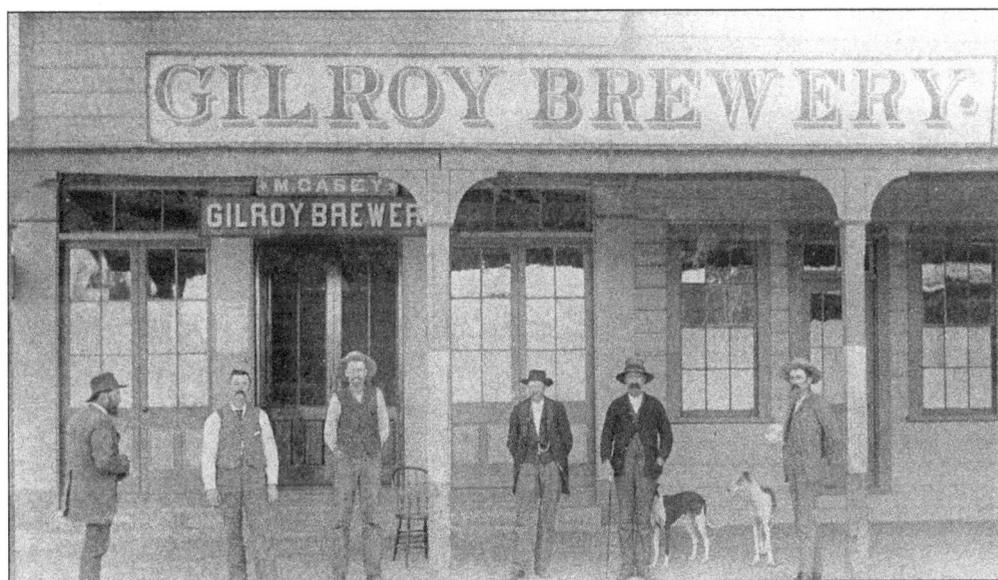

The Gilroy Brewery was another favorite gathering place, established in 1868 by German immigrant Adam Riehl and his partner Jacob Reither. The business expanded in 1877 under Adam Herold's direction. Herold's partner Michael Casey bought him out in 1886. Casey's place became an institution in the downtown, though some objected to the occasional disturbances caused by over-zealous imbibers. Despite this, Casey, who served as councilman, mayor, and fire chief over the years, remained a respected member of the community. (Courtesy Gilroy Museum.)

39

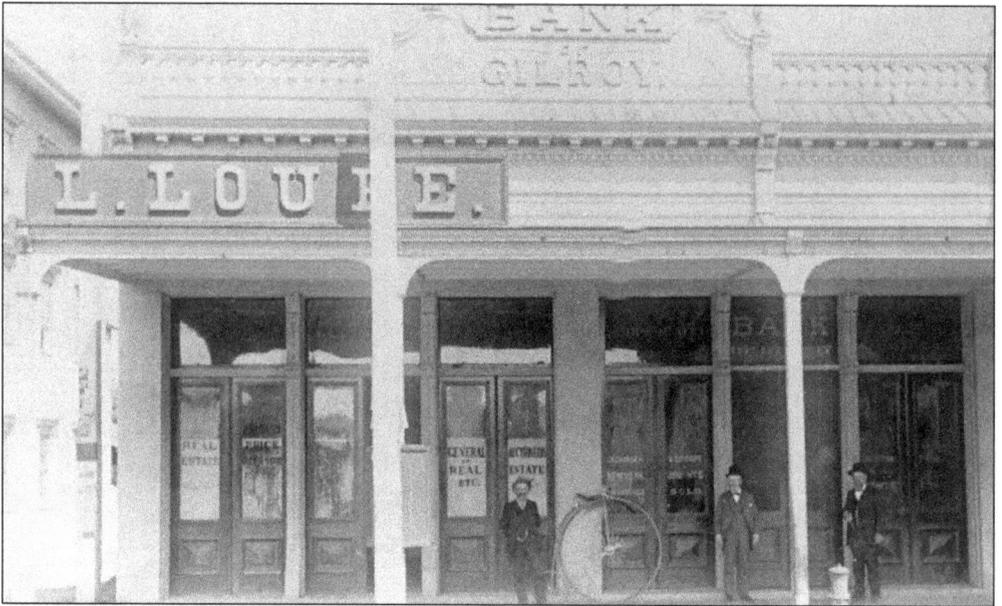

Many local residents felt that Gilroy was a secure place to invest and the bank had sound backing from the start. Lawyer James Zuck was president of the Bank of Gilroy when this photo was taken, c. 1876. He, along with Eugene Rogers and W.L. Hoover, planned the city's streets and subdivided its tracts to meet the needs of a growing population. Louis Loupe's real estate office can also be seen to the left, and note the "penny-farthing" bicycle out front. This was a derisive term for the contrasting wheel sizes of Englishman James Starley's 1870 invention—those coins being the largest and smallest copper coins of the period in Britain. Gilroy kept up with the trends all right. (Courtesy Gilroy Museum.)

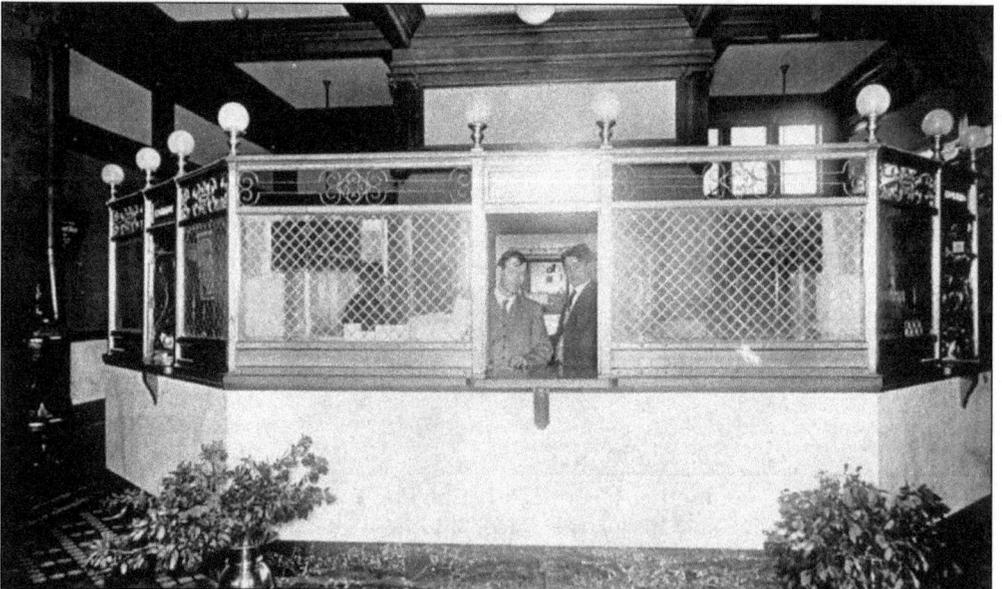

As Gilroy's main lending institution, the Bank of Gilroy was an integral part of the successful growth of the community and had an impressive interior design. Assistant cashier Arthur Chesbro and William A. Whitehurst are pictured here in 1910. (Courtesy Gilroy Museum.)

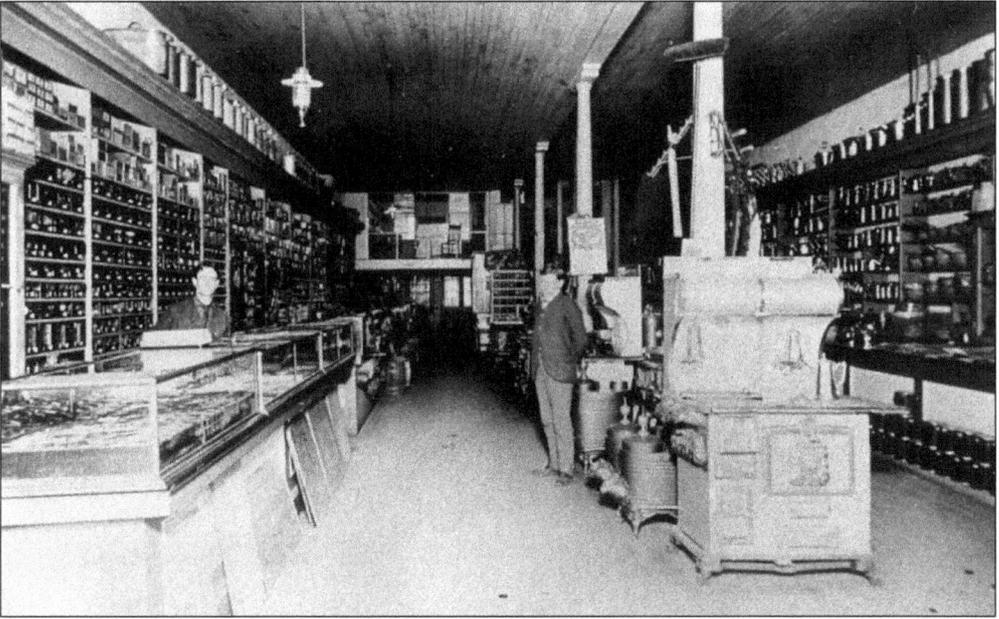

Amos Robinson was another 49er who was much more successful in Gilroy than in the gold fields. In the late 1860s he formed the Robinson Hardware business that initially specialized in well drilling, sheet metal, and dairy industry supplies. A two-story brick structure completed in 1891 allowed him to branch out into general hardware as well. His son Herbert, pictured here on the left, eventually became a full partner. Clerk Newt Hoover is on the right. (Courtesy Gilroy Museum.)

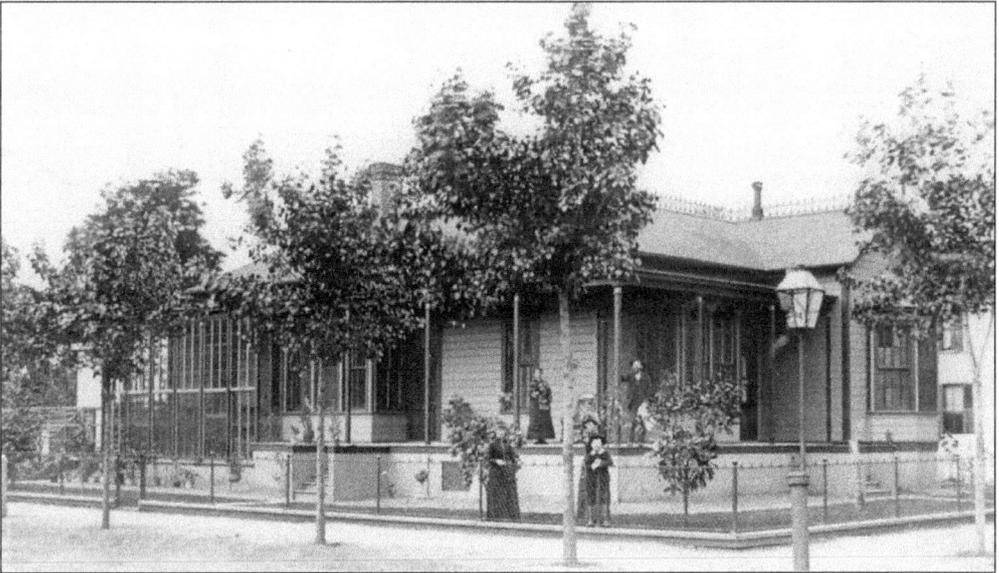

The Robinsons' fine home at Fifth and Eigleberry Streets was completed in 1885. Son Herbert stands at the fence, and his parents, Mathilda and Amos Robinson, can be seen on the porch. The family enjoyed exotic plants and their residence featured a conservatory, visible on the left. Amos Robinson was a Vigilant Engine Company volunteer, and son Herbert served as Gilroy's mayor from 1918–1920. (Courtesy Gilroy Museum.)

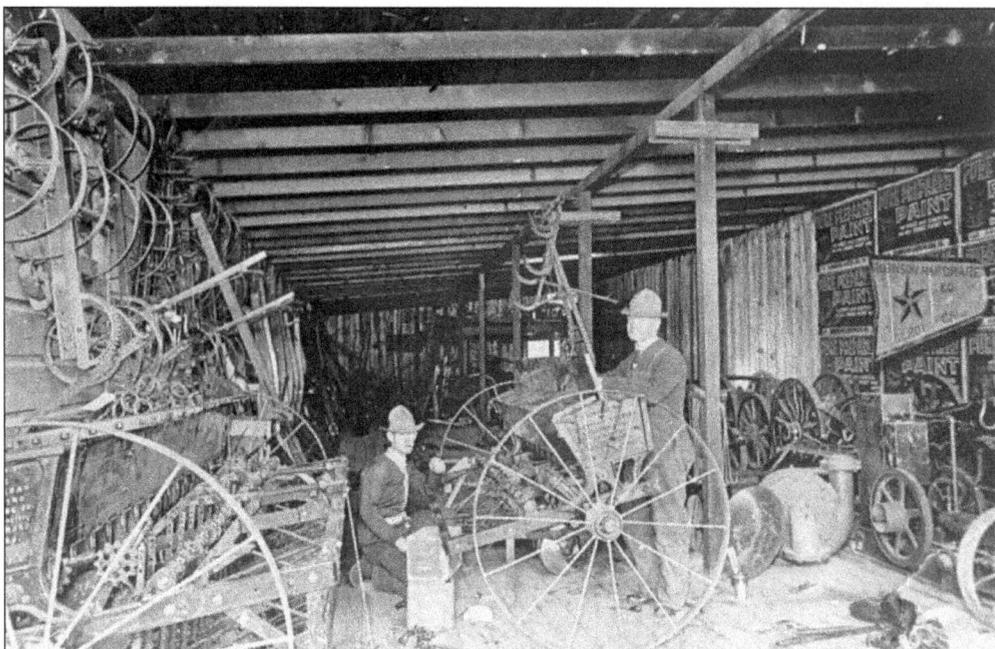

Robinson Hardware was a multi-faceted business. This separate machine shop offered, among other things, repairs and fabrication of vehicles and farm equipment as well as pipe threading and the manufacturing of well casings. Pictured here are employees Sprig Frederickson and Fred Rucker. (Courtesy Gilroy Museum.)

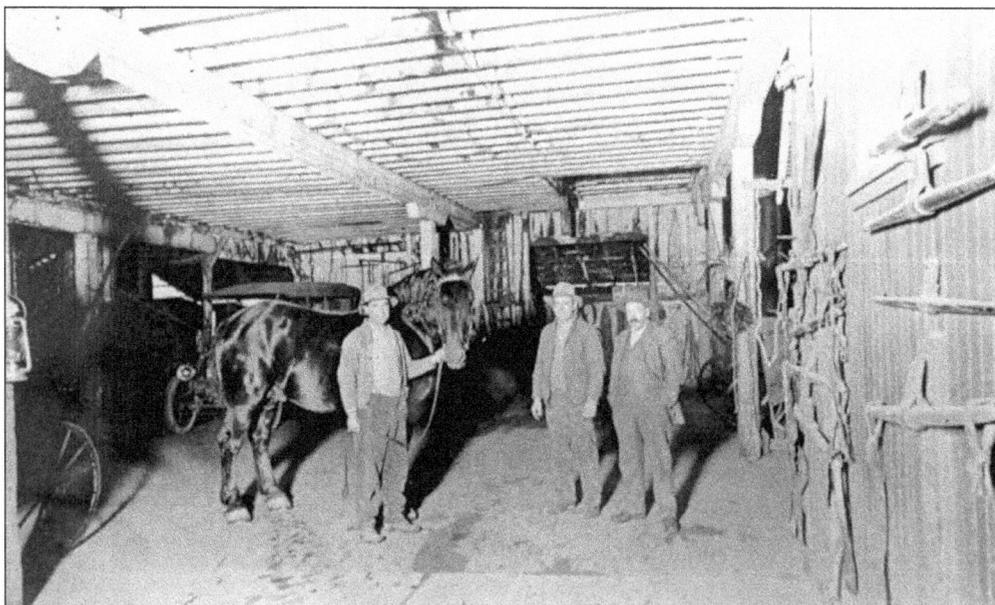

In the transitional days when equestrian travel was giving way to vehicles whose horse-powered engines did the transporting, local businesses provided for both. As is evident here, the Serpa & Pimentel Stable kept horses and cars in the same building and also operated the Gilroy Hot Springs stageline (see cover photograph). Tony Serpa, left, and two of his staff pose at the facility that stood off Monterey Street where Hornlein Court is today. (Courtesy Gilroy Museum.)

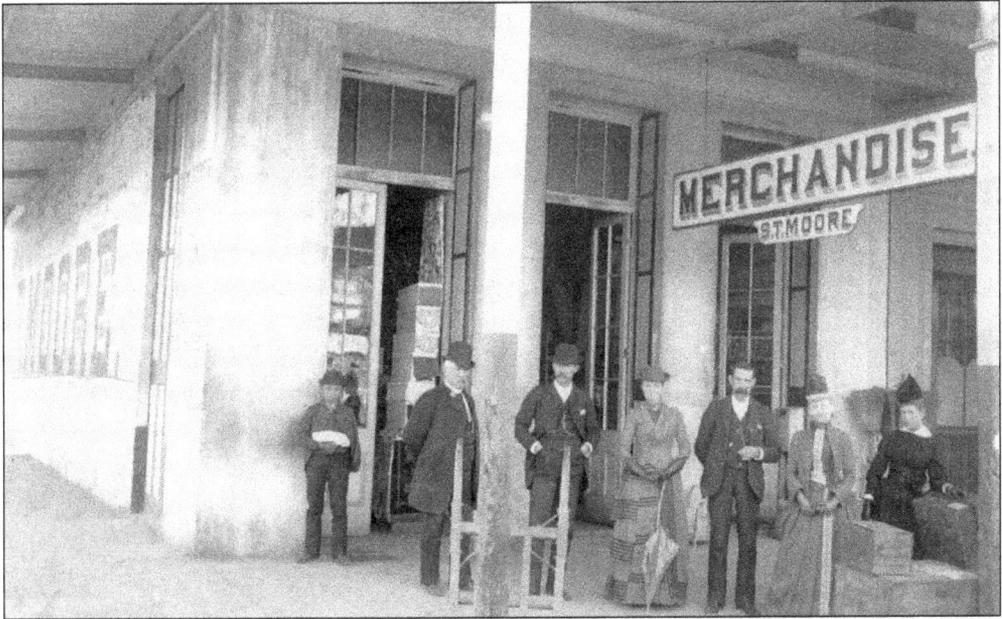

Samuel T. Moore came to Gilroy from Missouri in 1878. A man of many interests and talents, he first worked in the lumbering trade and then ran a 180-acre ranch. He ventured into the general merchandising business in the 1880s. His popular shop was located on the northwest corner of Monterey and Sixth Streets. (Courtesy Gilroy Museum.)

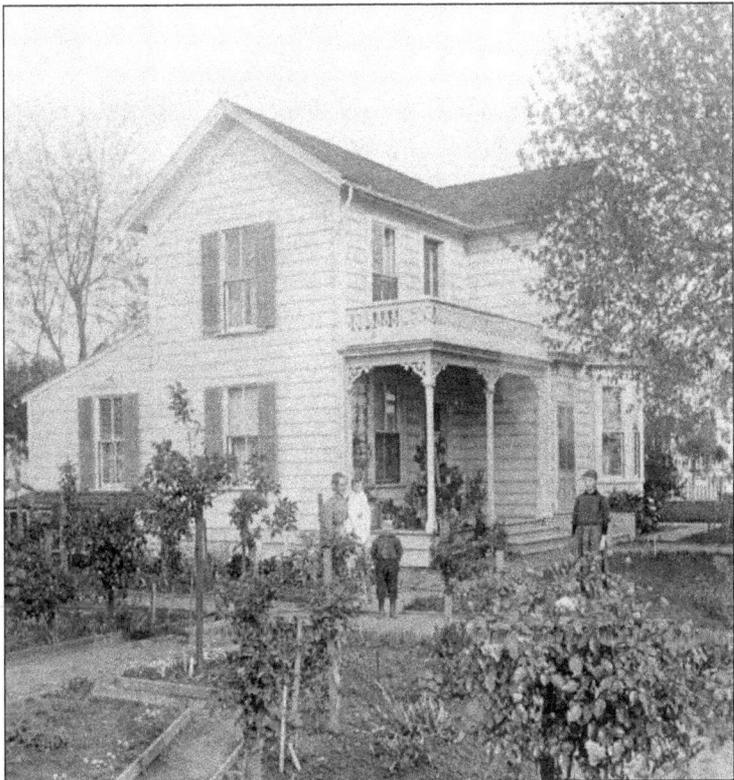

Samuel and Elizabeth Moore built this charming house on Church Street, complete with flower and vegetable gardens and numerous fruit trees. In this photo Mrs. Moore and the children appear to be enjoying the sunshine in their yard. (Courtesy Gilroy Museum.)

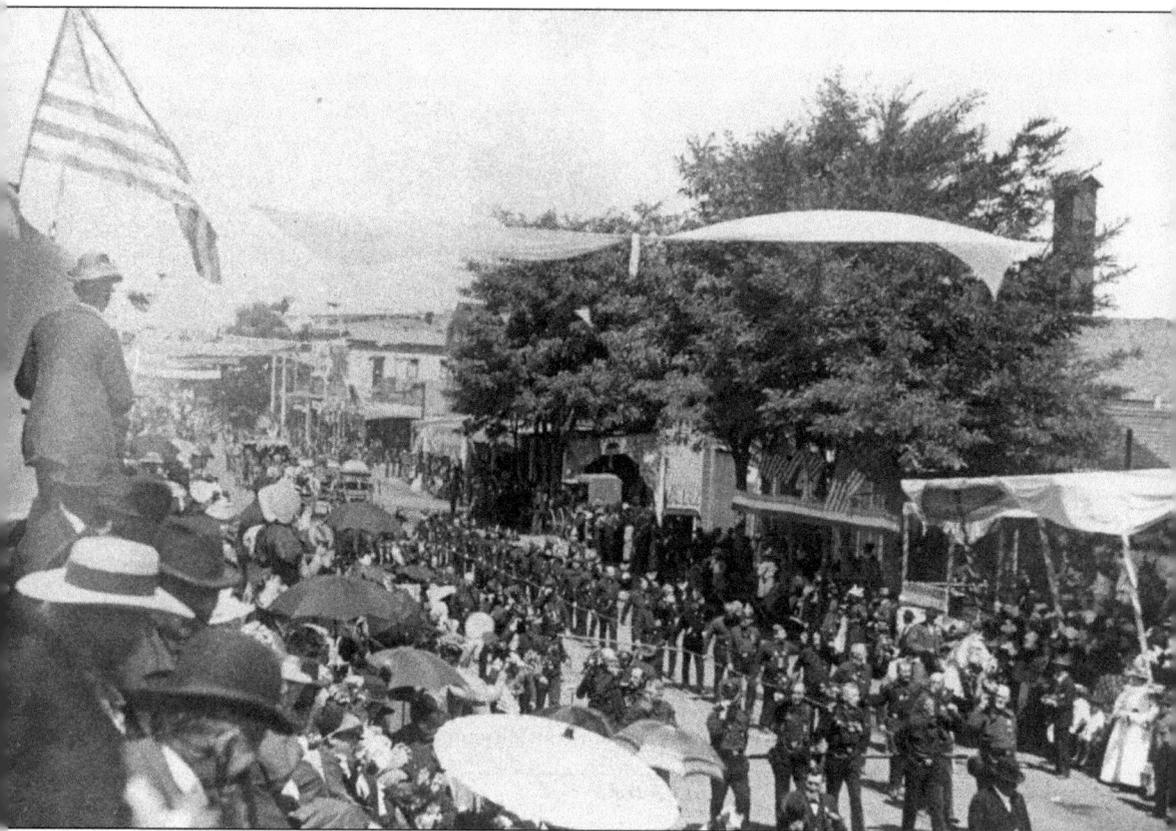

Most of the town, it seems, lined Monterey Street for this late 19th century Fourth of July parade. Notice the many firefighters proudly participating, several of them doffing their hats to the enthusiastic crowd. (Courtesy Gilroy Museum.)

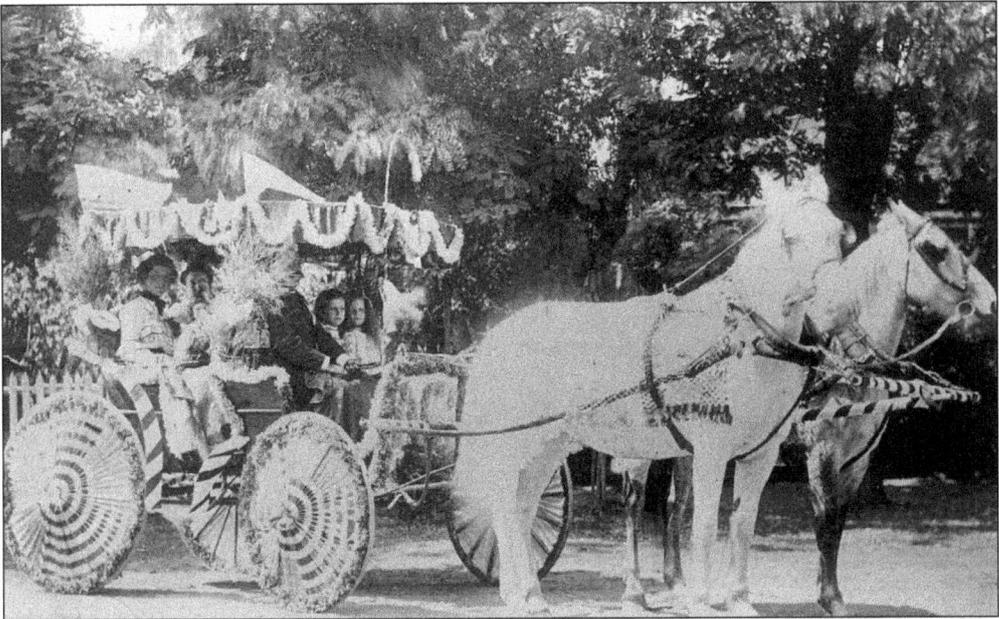

With the same festive flair that many present-day Gilroyans exhibit for holiday decorating, the Albert Carrey family members have prepared their carriage and steeds for the Independence Day festivities in 1906. Carrey was one of many successful cheese makers in the valley. (Courtesy Gilroy Museum.)

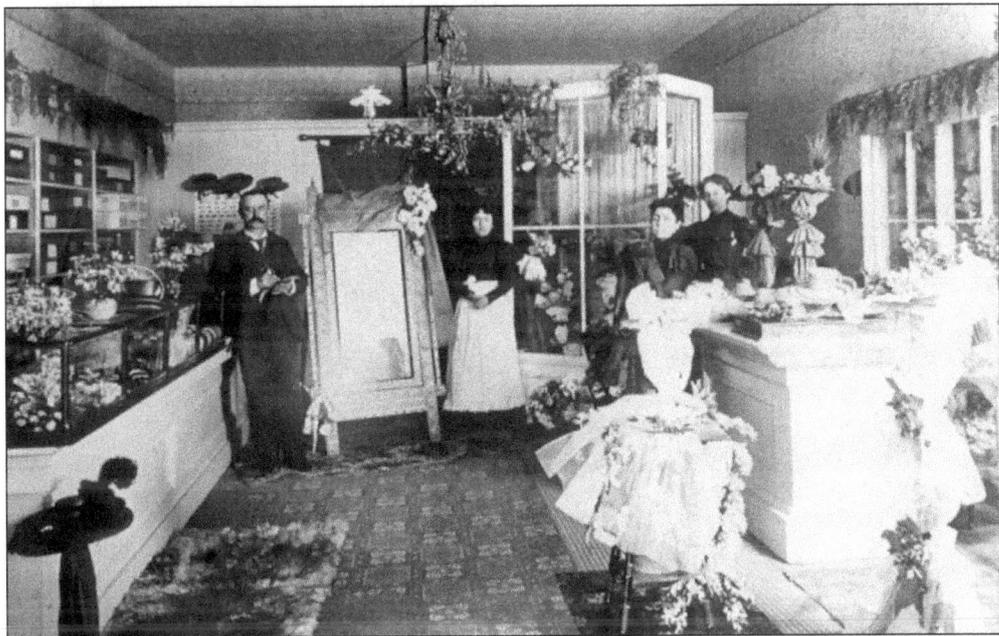

By the late 1800s, though primarily an agricultural community, many of Gilroy's ladies were nonetheless interested in keeping up with the latest fashions. The Ricketts' Millinery on Monterey Street was just the place for adding a touch of class to one's ensemble. Pictured here c. 1897, from left to right, are an unidentified gent, Bertha Ricketts, Mrs. Josephine Ricketts, and Edith Tharp. (Courtesy Gilroy Museum.)

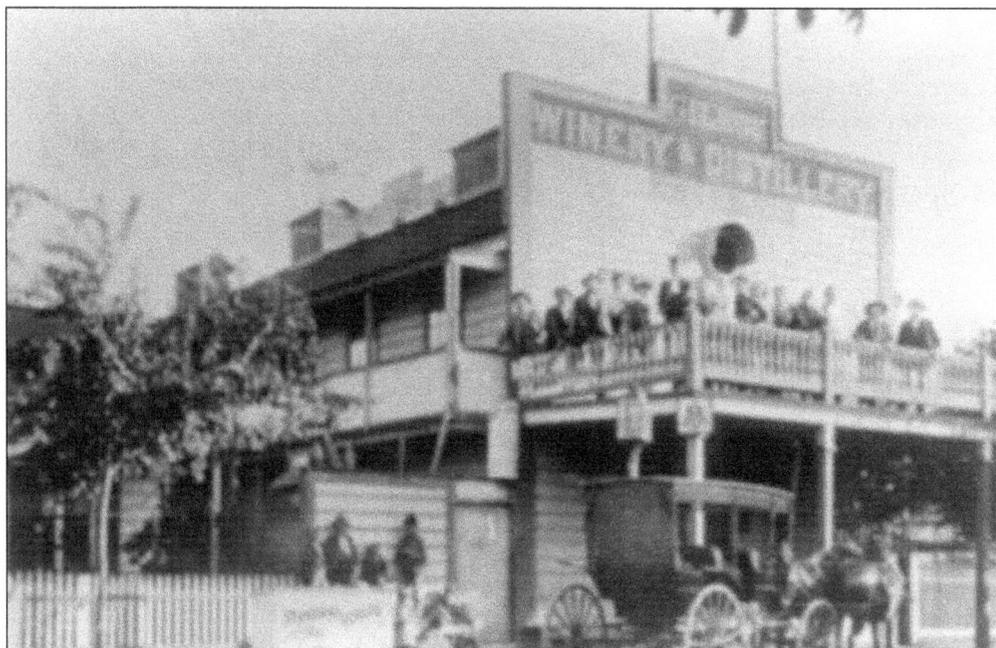

John Rea was among the enterprising Swiss immigrants who settled here in the 1870s. The Swiss Hotel on Seventh Street, just west of Monterey Street, was a popular one for many years as evidenced by the many who are gathered here in this turn-of-the-century photo. Rea also operated a winery and brandy distillery adjacent to the hotel. (Courtesy Gilroy Museum.)

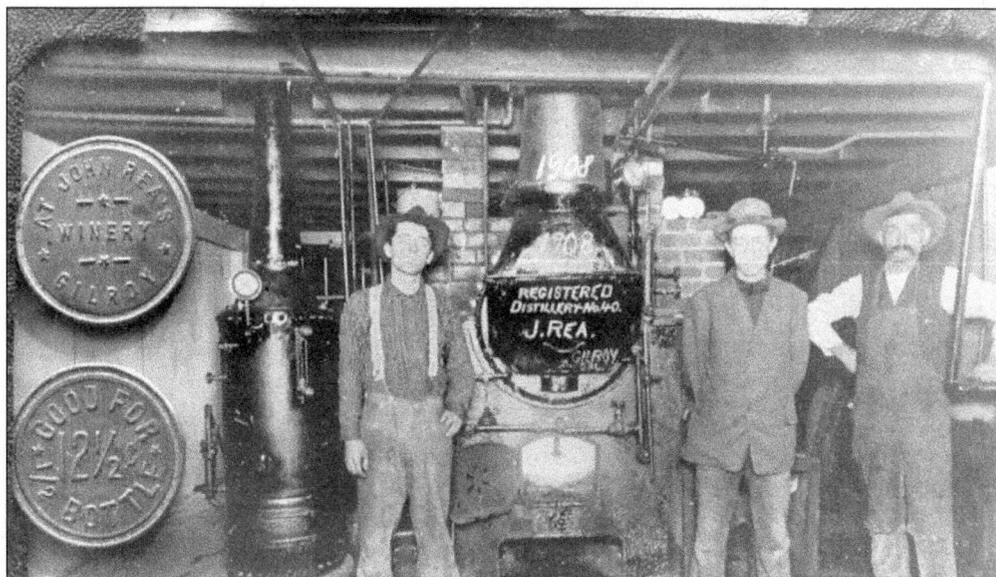

While most of Gilroy's early vintners were Italian immigrants with operations outside the city limits, John Rea produced a variety of wines and brandies right in town. Notice, especially, the sales promotional tokens pictured on the left, good for a half-bottle of wine worth 12.5¢. There were, by the way, many who objected to this enterprise. Former teacher Sarah Severance, for one, edited a Women's Christian Temperance Union column for the *Gilroy Advocate* for most of the 1880s, and this establishment was "on her list!" (Courtesy Gilroy Museum.)

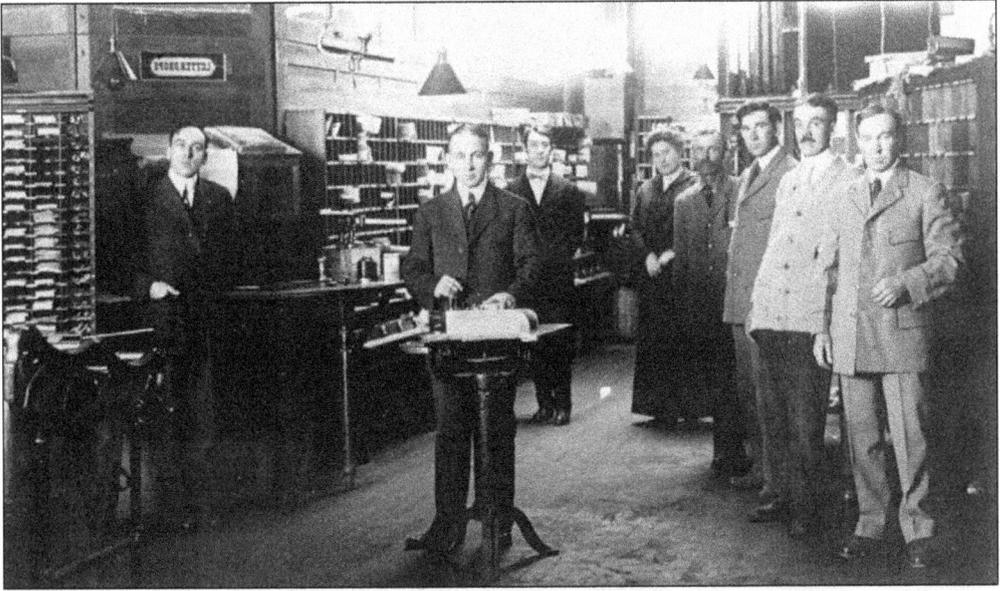

James Houck, who came to Pleasant Valley in 1850, is said to have established the first "post office"—a cigar box mounted on the front porch of his roadside inn. This photo, c. 1913, indicates that much progress was made in the intervening years. Pictured in the back room, from left to right, are Fred Sater, Willis Eustice, Robert Schell, Postmistress Catherine Ryan, Albert Berger, William Holmes, Hiram Schell, and Harry Holmes. (Courtesy Gilroy Museum.)

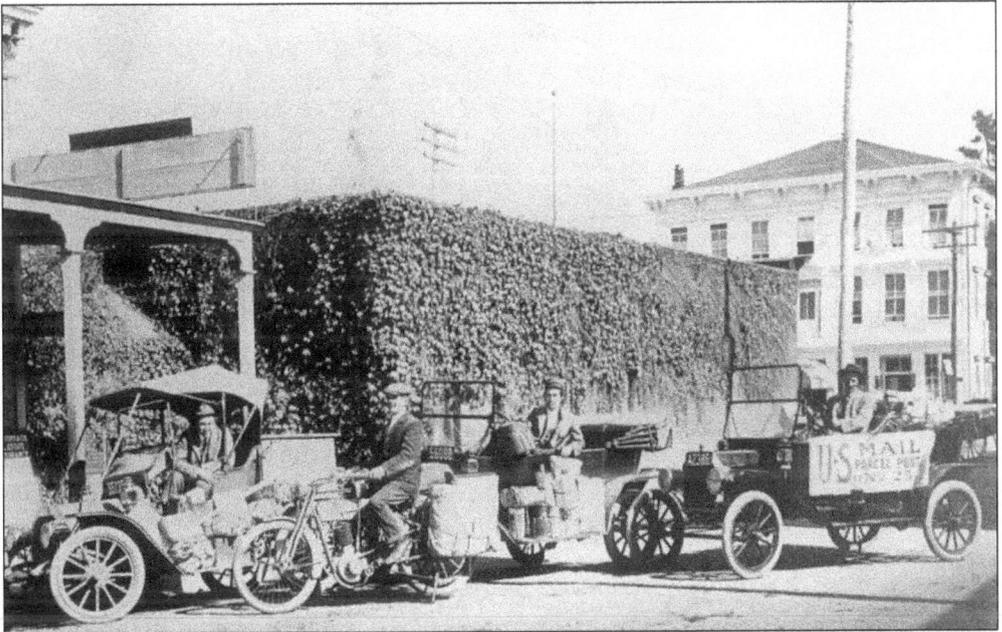

Gilroy had an impressive system in place for mail delivery to rural residents early in the 1900s. As can be seen, there were no standardized red, white, and blue postal vehicles back then. The carriers pictured from left to right, are Harry Holmes, Hiram Schell, William Holmes, and Albert Berger. The carriers supplied their own wheels. The Central Hotel is also visible in the background. (Courtesy Gilroy Museum.)

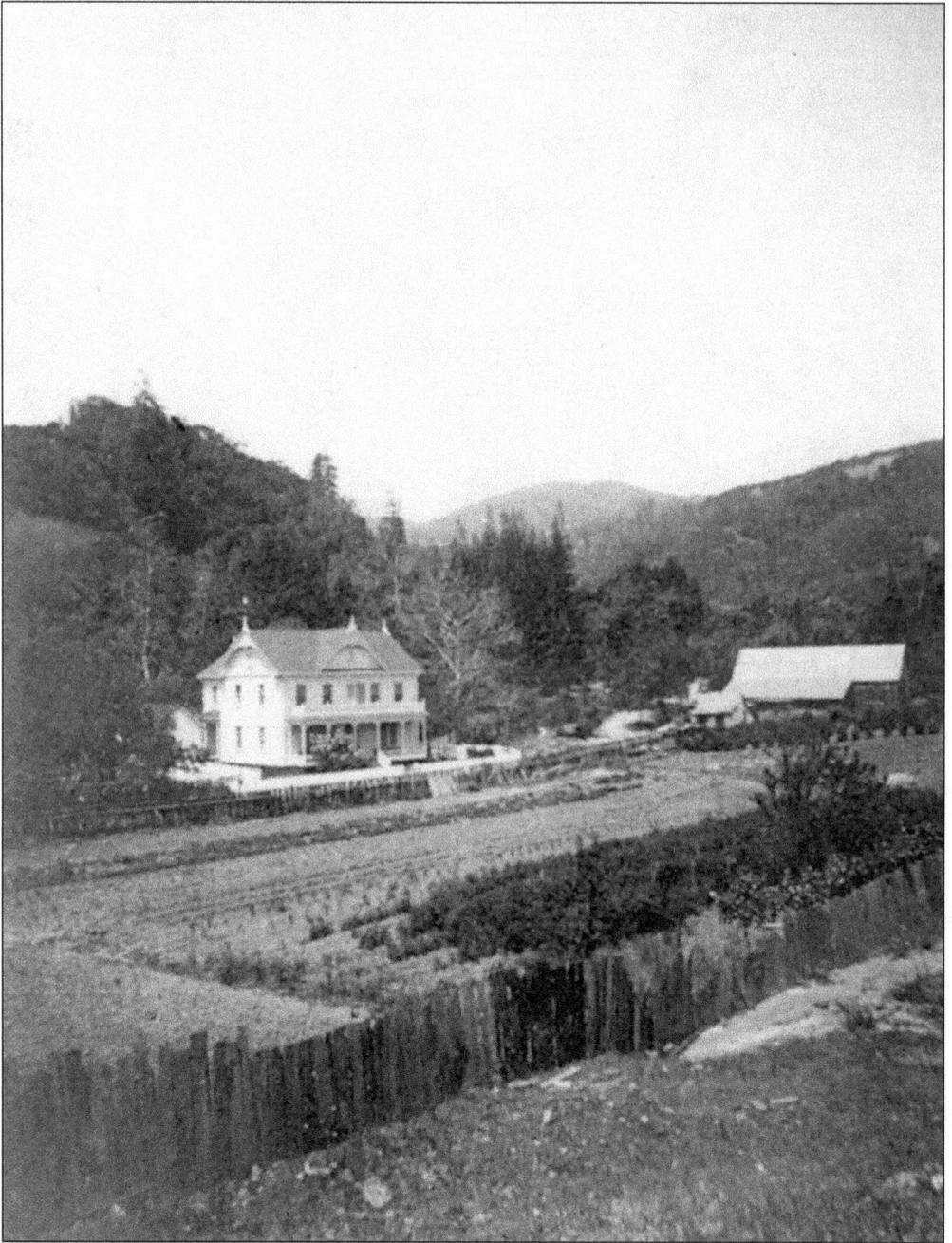

Charles Sanders caught gold fever in his native Nova Scotia but found a few nuggets after a decade of trying. He brought his wife, Annis, and their two sons to Gilroy in 1863, having obtained a homesteading tract in the hills to the west. Mrs. Sanders died just a few months later giving birth to their third child, a daughter. In 1891 Sanders and his sons, Wilburn and Irville, completed the Redwood Retreat Resort and opened for business. The building could accommodate 44 guests and the grounds included a swimming pool and tennis courts. Fishing was good in nearby Little Arthur Creek and there were miles of scenic hiking trails to enjoy. Dances were held on weekends in the converted prune shed to the right. (Courtesy Gilroy Museum.)

For guests who enjoyed being closer to nature, the Redwood Retreat Resort offered both cabins and tents on platforms that were tucked among the trees. Many San Francisco businessmen sent their wives and children to Redwood Retreat for the duration of the summer, joining them on weekends. (Courtesy Irville Gollnick and Gilroy Museum.)

By the early 1880s both Wilburn and Irville Sanders had built homes for their respective families on the property. While Wilburn and his household farmed the nearly 200 acres, Irville and Alice, pictured here, ran the resort. They suffered a huge blow when the hotel burned to the ground in July of 1908. Fortunately, there were no injuries. The Sanders rebuilt immediately, but just a small clubhouse and dining room structure. The cabins and tents were the only overnight accommodations from that point on. (Courtesy Gilroy Museum.)

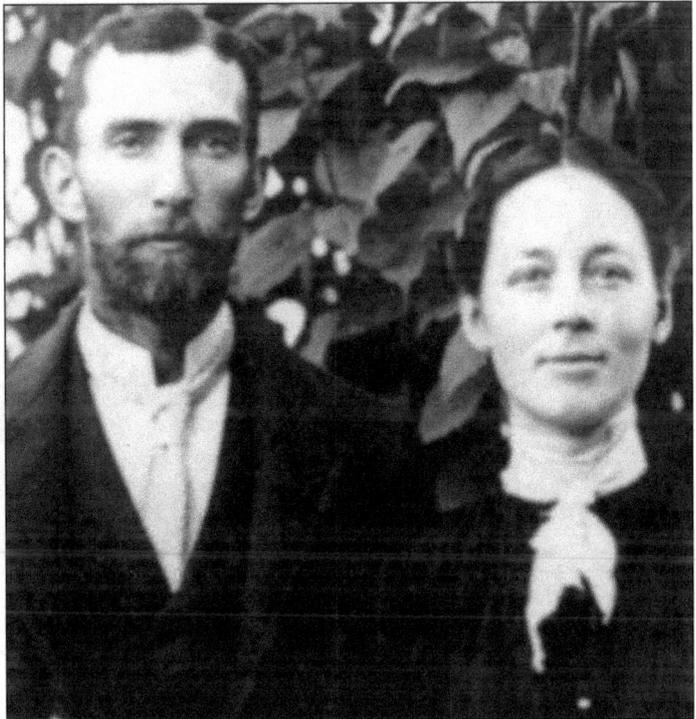

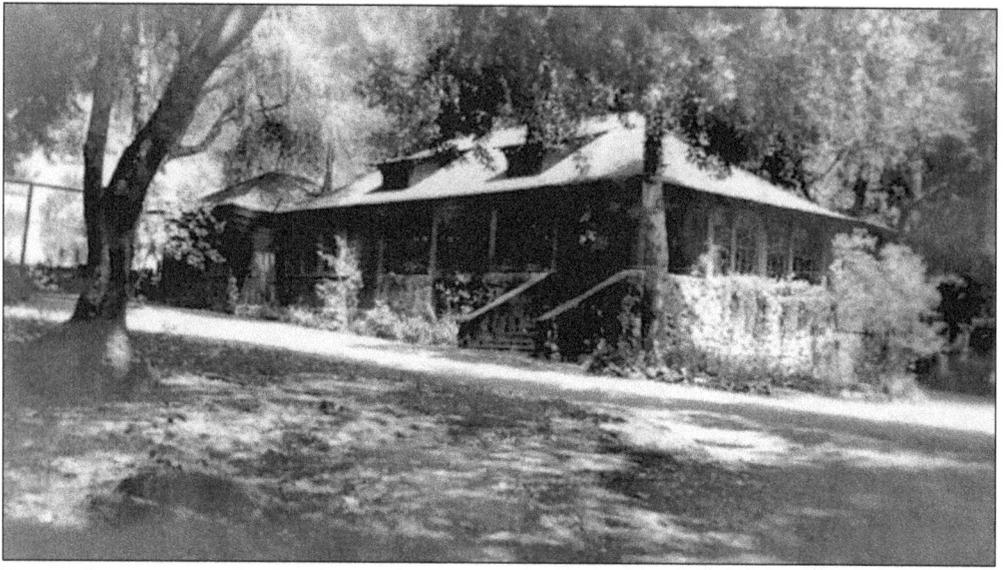

Fannie Stevenson, wife of author Robert Louis Stevenson, bought 40 acres from the Sanders family before 1900. Her parcel was in an area called Murphy's Canyon, and she named this rustic house she had built in 1902 *Vanumanutagi*, Samoan for "vale of the singing birds." Wilburn Sanders was overseer and foreman of her place for many years. Robert Louis Stevenson, whose health declined in his early forties, never did see this gracious residence Fannie had planned for his retirement. (Courtesy Gilroy Museum.)

The present-day home in the vale of the singing birds is a two-story New England colonial fashioned after the original structure and resting on the original stone foundation. Fannie Stevenson's son, Lloyd Osborne, and his wife, the former Ethel Head of Gilroy who was Mrs. Stevenson's nurse, took possession of the home after Mrs. Stevenson's death in 1914. The remodeling was done many years later. (Courtesy Kai Lai.)

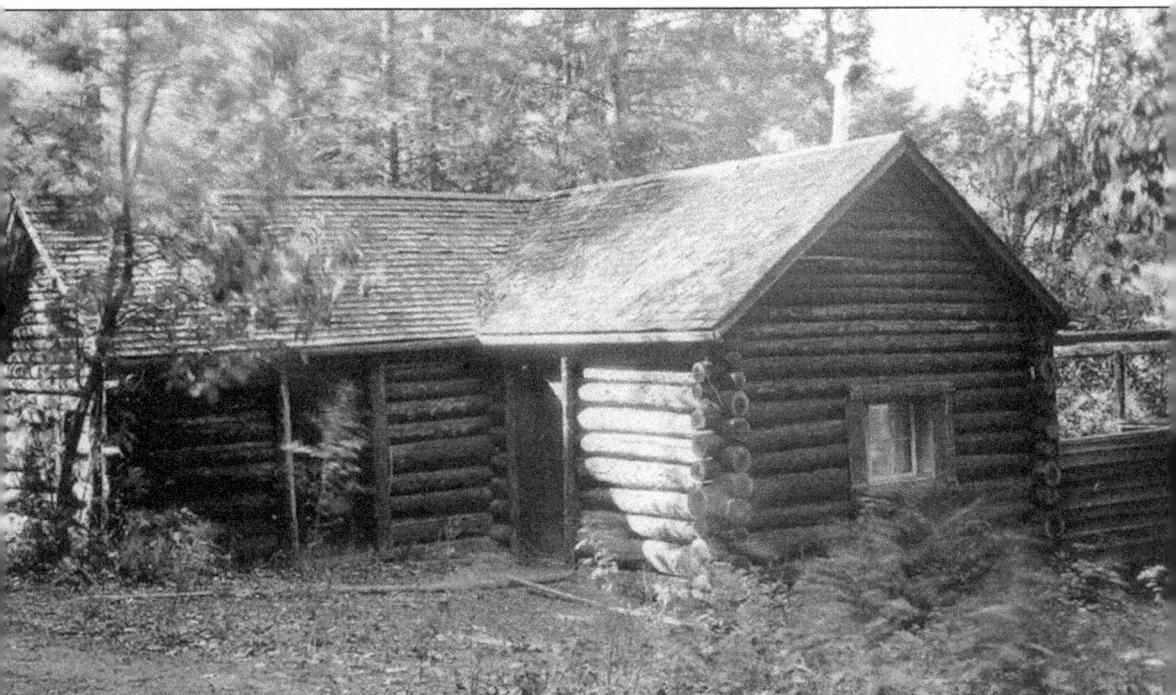

Author Frank Norris was encouraged to partake of Gilroy's western woodlands by his good friend Fannie Stevenson who gave him a part of her acreage. This redwood log cabin he had built was not far from her home. His plans to utilize this tranquil setting for writing the many novels whose plots filled his mind were dashed by his sudden death in San Francisco at age 32. Mrs. Stevenson was not only heartbroken personally but mourned the loss of such a promising literary talent. At her direction, Wilburn Sanders built a curved stone bench near the cabin site as a memorial to her friend. The inscription on it reads: "Frank Norris–1870–1902—Simpleness and Gentleness and Humor and Clean Mirth." (Courtesy Gilroy Museum.)

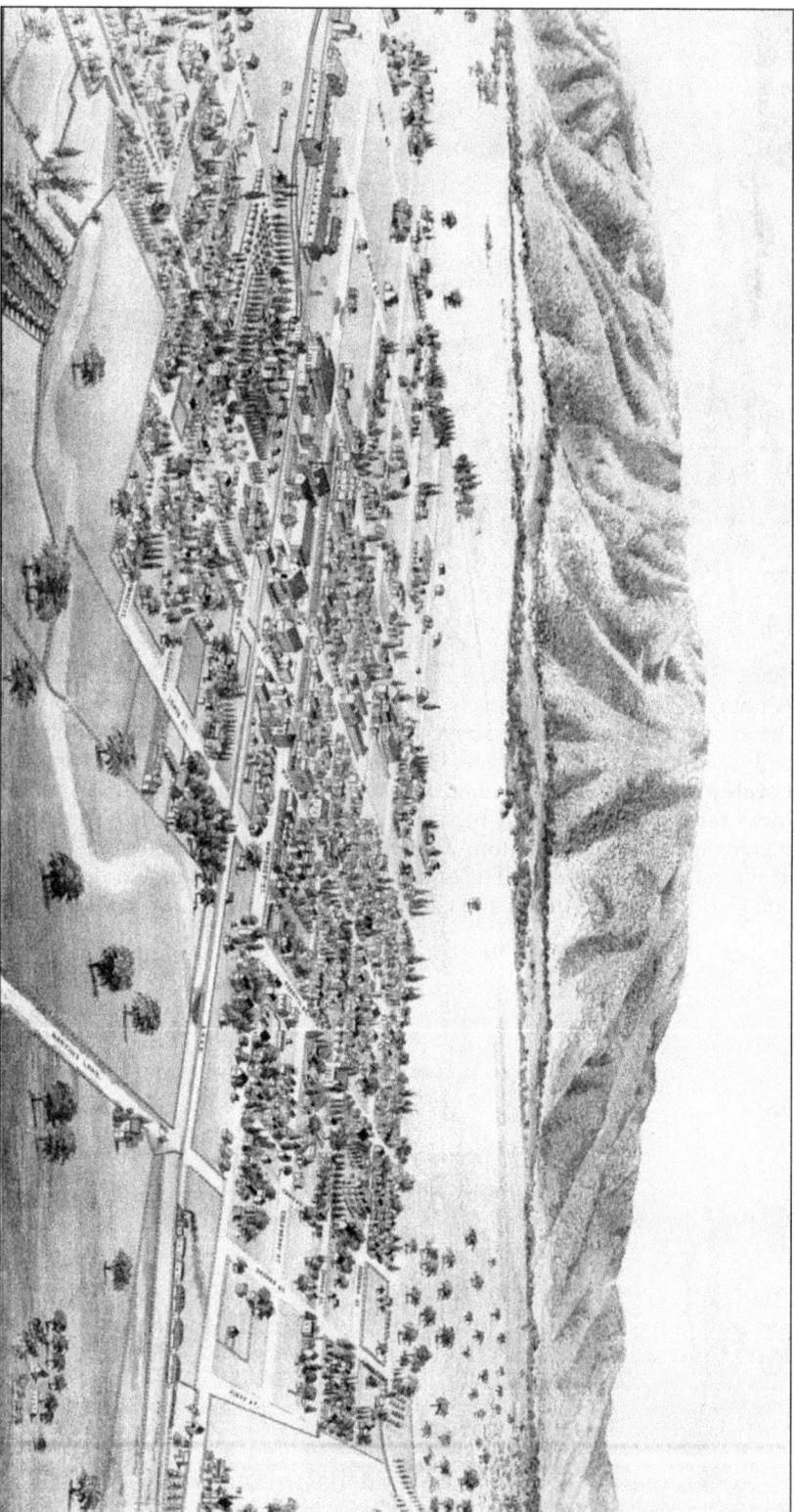

This 1885 map, indicating many of the principal buildings in the city at that time, was a promotional undertaking by Frederick W. Blake, editor and publisher of the *Gilroy Advocate*. Blake bought the newspaper in 1877 and was at its helm until his death in 1907 when his son Will took over. F.W. Blake was instrumental in the founding of the Santa Clara County Press Association and served as its president for many years. (Courtesy Gilroy Museum.)

Five

THE FORCES THAT SHAPED US

When F.W. Blake purchased the *Advocate*, he took it to a new level by covering state, national, and world news. Several smaller papers—the *Gilroy Union*, *Gilroy Independent*, and *Gilroy Telegram* offered alternative reading, but few of them endured. Only the *Gilroy Gazette* held on as a real competitor. In 1929 the *Gazette* merged with the *Gilroy Dispatch*, which had begun publication in 1925. *The Dispatch* was an energetic enterprise under John Hull and Thomas Losey and published six days a week while the other two remained weeklies. The *Advocate* succumbed to hard times in the Depression years, but *The Dispatch*, which persevered, continues to garner awards and serve the community well. (Courtesy *The Dispatch*.)

Caroline Hoxett came from Massachusetts with her husband Thomas in 1868. Mr. Hoxett started one of the first bakeries in town. Mrs. Hoxett became a member of the Unity Rebekah Lodge and served as president of the California Rebekah Assembly in the 1890s. (Courtesy Gilroy Museum.)

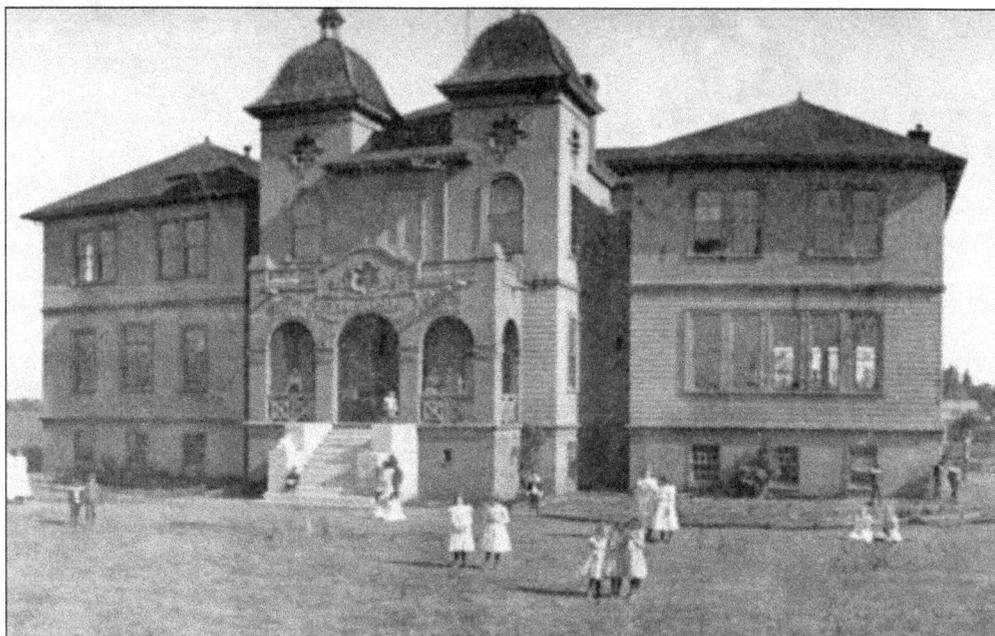

When a location was being sought for the Odd Fellow-Rebekah Children's Home of California, Caroline Hoxett made an impassioned speech to each of these groups in support of Gilroy and "its fresh air, sunshine, and good schools." Her persuasion won out, and Hoxett gave the land and money for the construction of this original orphan's home, completed in 1897. (Courtesy Gilroy Museum.)

In 1919, the Children's Home had outgrown its facility and there was talk of moving it to San Jose. Once again, Caroline Hoxett successfully made her case for maintaining this social ministry in Gilroy. The home pictured here was built at the corner of I.O.O.F. Avenue and Forest Street in 1921. Ever the generous benefactress, Mrs. Hoxett provided funds for the campanile and its set of chimes for this facility. To this day the Gilroy Children's Home is one of a kind and is still supported in part by the Odd Fellows and Rebekah Lodges throughout the state. (Courtesy Kai Lai.)

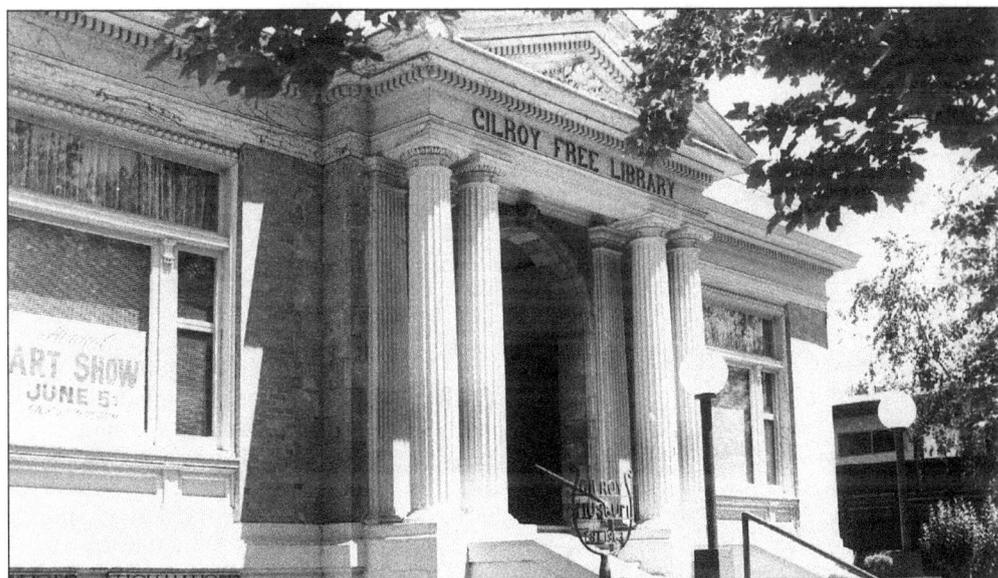

Caroline Hoxett believed a public library was essential for the positive growth of the community. Several rental libraries were operating, but she advocated free access to books, especially for children. A Library Board was created in 1906, and she attended all the meetings. Mrs. Hoxett also purchased a lot at the corner of Fifth and Church Streets and gifted it to the city. That donation and a $10,000 grant from the Andrew Carnegie Foundation made the Gilroy Free Public Library a reality in 1910. When a larger library facility was built in 1975, this building became the Gilroy Museum. (Courtesy Kai Lai.)

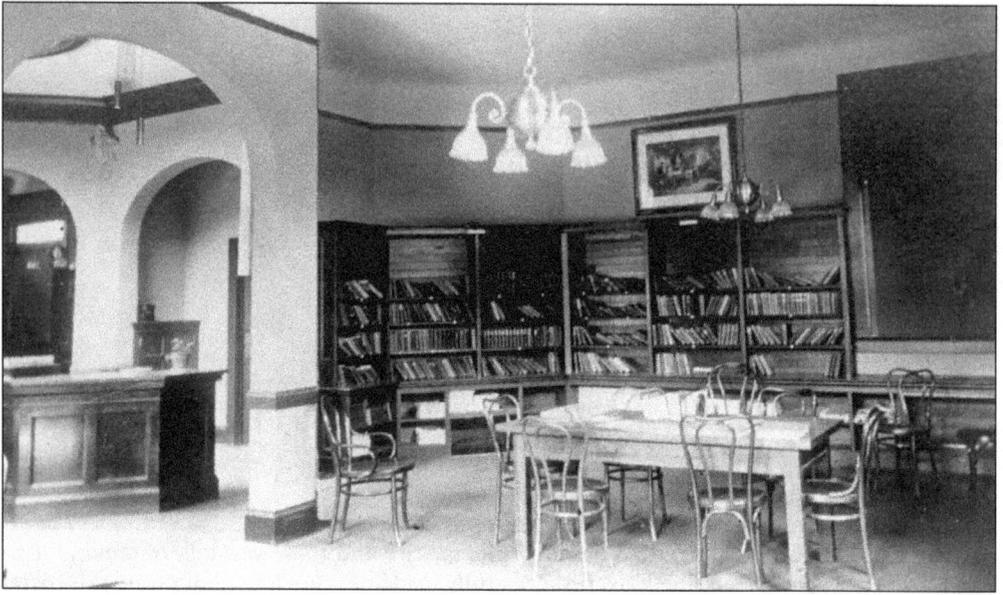

Long-time Gilroyans may recall the days when they climbed the double set of concrete steps leading to the Carnegie Library's entrance and checked out their favorite books at the majestic wooden desk on the left. I encourage you to visit again and enjoy the numerous exhibits on many facets of Gilroy's rich heritage that the Museum offers. It should also be noted that Postmistress Catherine Ryan, who campaigned with Caroline Hoxett for the library, served on its board for over 40 years. (Courtesy Gilroy Museum.)

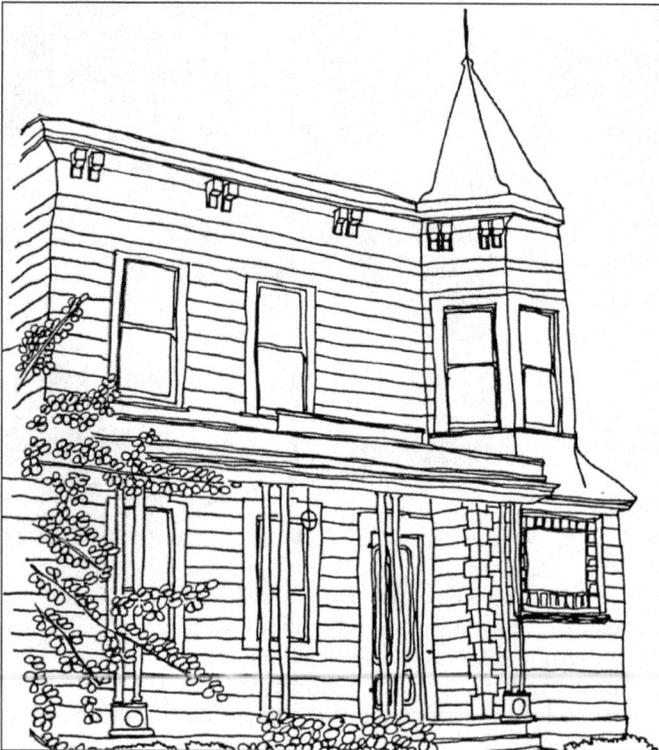

This Italianate-style Victorian was built for Thomas and Caroline Hoxett on Fifth Street in 1869. After Mrs. Hoxett's death in 1927, the home was for some time the site of the Women's Civic Club, a group with which Mrs. Hoxett was very active. Still a handsome dwelling, it has been a private residence again for many years. (Artwork by Robin McGinnis.)

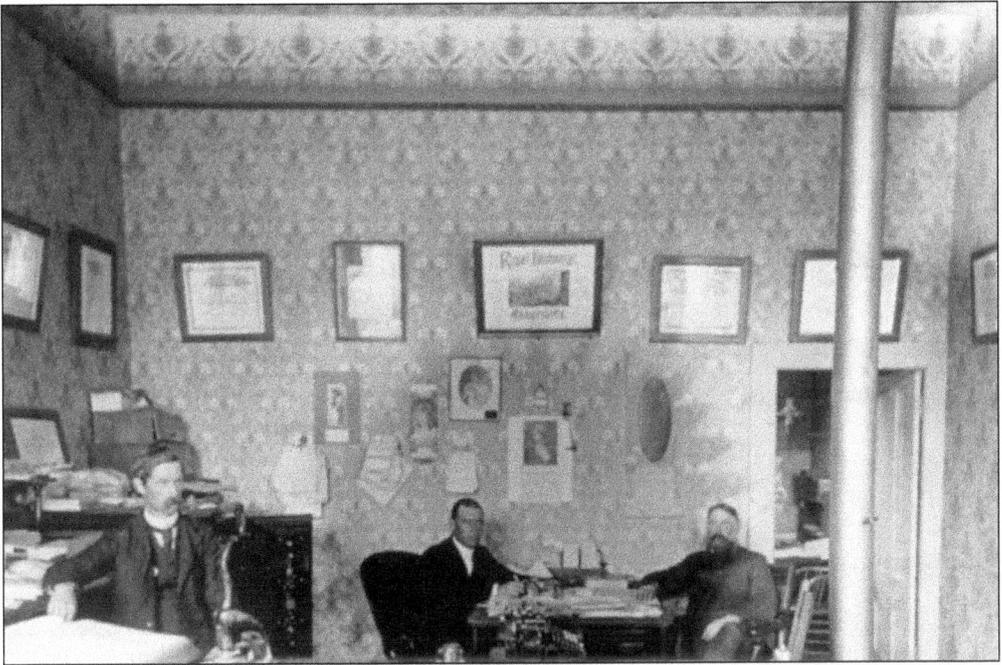

At the time of this photo, attorney Walter Fitzgerald, center, who was part of a dairy and livestock-raising pioneer family, worked with Gilroy native Eugene Rogers, left, in an insurance and real estate business. This office was in the old I.O.O.F. building at the northeast corner of Monterey and Martin Streets. Mr. Zuck is pictured on the right. (Courtesy Gilroy Museum.)

Dr. Clara Silvia, a 1903 graduate of the San Francisco College of Physicians and Surgeons, came to Gilroy that same year to do her residency at Dr. Clark's hospital. She opened her own ob/gyn practice in 1905 at Fourth and Eigleberry Streets. The women of the community thought her a guardian angel because she willingly rode out to farms and ranches to care for her patients and to deliver many Gilroy babies. (Courtesy Gilroy Museum.)

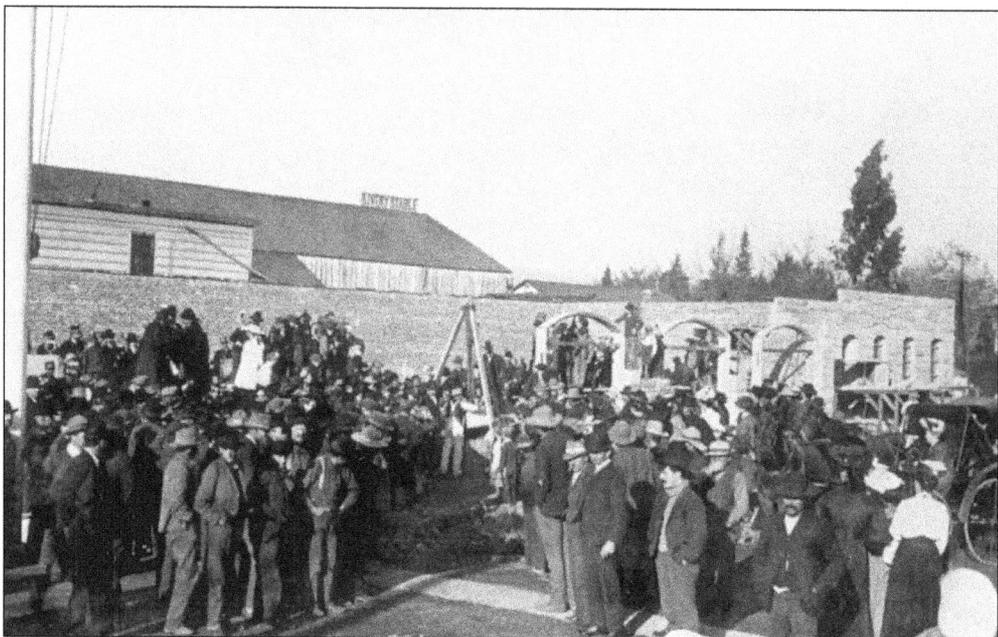

Under the direction of Mayor George T. Dunlap, a huge crowd assembled at Sixth and Monterey Streets on November 20, 1905, for the laying of the cornerstone of Gilroy's first city hall. A tin box was lowered into place on that day containing current newspapers, names of local and civic leaders, and coins of the period. (Courtesy Gilroy Museum.)

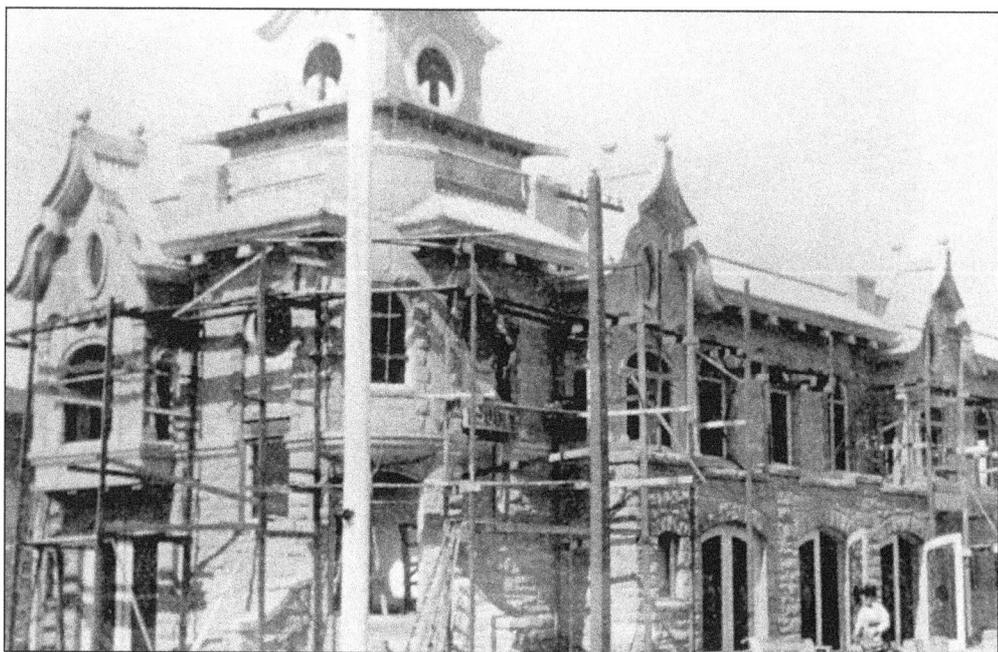

City Hall was still under construction when the infamous earthquake of April 18, 1906, struck northern California. The building suffered the loss of some of its stone veneer and the plaster cracked in places inside, but the $1,050 estimate for repairs was much less than initially feared. (Courtesy Gilroy Museum.)

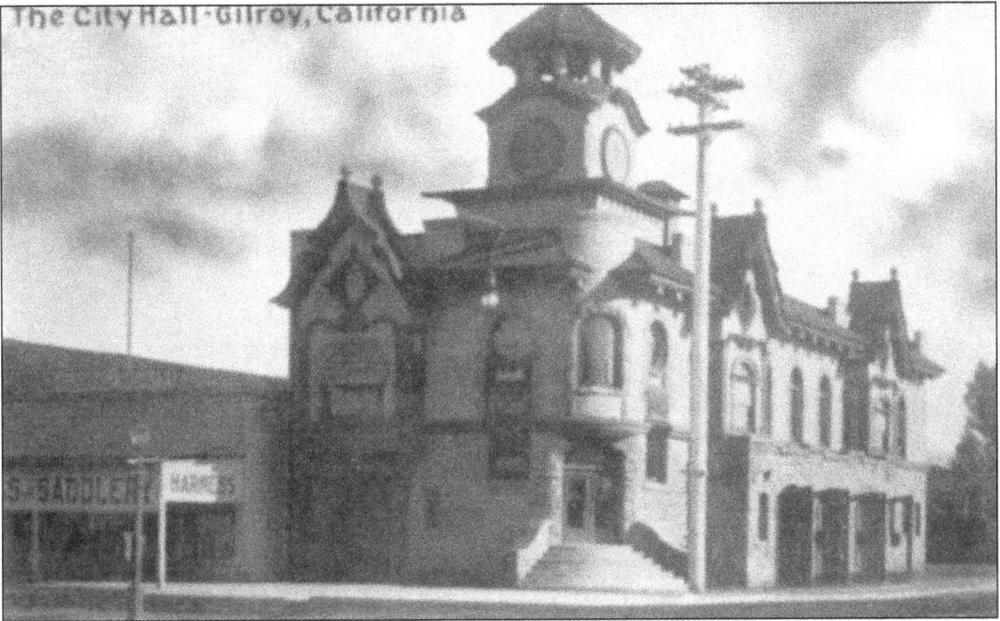

When complete, the first floor of the city hall was used by the fire department. Notice the large doors at bottom right, through which the equipment emerged. The second floor housed the beginnings of a city library, the courtroom and judges' chambers, and large and small meeting rooms and offices. The fire department relocated in 1916, but the city's other business and its services were conducted in this facility until the late 1960s. (Courtesy Gilroy Museum.)

Eugene Rogers, mentioned earlier, did much to improve the burgeoning city's infrastructure. He was a volunteer fireman for 23 years and in 1906 was elected City Clerk. Rogers was reelected to the position for 16 consecutive terms and died in office during his 37th year of service to the city. (Courtesy Gilroy Museum.)

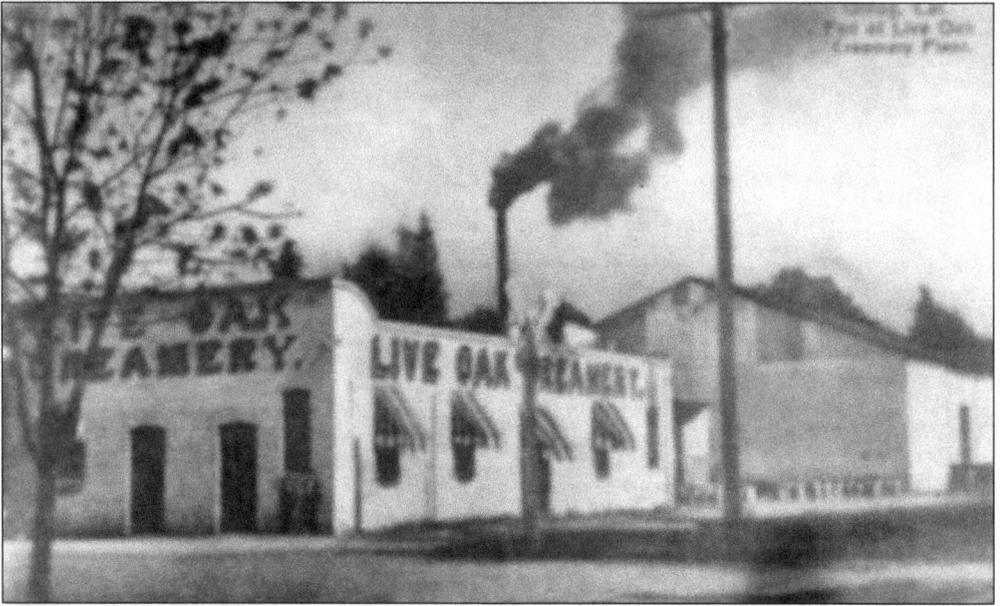

Dairy farms were plentiful here, and many farmers also produced fine cheese. By 1896 over one million pounds of cheese per year came from Gilroy. Tracy Learnard urged his colleagues to form a co-op to share the production costs. He created the Live Oak label and eventually built this creamery at Railroad and Martin Streets. The facility also turned out nearly 1,000 pounds of butter a day at its peak, a real boom for local dairymen. (Courtesy Gilroy Museum.)

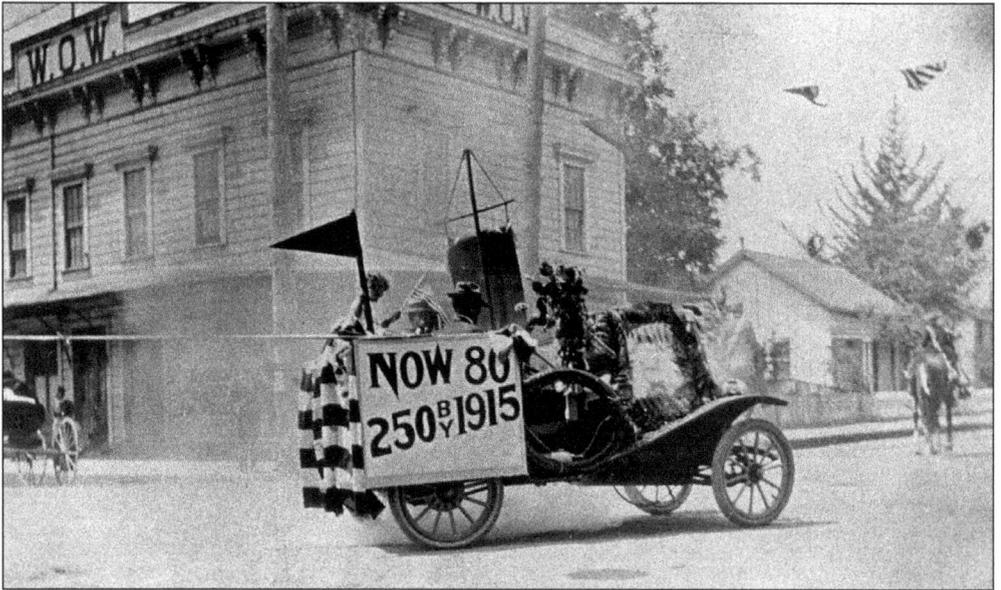

In April of 1905 a group of local business people gathered to organize a society for the promotion of the general interests in Gilroy and the surrounding area. They called themselves the Gilroy Promotion Society, and by 1912 the group became the Gilroy Chamber of Commerce. Their entry in a local parade that year refers to membership—their goal being 250 members by 1915. The Eigleberry house, the first single-family dwelling constructed in town, can be seen behind the Woodmen of the World building in this photo. (Courtesy Gilroy Museum.)

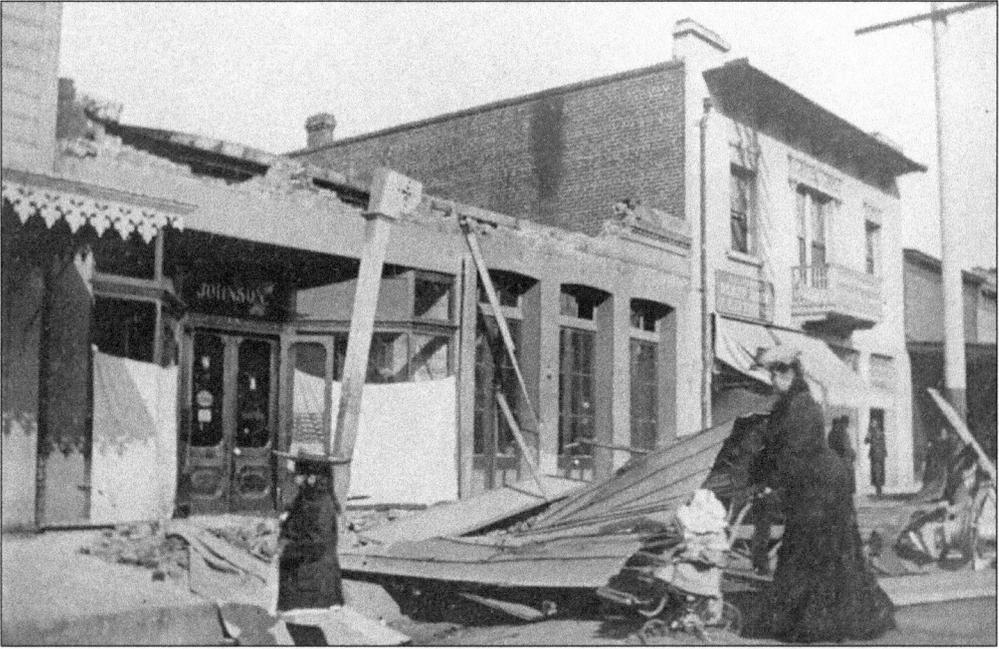

It's a chilling fact of life that despite any citizenry's best efforts to plan, disasters still strike. Gilroy certainly felt the 1906 earthquake. As reported on April 21 in the *Advocate*, "although nearly every chimney in town is down . . . damage was light and no lives were lost." Here a mother and her children make their way through the rubble on Monterey Street. Note that despite the upheaval, the chimneys on the two-story building to the right *did* survive. (Courtesy Gilroy Museum.)

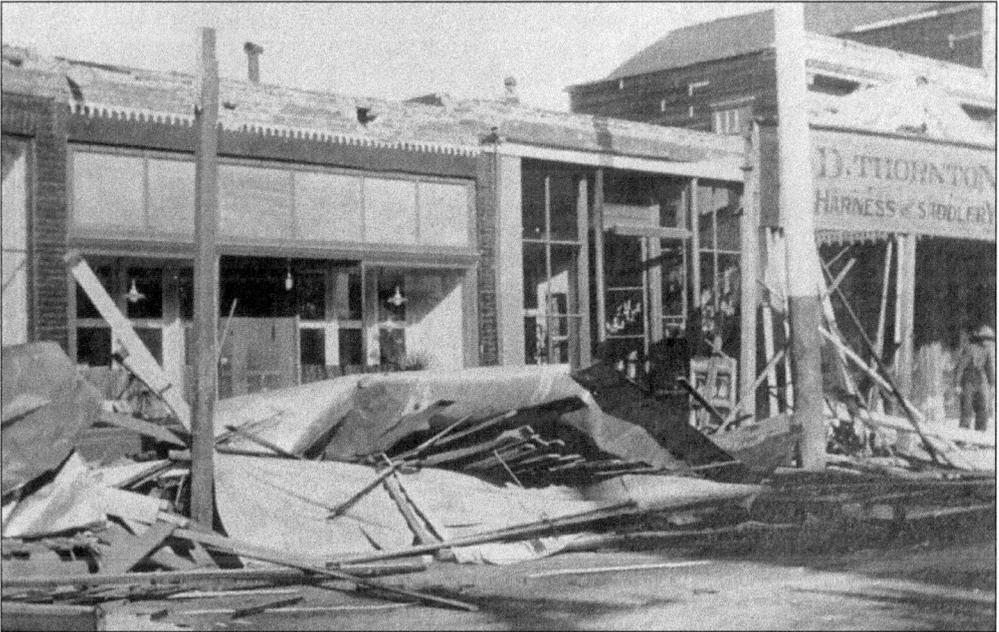

Earthquake damage in the block between Sixth and Seventh Streets was much the same. Collapsed awning and roofing materials clutter the sidewalk and street. The quake struck at 5:12 on a Sunday morning—a time which undoubtedly spared the city untold casualties. (Courtesy Gilroy Museum.)

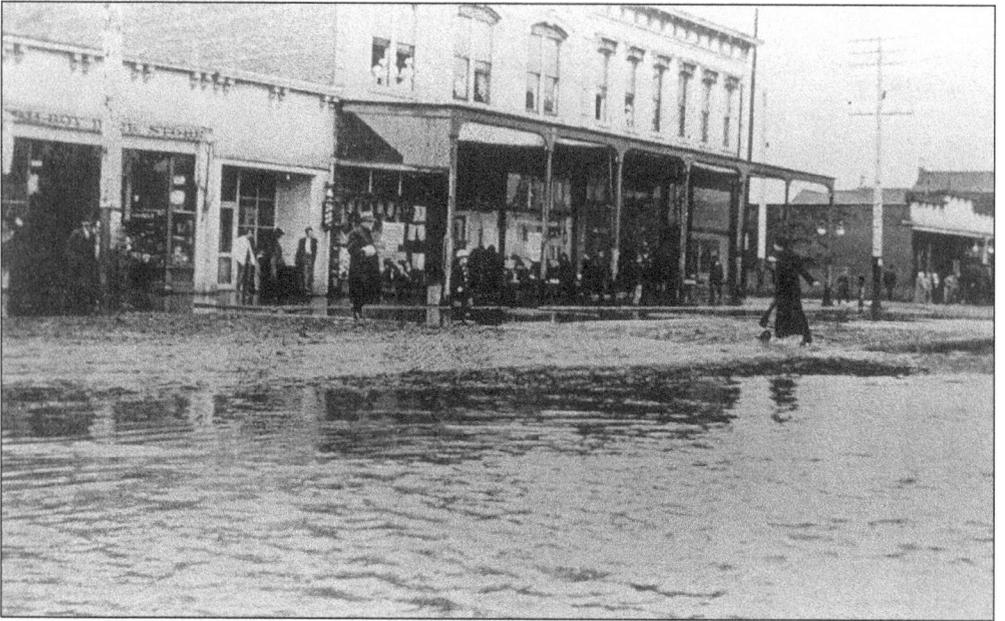

The skies opened in the winter of 1904-1905, and, between heavy downpours and the lack of a flood control system on the numerous creeks in the south county, Gilroy became the Venice of the West. Note the nurses in Dr. Clark's second floor hospital and training center observing the phenomenon. (Courtesy Gilroy Museum.)

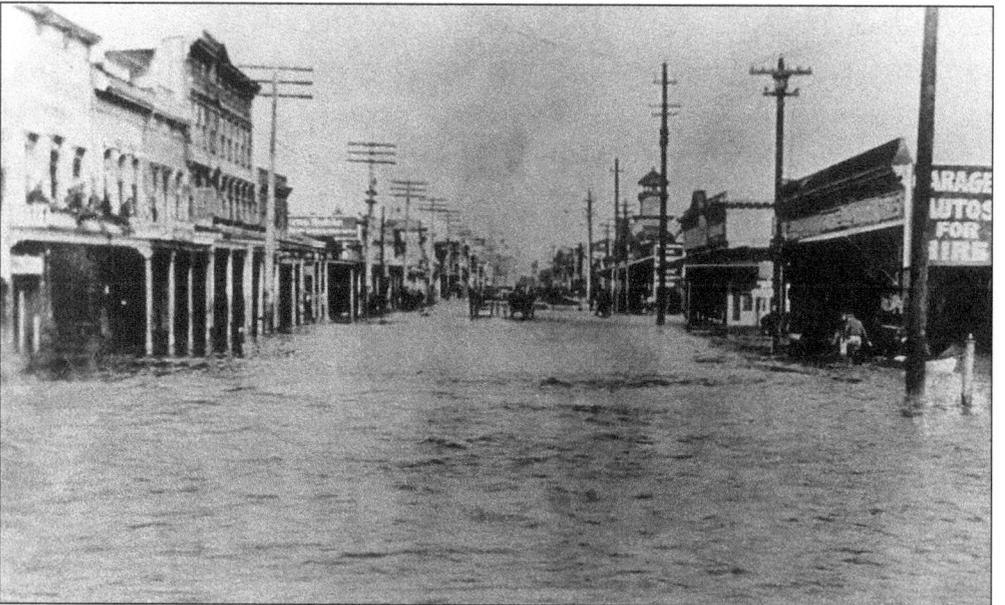

The flooding was worse several years later as seen in this photo taken from the intersection of Eighth and Monterey Streets, looking north. To the far right, the proprietor or an employee of the garage is loading inventory into a rowboat. Some years later, Dr. Elmer Chesbro, in addition to his private practice, gave another gift to Gilroy. He initiated the South Santa Clara County Water Conservation District and served on the Flood Control Commission as well. The Chesbro Dam and Reservoir are named in his honor. (Courtesy Gilroy Museum.)

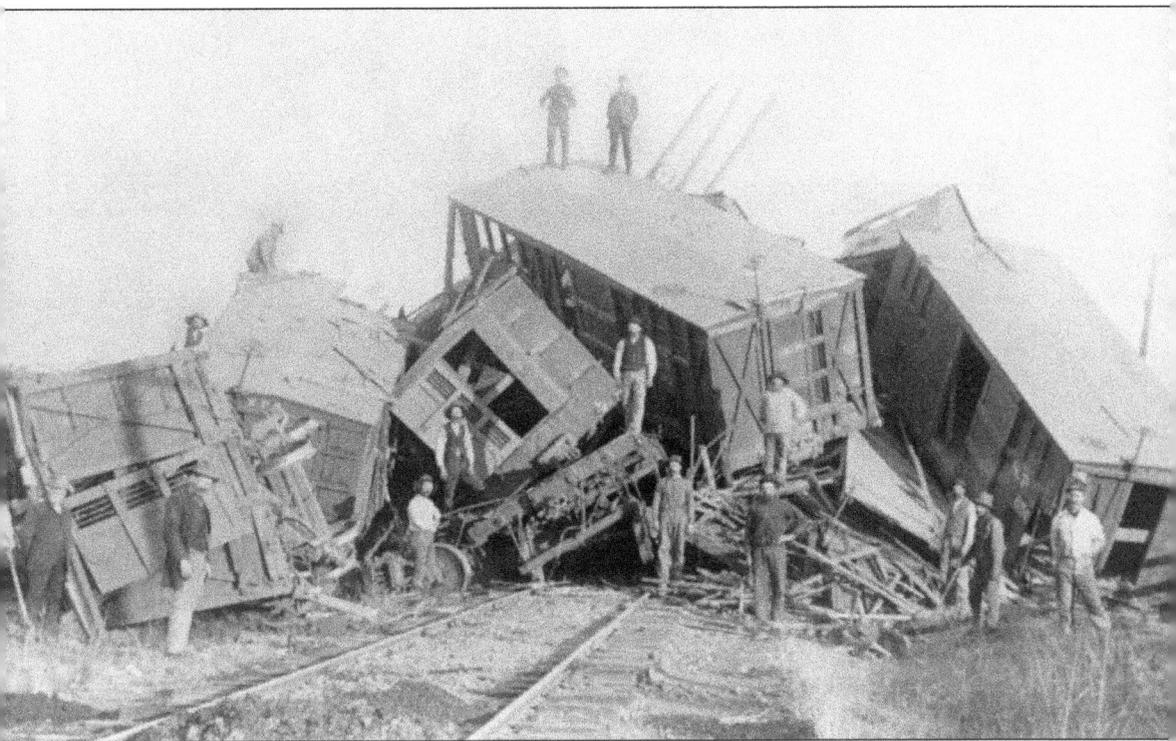

There were several colossal train wrecks in the Gilroy area in the early years of the railroad, like this one near Sargent Station, south of town. Causes ranged from faults with the axles or wheels on the individual cars, and deficiencies of the tracks to human error. Although the wreck of this 1895 freight train was no doubt a horrific job to clean up, there were no fatalities. (Courtesy Gilroy Museum.)

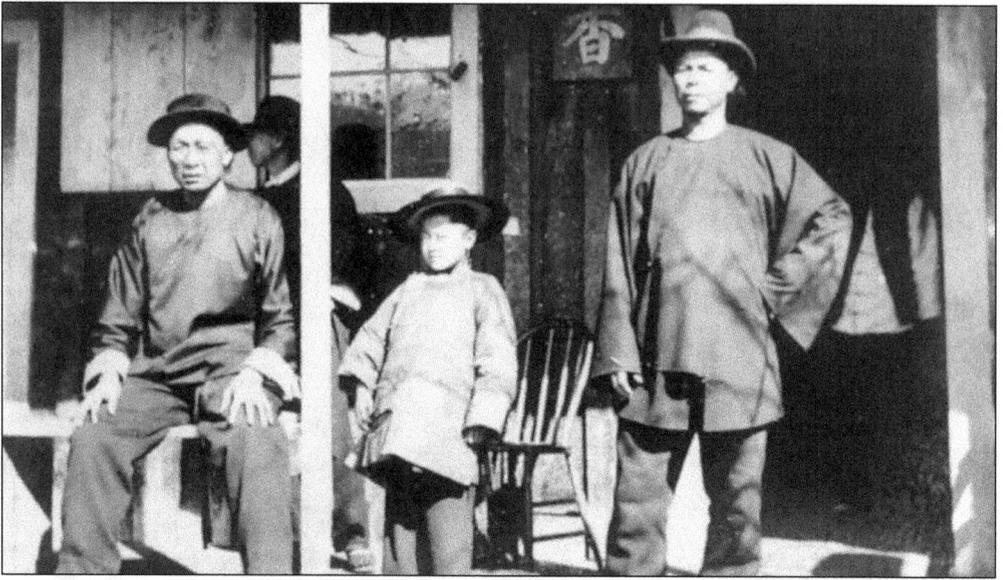

Lured by the rumors of *Gam Sann*, the Gold Mountain, many Chinese men came to America in the mid 1800s, but discriminatory legislation soon forced them from the gold fields. Many took work on the Transcontinental Railroad to survive. Some tried to save enough for their passage home where wives and families awaited them. Others opted to settle here. By the late 1800s, nearly a thousand Chinese lived in the Gilroy area. Chinatown stretched along Monterey Street, primarily between Seventh and Ninth Streets and contained numerous shops, restaurants, a laundry, several gambling halls, and at least one brothel. Many Chinese residents, like those in this 1897 photo, held to the customs of their homeland and wore tunic tops and loose-fitting pants that were the standard working-class dress of that time in China. (Courtesy Gilroy Museum.)

There were occasional outbreaks of violence in Chinatown, especially in the 1920s. Groups called Tongs formed, supposedly to provide mutual protection from the anti-Asian sentiment in California in those days. The Tongs assisted the poor and infirm as well. However, certain groups were more like gangs and used mob tactics to increase their power—often extorting "protection money" from shopkeepers. When Low Dan, Chinatown's unofficial mayor, refused to pay, his general store was torched and a large portion of that neighborhood burned to the ground. Fortunately, Low Dan persevered as did Fook Lee Young, the first pioneer Chinese to grow row crops. There are descendants of both men still living in Gilroy. (Courtesy Gilroy Museum.)

64

Six

ABOUNDING
AGRICULTURE

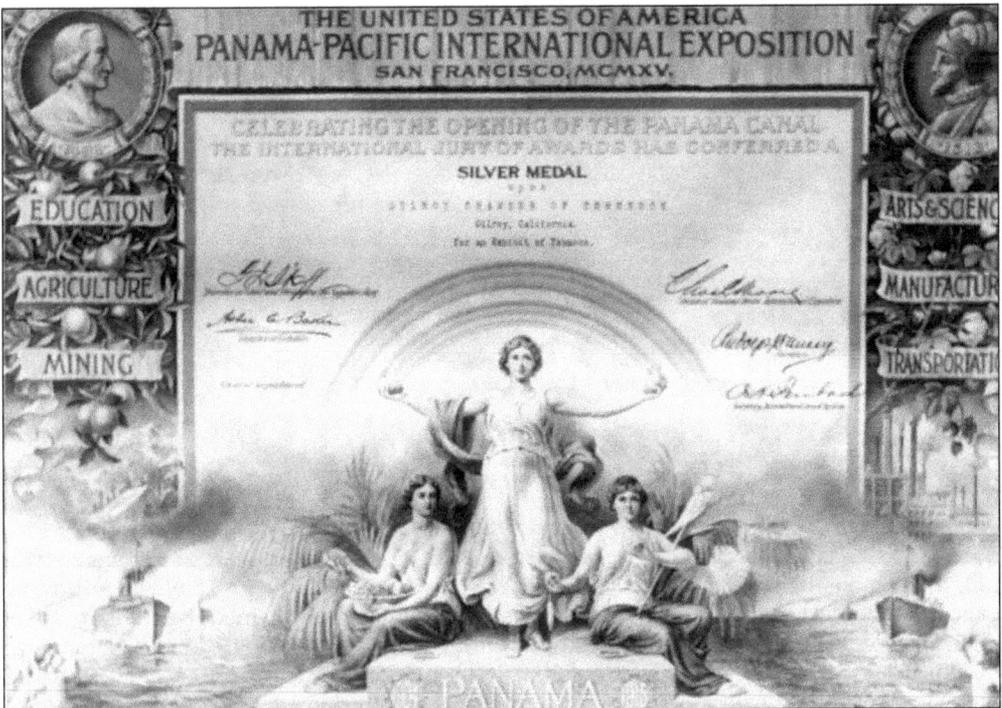

By the time James D. Culp and other tobacco growers won this award at the Pan-Pacific Exposition of 1915, they had generally conceded that the hot, dry summers in Gilroy created a bitterness in the leaves that even specialized curing could not eliminate. Despite this, in the late 1800s the tobacco industry was highly successful here, employing over 1,500 workers. (Courtesy Gilroy Museum.)

J.D. Culp brought his tobacco-growing skills from the east coast in 1859. In Gilroy he experimented with curing and drying processes for which he obtained a patent in 1872. His American Tobacco Company and the Pacific Company consolidated a year later, with headquarters in San Francisco. By the fall of 1873, the local factory on Rosanna Street was producing some 2,000 cigars a day and this ad ran often in the *Advocate*. Culp preferred to hire Chinese workers whose hands, he felt, had a special finesse in rolling the leaves for a premium cigar. The Cigar Makers Association of the Pacific adopted a discriminatory policy in July of 1876 that cigars must bear a label, "manufactured by white labor." Culp's non-compliance with this marketing requirement forced him to close his operation two months later. (Courtesy Gilroy Museum.)

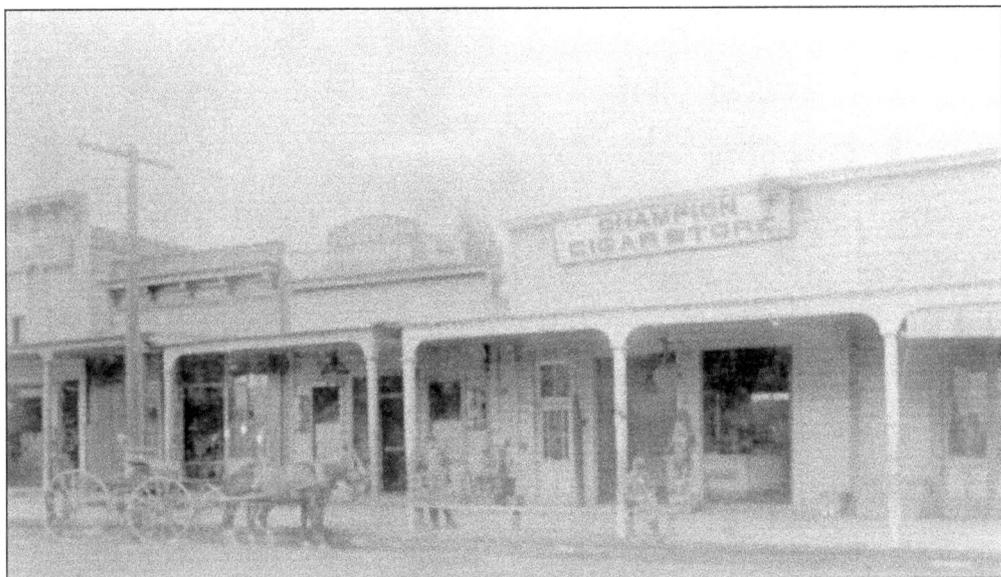

Many of the Chinese, left unemployed when Culp shut down, sought agricultural jobs in the San Joaquin Valley. Some stayed with Culp when he moved the business to his ranch in the San Felipe district, southeast of town. Culp continued a small operation into the early 1900s, earning the title, "Father of California Tobacco Culture." There were several shops in town, like A. Wolfram's Champion Cigar Store shown here, that carried the popular, locally-produced cigars. (Courtesy Gilroy Museum.)

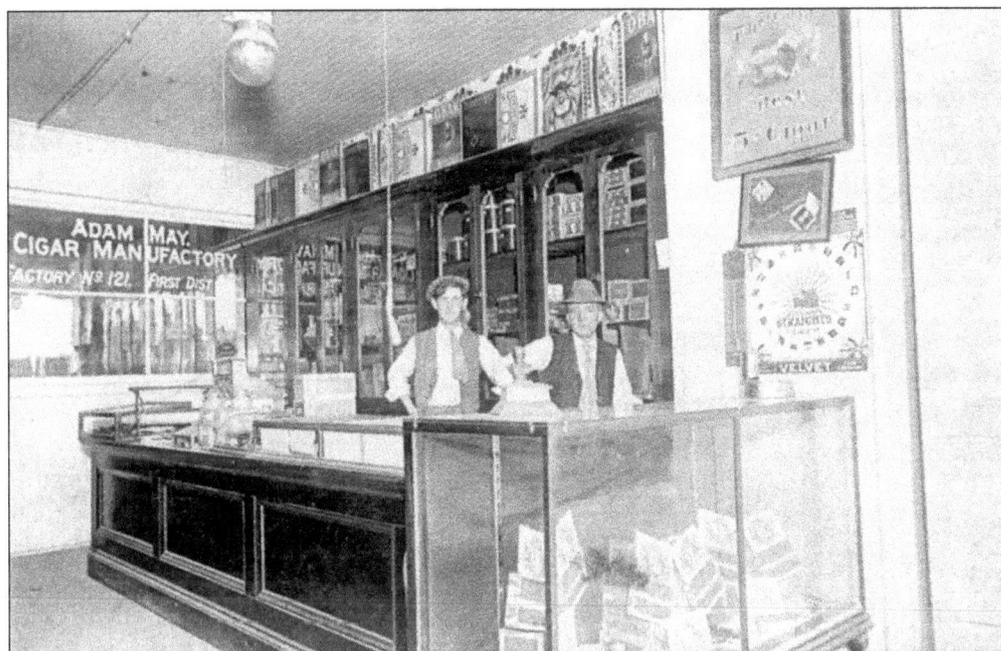

Adam May's Cigar Manufacturing Store also did a lively business in downtown Gilroy. Eddie Burgess, left, and Adam May sold local brands sporting names like "San Felipe Gold," "Golden Gate," and "Pride of Gilroy." And here's an interesting one, "*Bouquet* of California"—remember we're talking cigars. (Courtesy Gilroy Museum.)

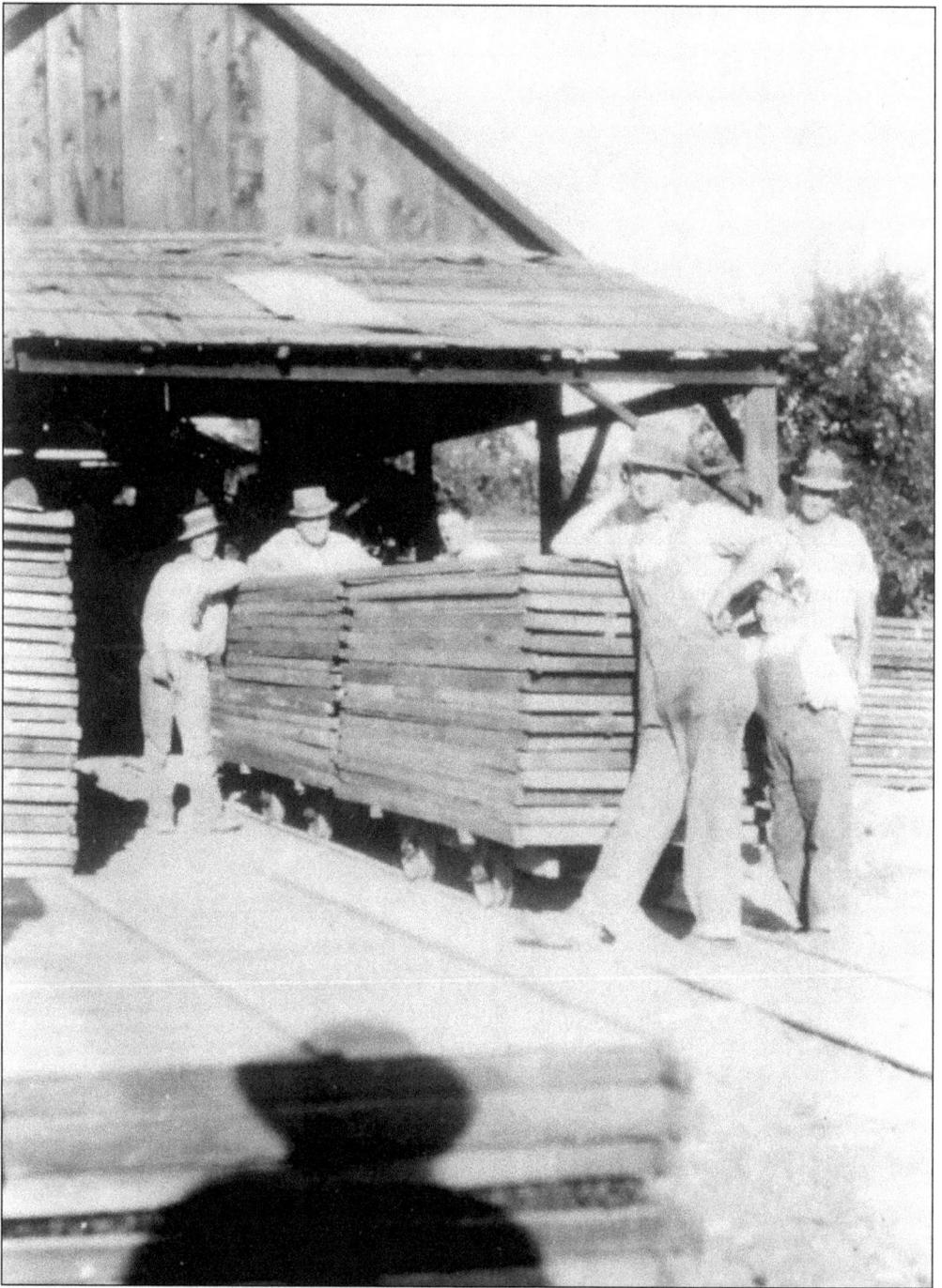

Angelo Sturla emigrated from his native Italy to San Francisco in 1862. The family came to Gilroy in 1873 and raised fresh vegetables for market on acreage in the Old Gilroy area. The next generation became orchardists, primarily raising prunes. Pictured here with trays of prunes stacked for drying, from left to right, are Pete Fillipelli, Louis Sturla, Harold Sturla (the last city marshal), Alex Sturla, Jack Sturla (as a boy), and Tony Sturla. The shadow in the foreground is young Jack's father, Angelo, the photographer, c.1928. (Courtesy Jack and Dorothy Sturla.)

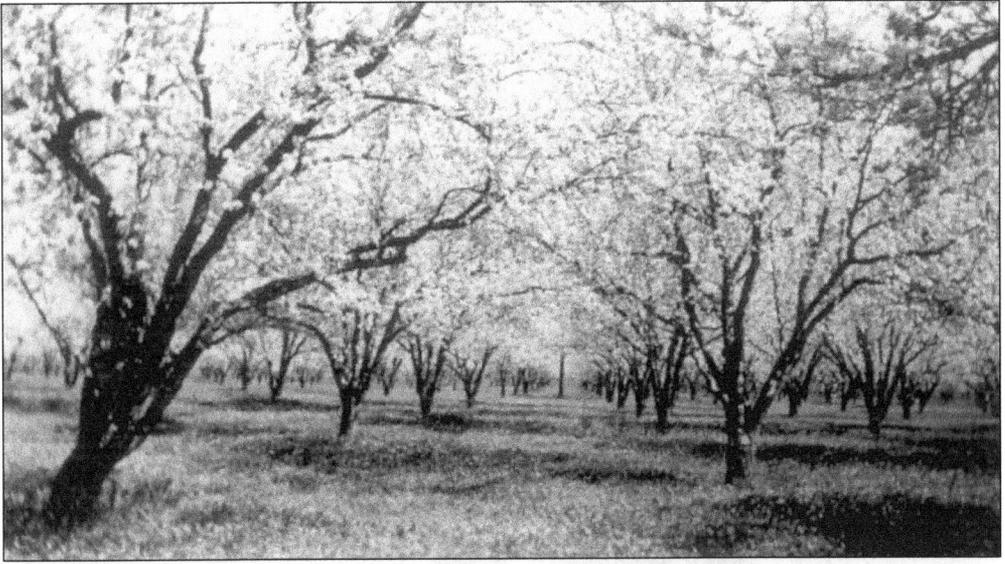

Frenchman Louis Pellier was another discouraged 49er that found his gold in the rich soil of the Santa Clara Valley. He started a nursery in San Jose, and in 1856 his brother arrived with cuttings from the renowned Prune d'Agen, regarded as the finest drying plum there is. Pellier grafted these cutting to native wild plum stocks and they flourished here. Many Gilroy farmers invested in this stock, creating thousands of acres of prune-plum orchards. In late March, as pictured here, c. 1948, these trees, with their fragrant white blossoms, are a beautiful sight. (Courtesy Jack and Dorothy Sturla.)

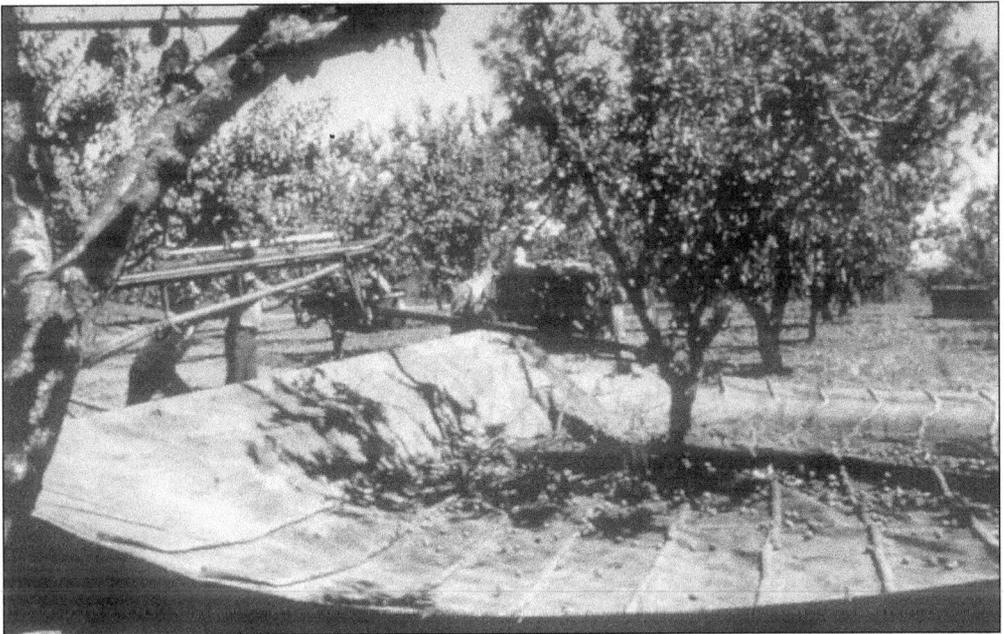

Unlike the "pole 'em and pick 'em up" harvesting methods of the early 20th century, many farmers were quick to utilize this later process where mechanical arms on a tractor give each prune tree a thorough shaking. The fallen fruit collects on a canvas drape that, as it is rolled up, conveys the harvest into wheeled containers. (Courtesy the Jack Martin collection.)

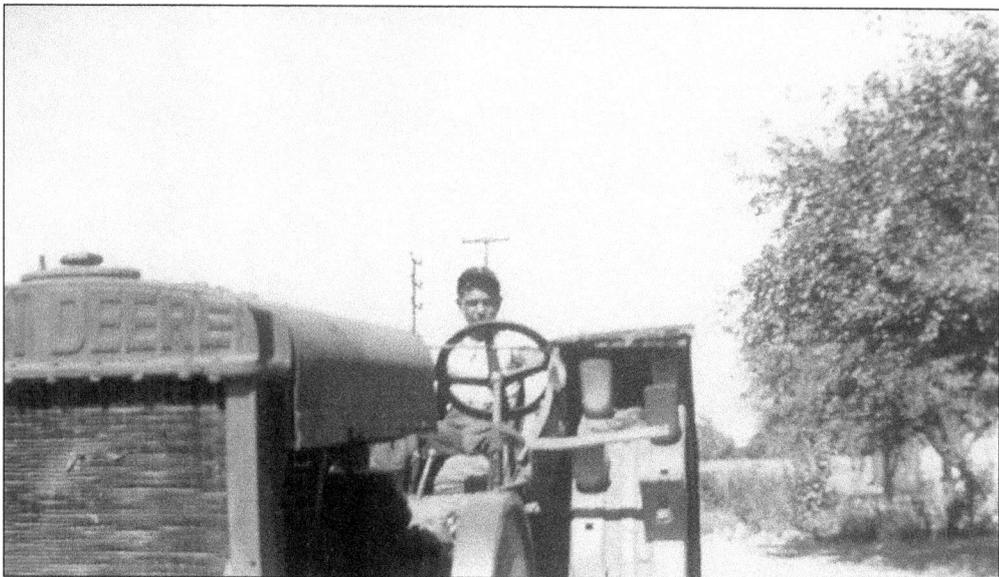

Filled containers were hitched to a tractor and hauled to the processing area. Many local prune farmers were equipped to handle all the steps of market preparation at their own ranches. In this 1936 photo, young Al Gagliardi gathers bins using his family's tractor. Until the early 1980s, Gilroy's schools started later than others in the county because so many children helped with their families' harvests. (Courtesy Al Gagliardi.)

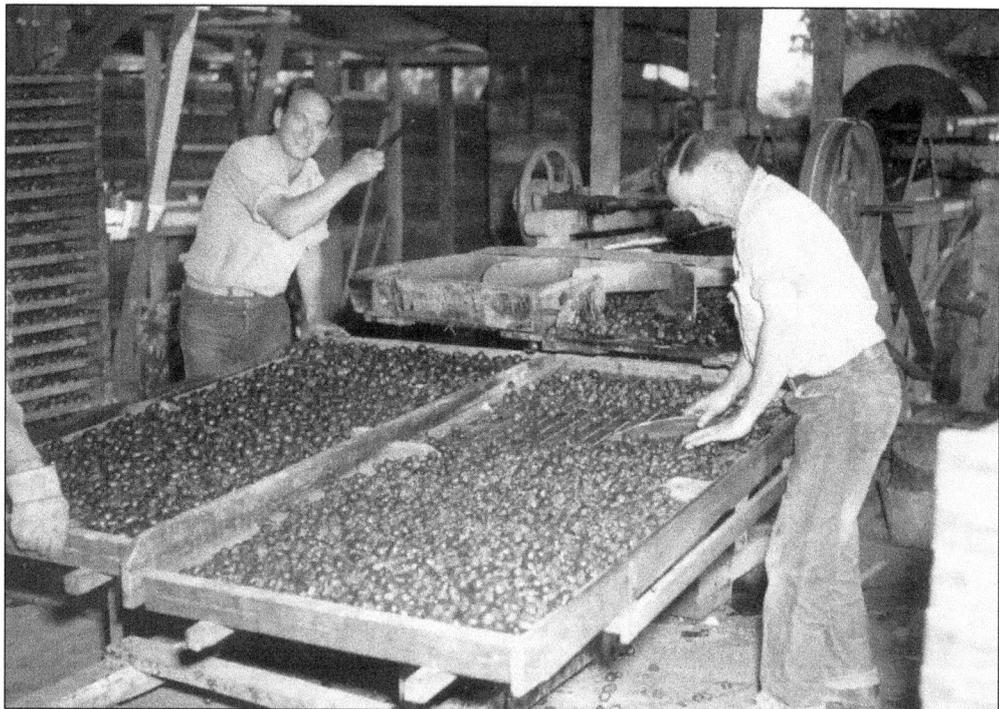

At the Sturla Ranch east of town, the prunes were sorted, dipped to soften the skins, and eventually set out on trays to dry in the sun. Jack Sturla, left, works on this phase of the harvest with his uncle, Alex Sturla, in 1946. (Courtesy Jack and Dorothy Sturla.)

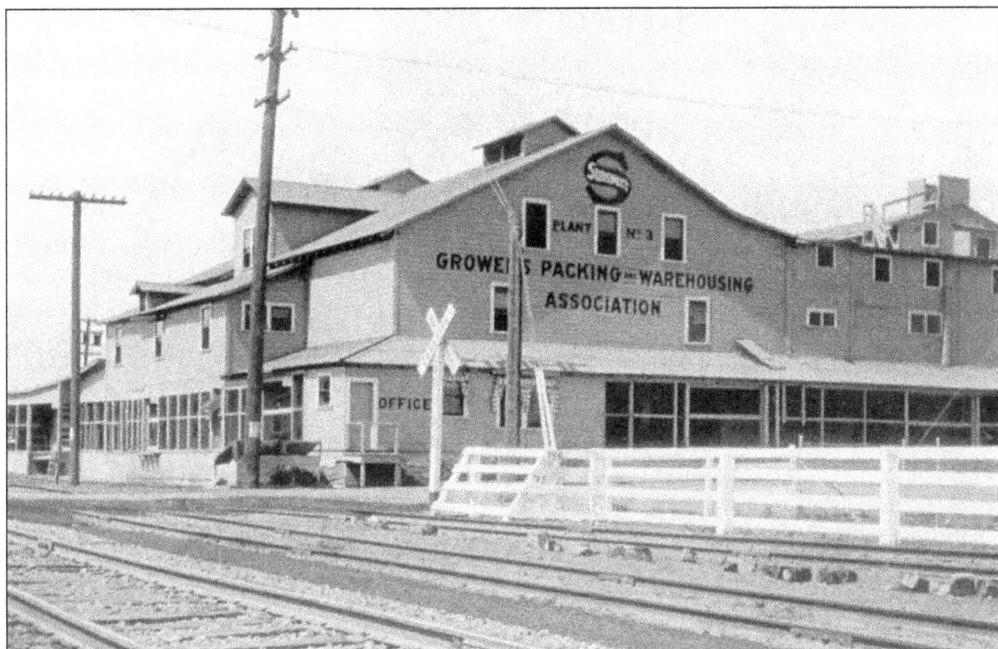

The Sunsweet Growers established farmers' marketing cooperatives in 1917. Dehydrators were installed at facilities such as this one, which operated until the late 1970s near the intersection of Leavesley Road and Monterey Street. (Courtesy Gilroy Museum.)

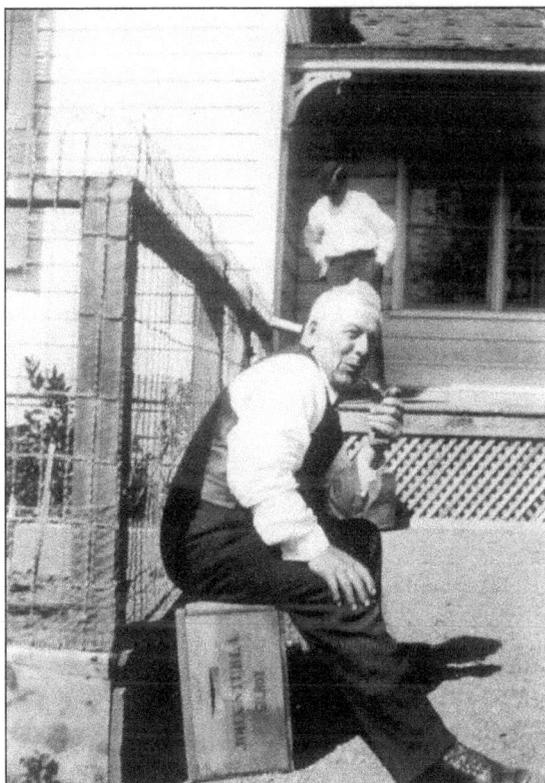

Farmers stenciled their names on every fruit box to ensure proper credit for what was sold. When the majority converted to the cooperative dehydration system, this was another way to ensure the return of as much quality fruit as they'd left off. Here, orchardist John Sturla relaxes with his pipe on his own makeshift stool. (Courtesy Jack and Dorothy Sturla.)

71

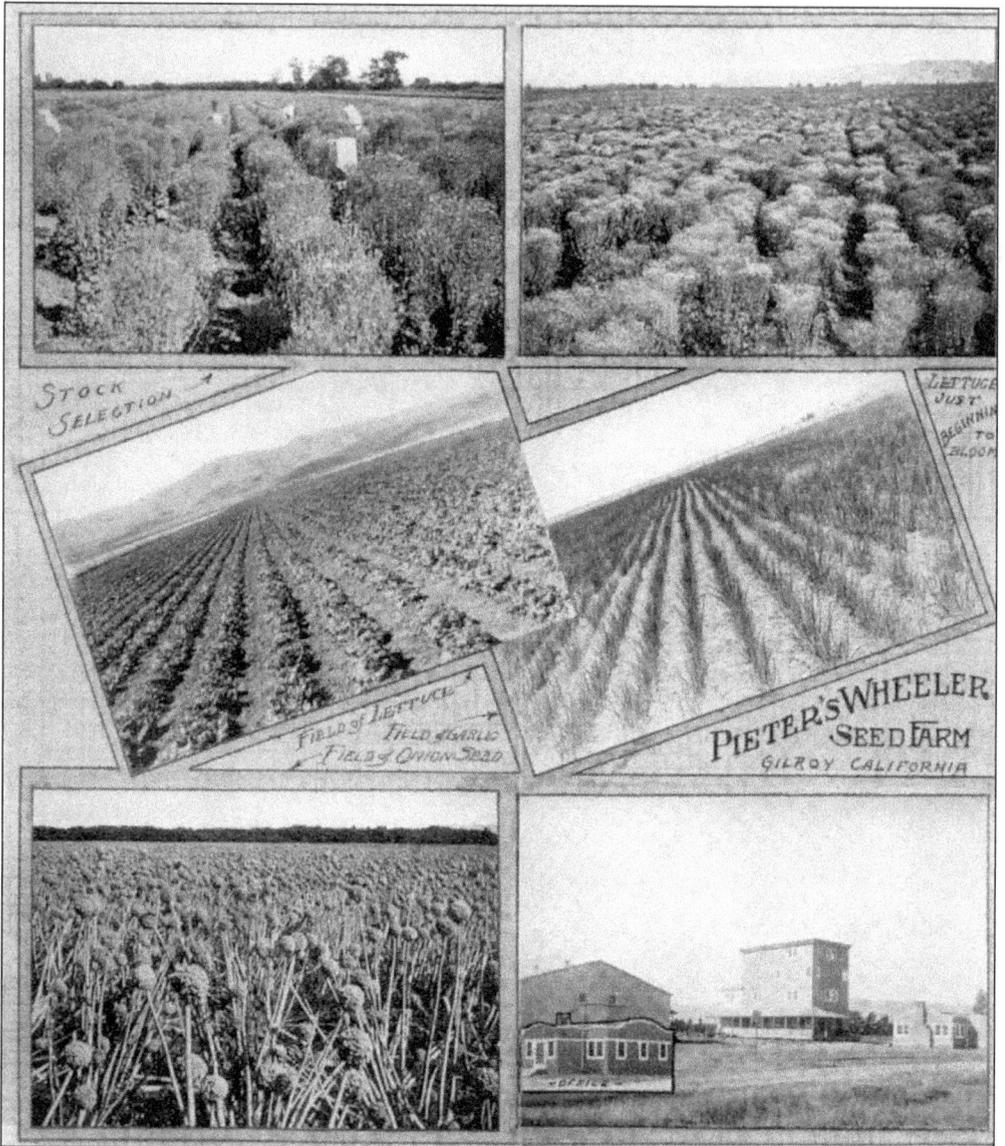

Seed farms were another successful aspect of Gilroy's agricultural bonanza. C.C. Morse had hundreds of acres under cultivation in flowers and vegetables as the 20th century began, utilizing the skills of nearly 100 Chinese. Another, the Pieters-Wheeler firm, was named for A.J. Pieters, who began in Hollister, and L.W. Wheeler, who worked with Pieters and who eventually purchased the company, moving the business to Gilroy in 1913. John W. Scherrer, godson to Wheeler, took charge of the firm in 1944 after Mr. Wheeler's sudden death. (Courtesy Gilroy Museum.)

The Japanese who settled here greatly enhanced the variety of crops grown in this valley despite being hampered by discriminatory laws. Often they could only lease the land due to the purchasing restrictions placed on Asians. Bell peppers, strawberries, tomatoes, celery, and garlic cultivation primarily began in Gilroy because of growers like Yamane, Nakashiki, Kishimura, Hirasaki, and Nagareda—to name a few. In this photo, employees of Kiyoshi "Jimmy" Hirasaki's enterprise are preparing celery for shipment to eastern markets. Hirasaki had over 1,500 acres in garlic and was one of the first farmers to do so. (Courtesy Gilroy Museum.)

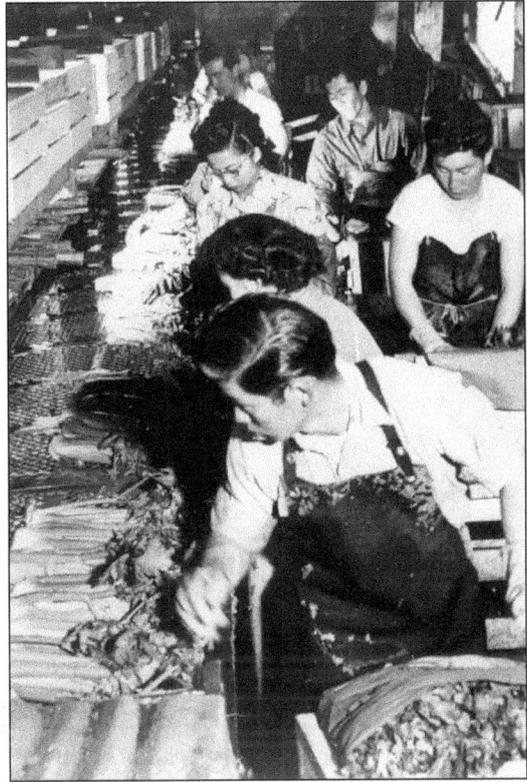

Gubser and garlic go hand in hand in Gilroy. Joseph Gubser Jr., pictured here, followed his father into the garlic business. Joseph Sr. was part of that handful of early growers who invested many acres in the 'stinking rose.' His son branched into the marketing aspect of the business, assisting growers the world over to find buyers for their crops. In 1993, his 50th year in the fresh garlic business, Joseph Gubser Jr. was presented with a special commendation from the Gilroy Garlic Festival Association. (Courtesy Doris Gubser.)

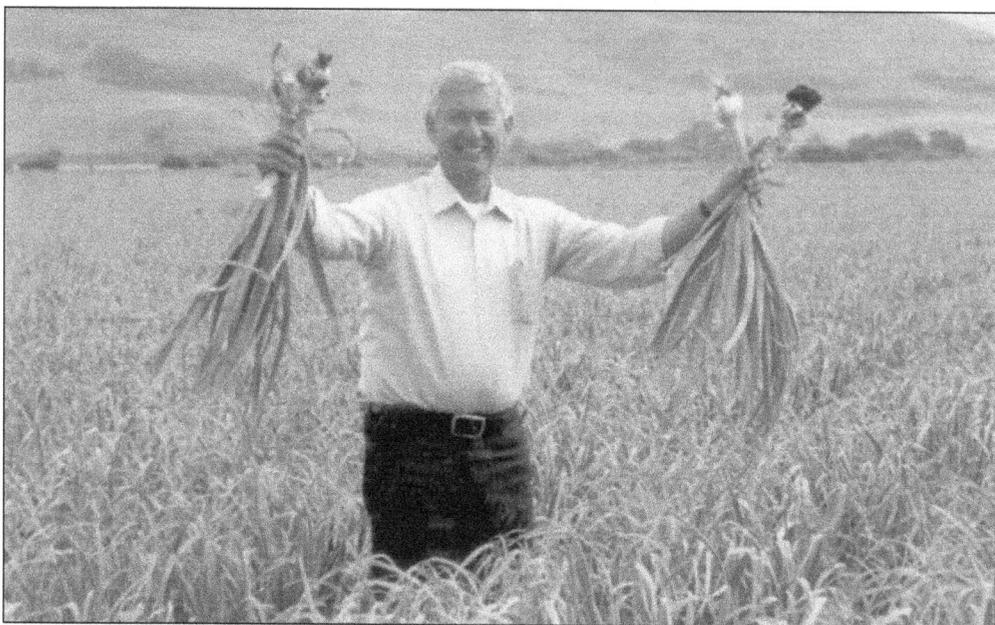

Vast fields of garlic plants, their slender green toppings reaching for the sun, are a common sight around Gilroy. It was at his ranch, south of town, that grower Don Christopher, pictured here, and his colleagues hosted a Rotary luncheon that blossomed into Gilroy's initial garlic festival. Here he clowns with a staff member who's behind the camera. The Christopher Ranch ships fresh and processed garlic products all over the world. (Courtesy Pat De Stasio and the Christopher Ranch.)

GILROY • CALIFORNIA

SOUTH SANTA CLARA COUNTY
WINE REGION

The efforts of many European immigrants in the very early 1900s gave birth to the continuing fine reputation of South County's wine industry. Eduardo Scagliotti opened one of the first wineries on the west side of the valley, as did Pietro Bonesio on land that had once been part of the Solis Rancho. The former Bonesio home is one of the oldest structures in the county. The prohibition years were tough ones for Gilroy's vintners, but between selling their grapes for home wine-making (which was not illegal) and making sacramental wine, also within the law, the winemakers of Gilroy's "Little Italy" persevered and went on to become bigger and better. (Courtesy Gilroy Visitors' Bureau and Gilroy Museum.)

Gennaro Filice arrived from his native Italy in 1907 and first worked for Bisceglia Brothers Cannery near Hollister. In 1914, Gennaro, his father Michael, and a partner, John Perrelli, built a cannery. They expanded to another plant at Lewis and Railroad Streets and were Gilroy's largest industry for many years. These men were pioneers in the food-processing business, and the Filice & Perrelli facility, pictured here, canned over 50 varieties of vegetables and fruits. (Courtesy Gilroy Museum.)

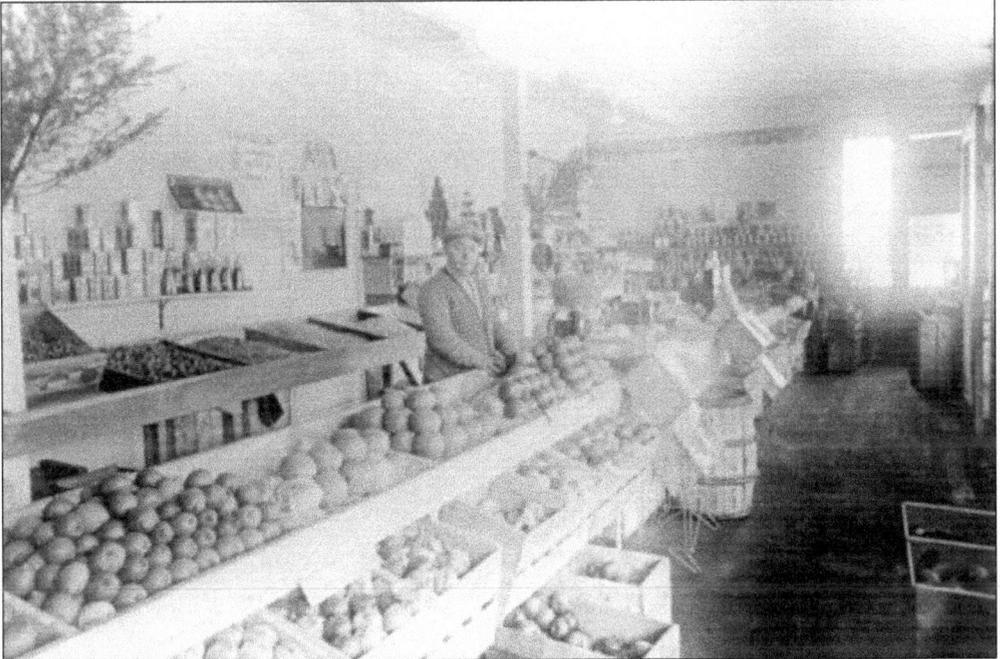

Frank Rossi, pictured in this 1940s photo, was a well-known produce merchant in town. The Rossi market on Monterey Street sold a variety of goods as evidenced here, but the featured specialties were their fresh fruits and vegetables. (Courtesy Gilroy Museum.)

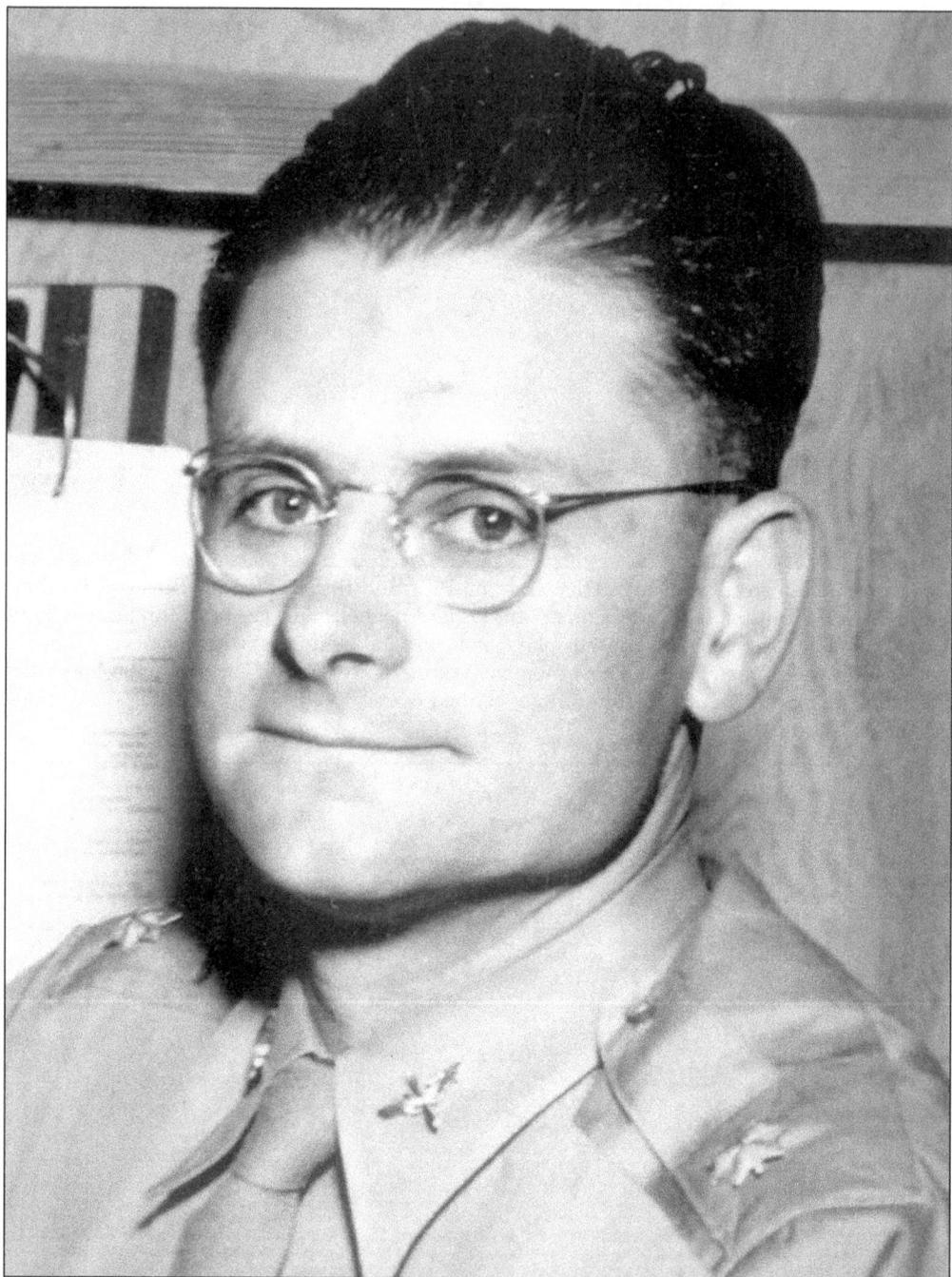

Myrle J. Wolfe's family came west from Nebraska when he was nine. His parents farmed a hundred-acre prune ranch on New Avenue. Wolfe had planned to travel the world, but when his father was seriously injured in a farming accident in 1929, he returned to run the family business. He was active in the Gilroy Grange and gave $400,000 to the Gilroy Unified School District for perpetual scholarships for students of agricultural families or for those wishing to study any of the agricultural sciences in college. This gift is still creating educational opportunities for South County's graduates every June. (Courtesy Gilroy Museum.)

Seven

CULTURALLY
SPEAKING

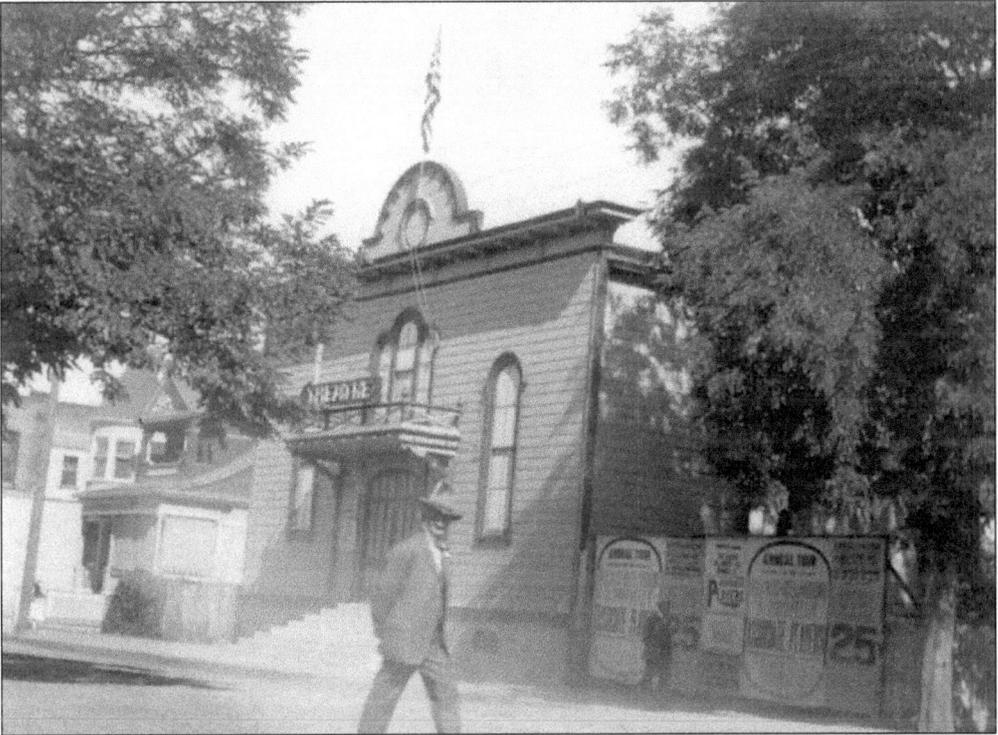

In 1874, the citizens of Gilroy bought stock shares in anticipation of a music hall for social and cultural events. After the funds were raised William Hanna constructed the building on Fifth Street, between Monterey and Eigleberry Streets. Complete with stage, a dressing room area, and a balcony, the hall could accommodate 750 people. Downstairs the seating was moveable, so the space could be used for dances and sporting events. (Courtesy Gilroy Museum.)

Programme :-:
YEAR 1910

Gilroy Opera House, Thursday, May 28th

Frederick Macmurray, Violinist

assisted by

Mrs. Henry Hecker, violinist and accompanist

Mrs. Elsie-Cook Hughes, pianist

Miss Vivian Moore, soprano

Mr. Edward M. Hughes, violinist

1. (a) Romanza Macmurray
 (b) Menuett Beethoven
 MACMURRAY
2. " Daddy " A. H. Behrend
 MISS MOORE
3. Ave Maria Schubert-Wilhelmji
 MACMURRAY
4. Liebestraum Liszt
 MRS. HUGHES
5. Trio (three violins) arranged by Mr. Hughes
 MR. HUGHES, MRS. HECKER, MR. MACMURRAY
6. (a) Air for G. string Bach
 (b) Salut d' Amour Elgar
 MR. HUGHES
8. Faust Fantasie Sarasate
 MACMURRAY

Rev. Dr. Thomas MacMurray was pastor of the Presbyterian Church for a time. His son Frederick gave a concert at the Music Hall in 1905. Frederick returned for another performance in 1910, which, as the program here indicates, also featured local teenage soprano, "Miss Moore." Frederick later had a son, Fred, who became a popular actor of films and television. Vivian Moore Barshinger Head became a much beloved music teacher in the Gilroy Schools. (Courtesy Gilroy Museum.)

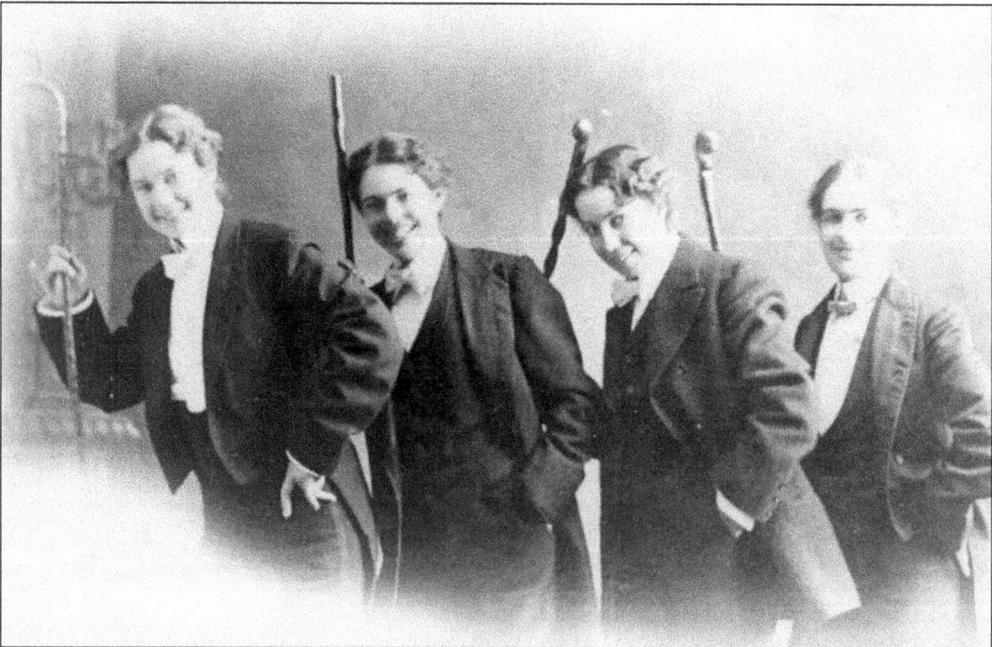

Many civic fundraisers took place at the Music Hall, which brought out the hambone in Gilroy's residents. The jaunty quartet featured here, from left to right, includes Mrs. Ellis, Mrs. Eschenberg, Mrs. Nellie Whitehurst Brownell, and Mrs. Joan Lennon Riley. (Courtesy Gilroy Museum.)

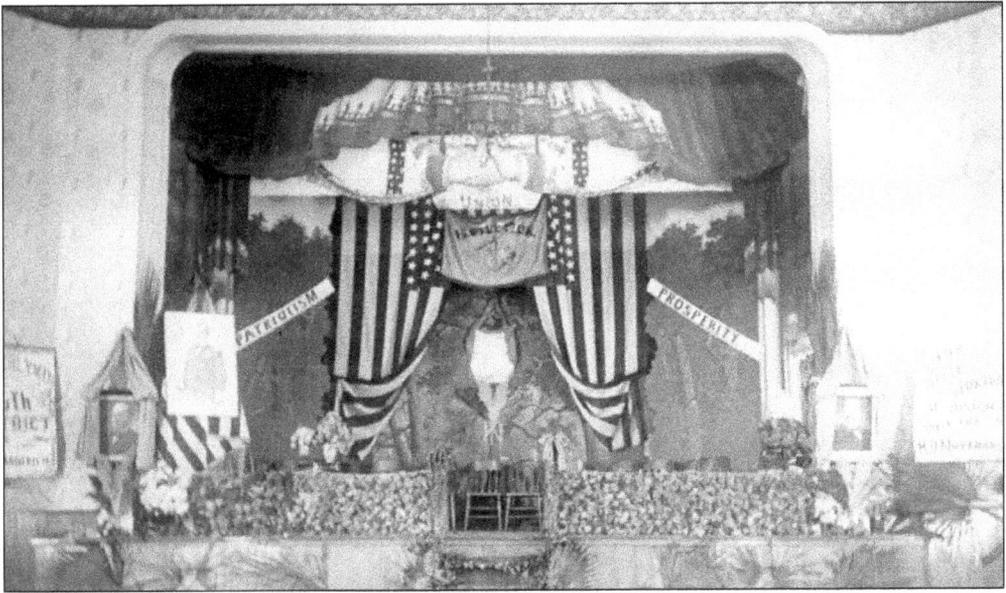

Over the years, vaudeville touring acts, traveling choirs and bands, and plays of all kinds appeared on the stage of the Music Hall. Before the gymnasium was completed at the high school campus, the boys' basketball team played their games here. This 1896 photo was taken when a Republican candidate for the state senate held a political rally in the hall. It was, indeed, a multi-purpose auditorium. (Courtesy Gilroy Museum.)

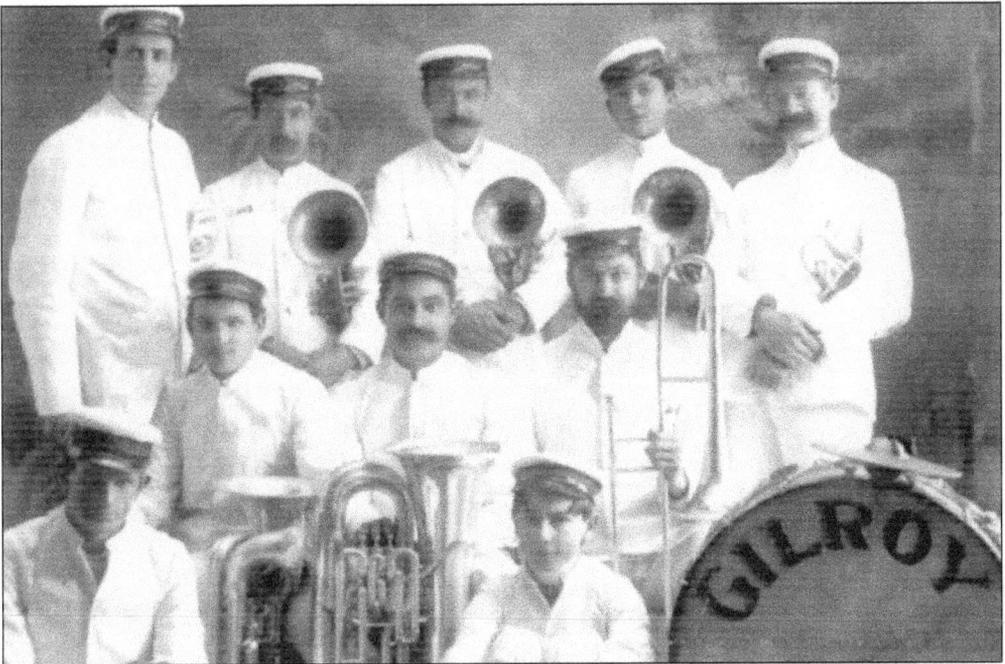

The Gilroy Band was a popular group of local musicians for whom performing was a side job. A versatile bunch, they participated in parades and provided the live music for various evening functions around the area, such as Saturday night dances at the rural resorts. (Courtesy Gilroy Museum.)

The STRAND

VOL. I, NO 1. GILROY, CALIFORNIA DECEMBER 3, 1921.

FORMAL OPENING DECEMBER 3, 1921

"The STRAND Theatre Building Erected and Equipped at a Cost of $175,000

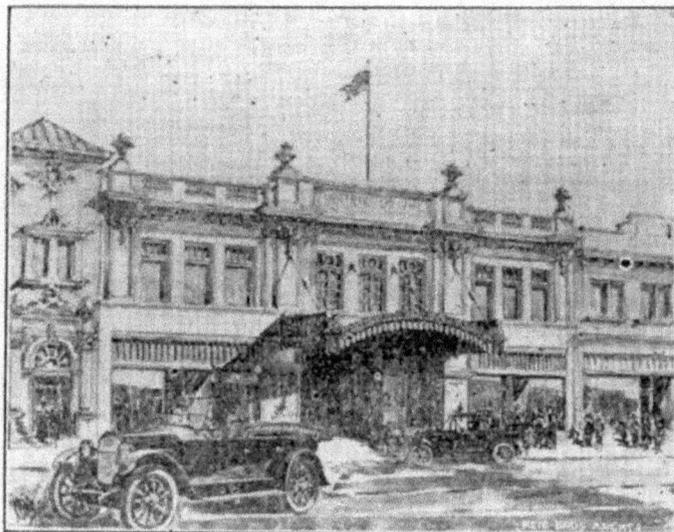

A Monument to the Progressive Spirit of the Citizens of Gilroy, Calif.

P R O G R A M M E
—1—
ADDRESS BY MAYOR JAS. PRINCEVALLE
(Programme Continued on next page)

Tucker Bros.

ARE OPEN UNTIL AFTER THE SHOW

Why not Store your Car with us, where everything will be safe
and then you can enjoy the play.

Courteous Service Storage

Goodrich Tires---Exide Batteries
Expert Automobile Repairing

Tucker Bros. Garage

Just South of STRAND Theatre Telephone 174

The Strand Theatre has been recently revitalized, and in its former heyday it was a superbly elegant entertainment center for the city. William Radtke did the contracting. Here is a copy of the front page of the opening night program. There were four large dressing rooms on the stage level for star performers, and the basement had additional accommodations for other cast members. (Courtesy Gilroy Museum.)

80

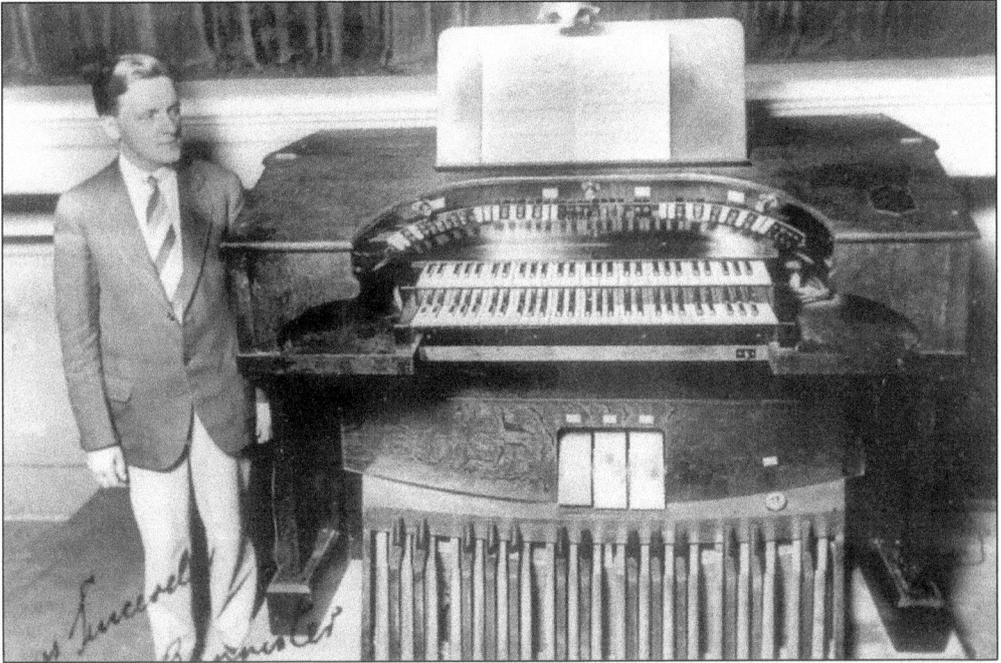

The Strand boasted a $15,000 pipe organ and a formal orchestra pit. Harry Bannister, who emigrated from England and was one of Gilroy's premier musicians, was the organist here for years. He accompanied the silent movies and offered delightful recitals before and after the main features. With the advent of talking films, Bannister still performed for special occasions and gave private music lessons. (Courtesy Gilroy Museum.)

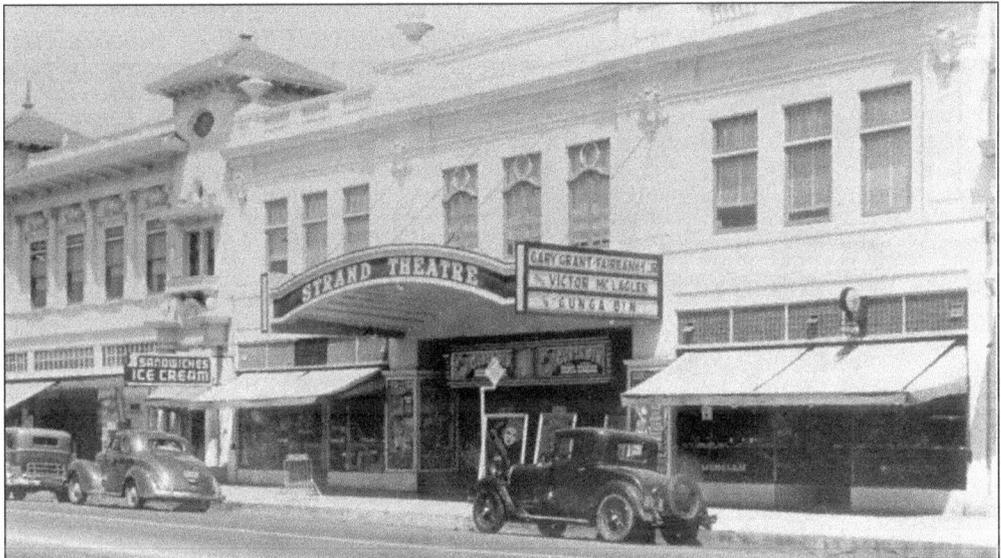

The Masonic Temple, home of the Keith Lodge of Free & Accepted Masons, is on the left in this photo. Tucked between the temple and the theatre is Schilling's, a classic soda fountain where Gilroy's teens headed after the movie. The Strand was the site of many live performances and benefits as well, such as the Elks' gala Christmas show each holiday season. (Courtesy Gilroy Museum.)

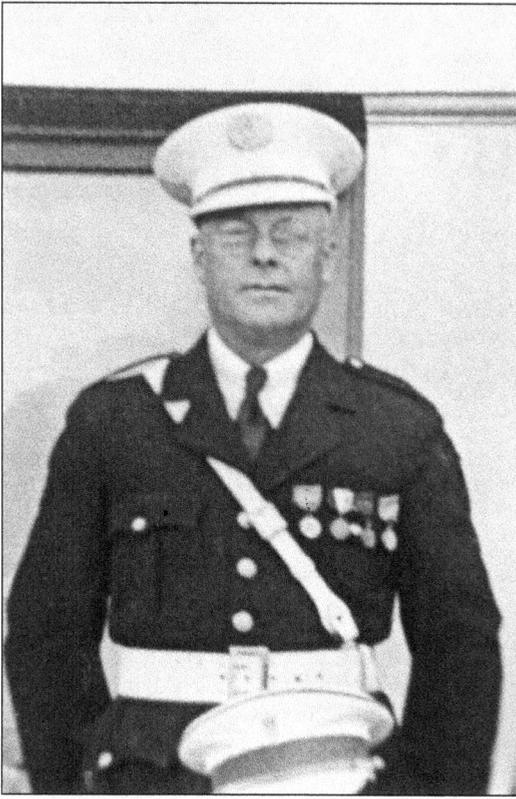

Another exceptional educator and musician was Edward H. Towner, band director and head of all instrumental music in the Gilroy schools from 1930–1945. He, too, was from England. Towner arrived here during the Great Depression when "extras" in the curriculum were almost nonexistent and set to work to change that. From all reports, he was a strict but beloved teacher who also made a fine marching unit of the high school band. (Courtesy Gilroy Museum.)

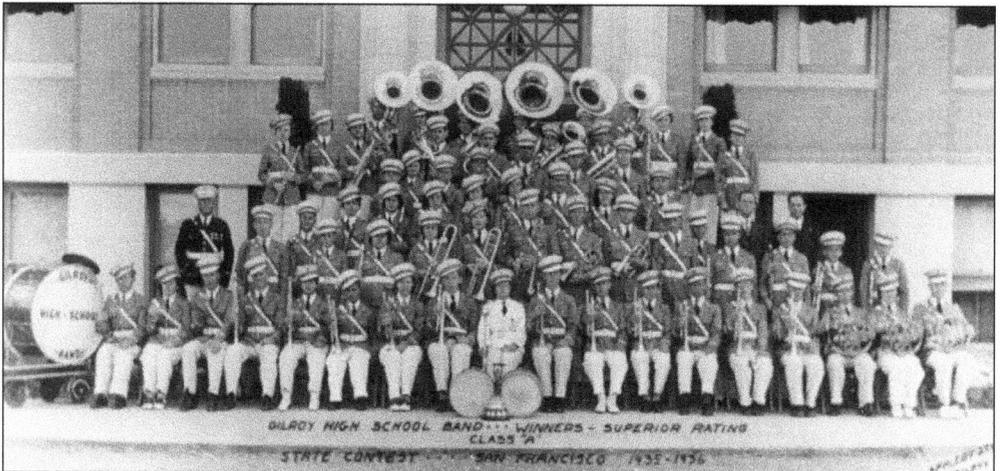

Within months of Mr. Towner's arrival the high school band, pictured here, won first runner up, B division, in the State Championships. They took top prize from 1934–1936 and even did well in the A division, the competitive category for larger high schools. When Towner left the high school in 1946, he formed—and conducted for many years—the Eagles Band, which was comprised of former students while also serving as band director at Santa Clara University. (Courtesy Gilroy Museum.)

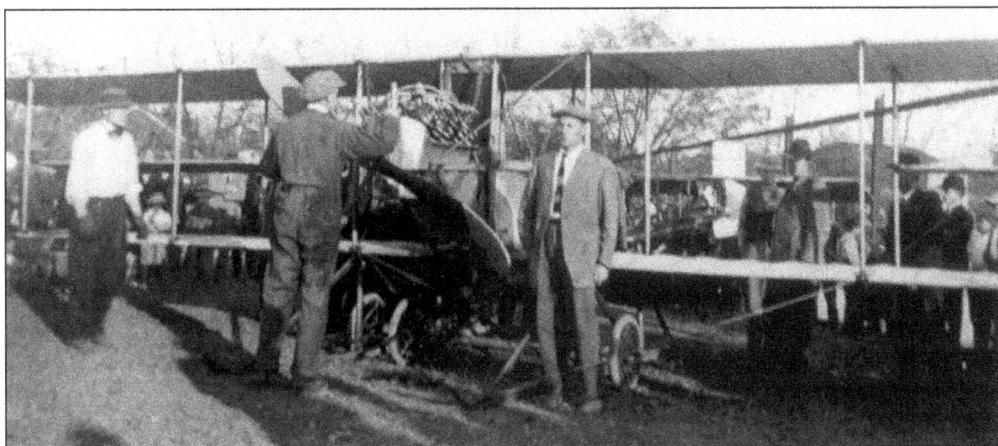

The historic first flight of the Wright brothers in 1903 led to many changes in our culture. Robert Fowler, born in 1884 at Gilroy Hot Springs where his father was hotel manager, was one to explore those new horizons. As a teen he set a land speed record for driving from Los Angeles to San Francisco. In 1910 he and two friends invested in a Curtiss bi-plane and taught themselves to fly. Our local daredevil even studied with Orville Wright in Ohio. It is claimed that Fowler was the first man to fly east across the United States, the first to land a plane in Gilroy, and the first to fly over both San Francisco in 1911 and the Panama Canal in 1914. Gilroy artist Joe Kline, whose work specializes in aviation themes, has captured in exquisite detail many of the accomplishments of our pioneer aviator. (Courtesy Gilroy Museum.)

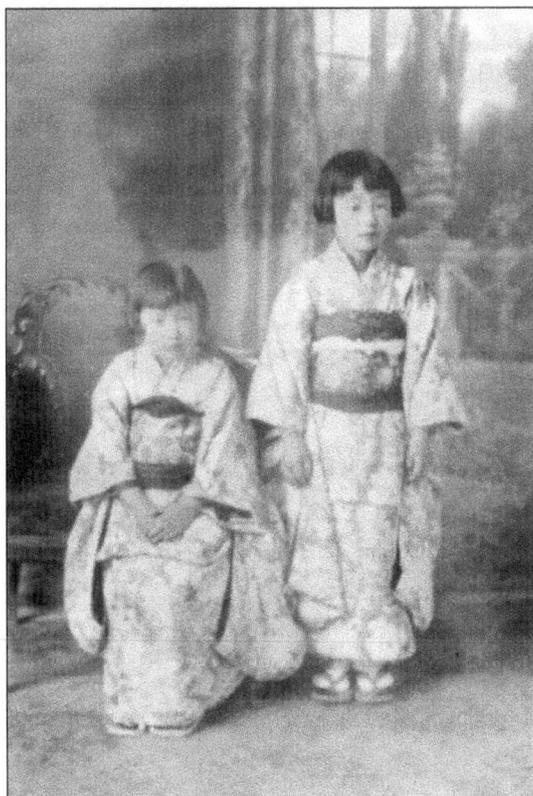

The Japanese use the term *Issei* to indicate one who has come from Japan and settled in a new land. The *Nisei* are those born here, the second generation. Kiyoshi Hirasaki, a pioneer garlic grower mentioned earlier, was *Issei*. His daughters, Fumiko and Mineko, *Nisei*, are pictured here in lovely traditional kimonos—American girls proud of their Japanese heritage. (Courtesy Mineko Sakai.)

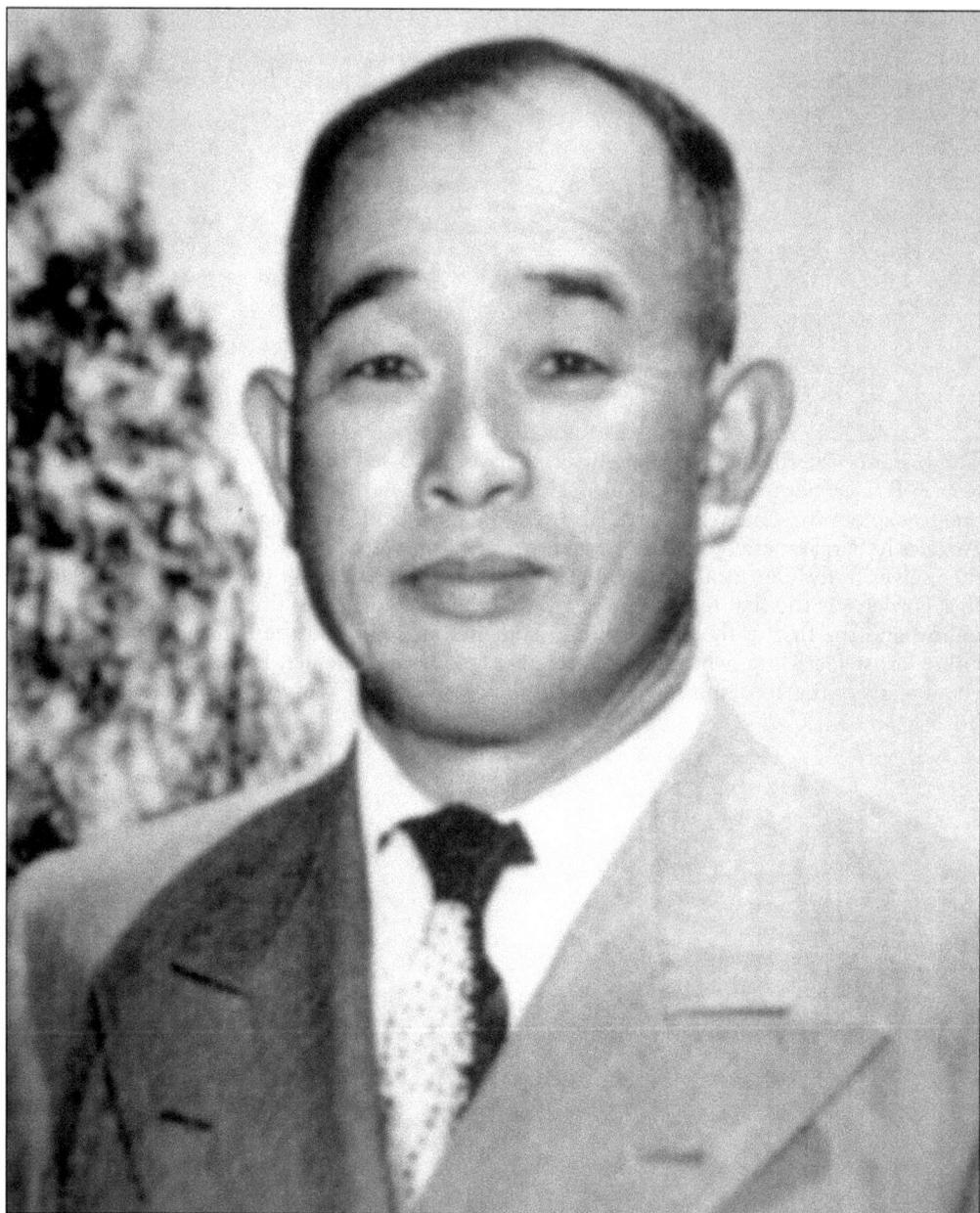

Kiyoshi "Jimmy" Hirasaki arrived in the United States in 1914 to attend school. Soon after, he came to Gilroy and learned the seed business. He went to Japan in 1928 and returned to Gilroy with a lovely bride. Years later the couple remodeled their farmhouse along the Pacheco Pass, utilizing parts of what had been the Japanese Pavilion at the 1938-39 World's Fair on Treasure Island in San Francisco Bay. As spokesman for the Japanese community, Hirasaki was one of the first to be detained by the FBI in the panic that followed the attack on Pearl Harbor but was later cleared of any wrong-doing. Following the war years, which the family spent in Colorado, they returned here to begin anew. Hirasaki had the original farmhouse moved to town in the 1950s where it still serves as the Japanese Community Hall. (Courtesy Mineko Sakai and Gilroy Museum.)

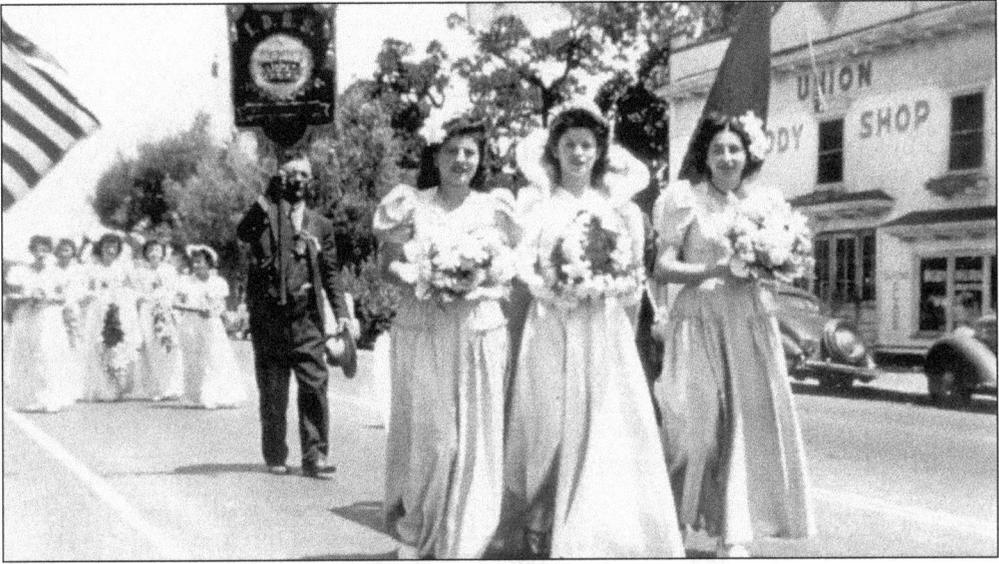

Many of Portuguese descent live here as well, and in 1901 the IFDES (Irmandade da Fesa do Divino Espirito Santo or Brotherhood of the Festival of the Holy Spirit) was founded. In keeping with their name, one of the sacred traditions the early immigrants brought to this community is the Holy Ghost Festival which traces back to a 13th century legend about Portugal's Queen Isabella, later canonized St. Elizabeth. Every spring, mirroring the queen's joyful procession to her church after answered prayers saved her people, Gilroy's IFDES celebrants proceed down Eigleberry Street to St. Mary Church and hold a feast to which all are welcome. Pictured here, from the early 1940s, is Queen Marian Bettencourt with her two side maids. (Courtesy Gilroy Museum.)

Carlo (later, Charles) Porcella ventured here from his native Italy in the 1890s. He had cavalry experience in Italy, which may have assisted him in getting a teamster position for the Miller & Lux cattle enterprise. By 1900 he was a partner in a Monterey Street clothing store and bought out H.L. McDuffie in 1908. Porcella had an aptitude for languages and knew Spanish, Portuguese, English, and his native Italian. He acted as an interpreter for Miller & Lux, especially on payday. Later, when called upon, Porcella offered his services for the courts—municipal, county, and occasionally the state court, thereby creating more trust and understanding amongst California's increasingly diverse population. (Courtesy Gilroy Museum.)

James Rule was perhaps the first pastor of the Gilroy Christian Church and this home on Fifth Street was constructed just east of the church, c. 1857. Judge Howard Willey, who served as justice of the peace in Gilroy from 1883 to 1919, bought the home some years later and made several additions. His two talented daughters, Grace (Key) and Minnie (Stoddard Moore), held frequent recitals here, both vocal and instrumental, and put on elaborate social gatherings as well. The Theatre Angels Art League purchased the home in 1974 and opened it as an arts center. The city now owns and maintains it in that same capacity. (Artwork by Robin McGinnis.)

Inez Fitzgerald learned the art of photography in the east. As a woman, she was rebuffed in her efforts to open a studio in San Francisco when she came west in the early 1880s. But Gilroy welcomed her. She did fine portraitures, as evidenced in this self-portrait, c. 1895, and she excelled at outdoor work as well. For example, she would often load her equipment into a wagon to be first on the scene of an area train wreck or to capture on film some celebrity guest or event at the Hot Springs Hotel. (Courtesy Gilroy Museum.)

Eight

A HAPPENING PLACE

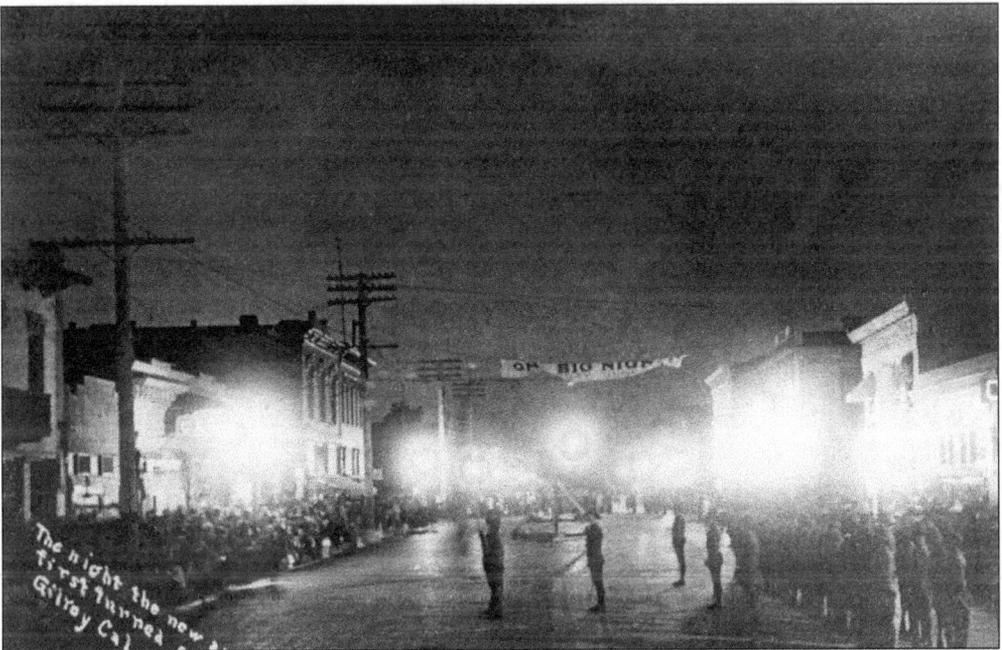

There was much ado on Monterey Street when the downtown lighting system made its debut the night of June 3, 1916. The Cadet Band played and a huge crowd gathered to witness yet another modernization of the community. (Courtesy Gilroy Museum.)

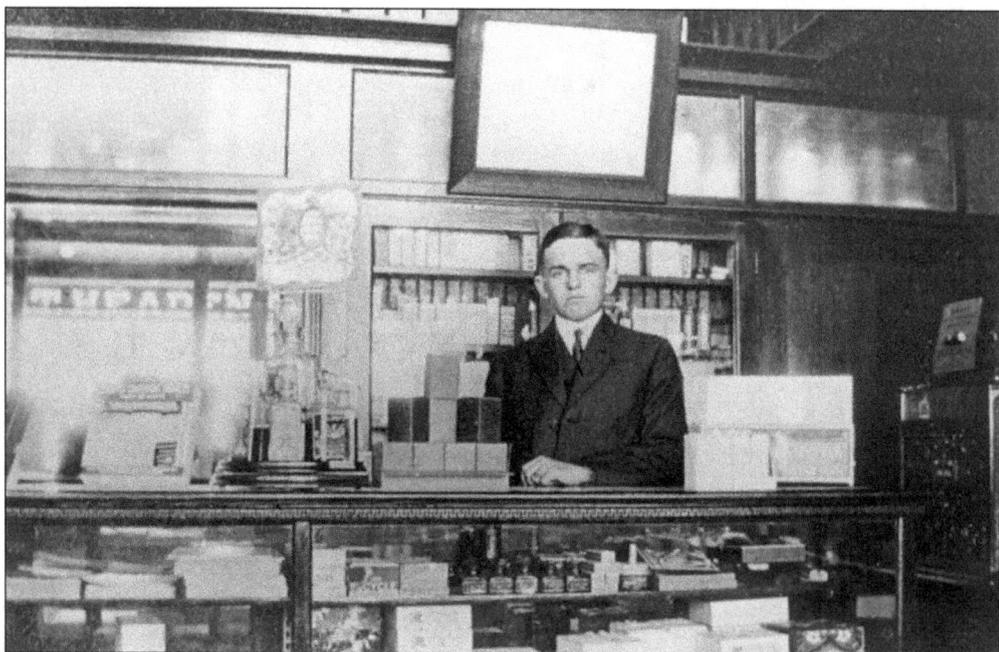

Gilroy-born George Wentz was in partnership with Dr. Clarence Weaver, a local dentist, in a drugstore on Monterey Street. By 1890, Wentz became sole owner. When he retired in 1925 his son Carroll, pictured here, took over. George Wentz was active in local politics and was instrumental in establishing our City Planning Commission in 1937. (Courtesy Gilroy Museum.)

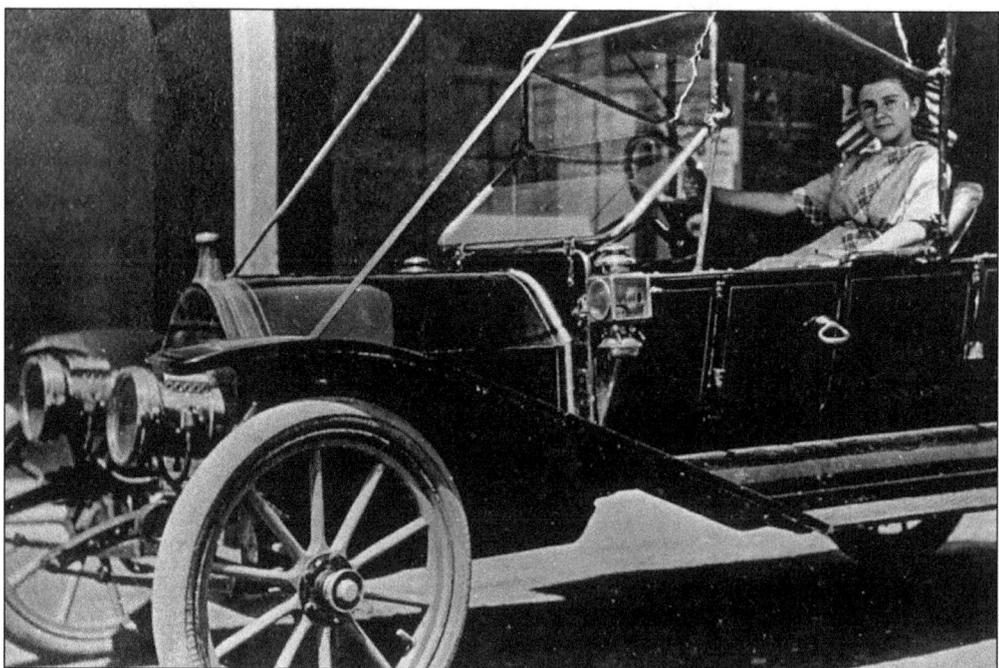

Gladys Wentz, wife of Carroll, must have been an adventurous young woman. In the early 20th century when automobiles became popular, she was reported to be one of only three women drivers in town. Here she poses behind the wheel of the couple's Hupmobile. (Courtesy Gilroy Museum.)

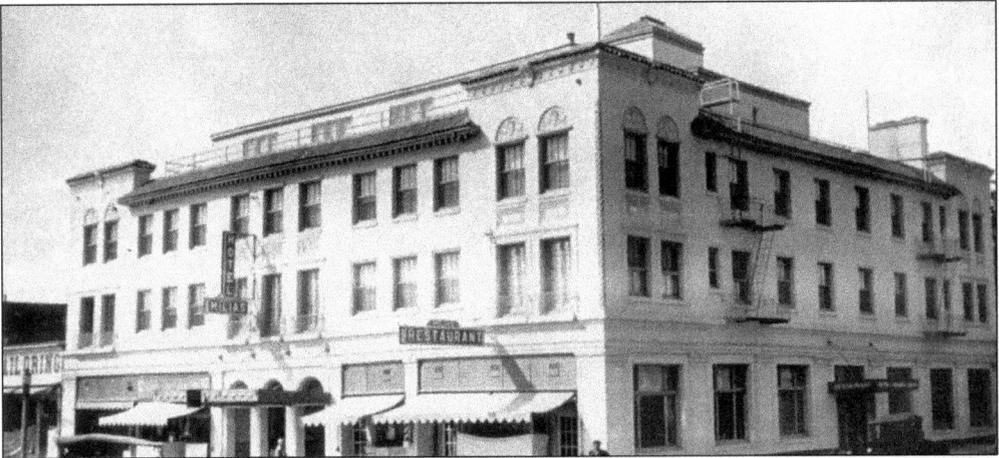

George Milias Sr. emigrated from Yugoslavia in 1881 and ran a restaurant in San Jose for ten years before settling in Gilroy. He married Minnie White and in 1922 established the Milias Hotel, pictured here, at the southwest corner of Sixth and Monterey Streets. The architect for the project was the esteemed William Weeks. The hotel featured a fine ground-floor restaurant, a room at the top that could be rented for banquets and receptions, and—a first for Gilroy—an elevator. (Courtesy Gilroy Museum.)

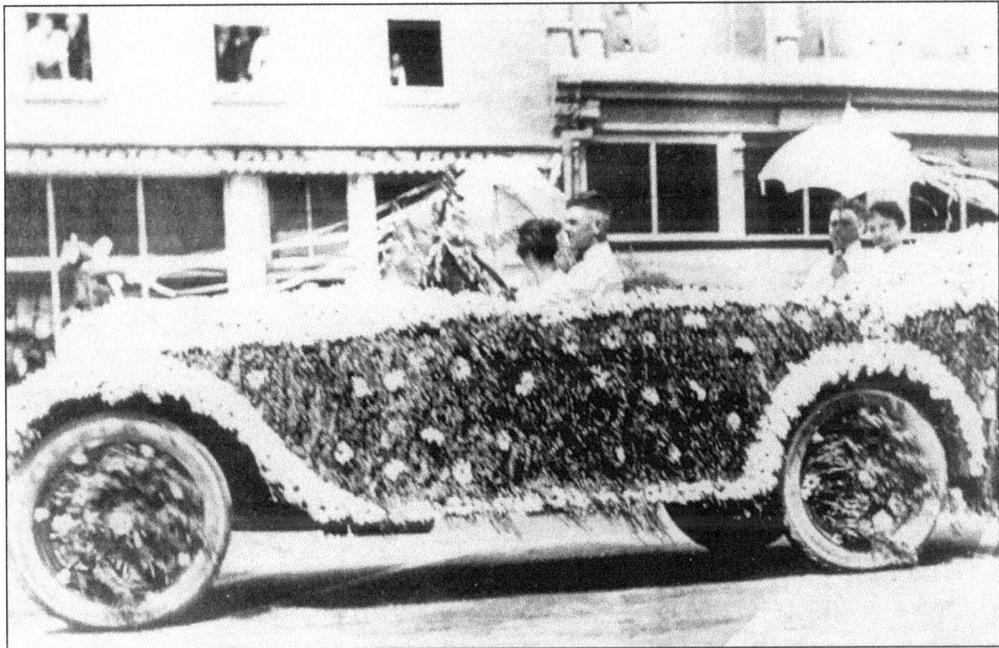

George Cavanaugh Milias, son of George Sr., had a 1920 contract with the Pittsburgh Pirates but instead learned the hotel business at the St. Francis in San Francisco that year. He managed the family hotel for years and also ran the family's cattle business in the foothills east of town. Civic-minded like his father, George C., as he was known, was a councilman, a two-term mayor, general manager of the Gymkhana Rodeo, and an early sponsor of Gilroy's Bonanza Days. Here he's at the wheel of an entry in one of Gilroy's many parades. (Courtesy Gilroy Museum.)

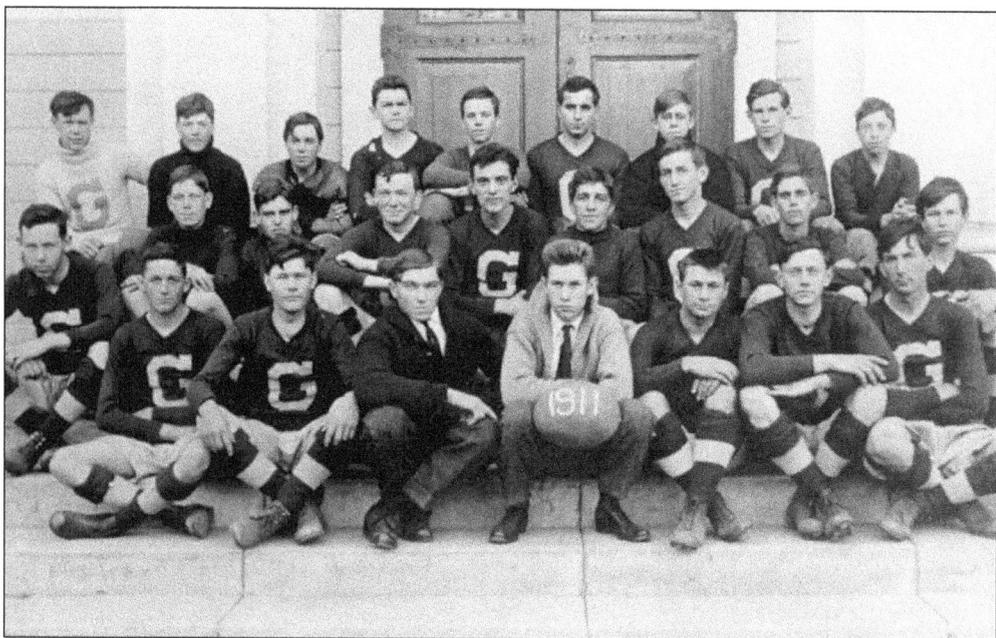

Here's a formidable looking bunch of Gilroy High athletes—the 1911 rugby team. These young men are sitting on the steps of the old Severance School (their high school was right next door) because it wasn't until the following year that the modern high school campus on I.O.O.F. Avenue was completed. (Courtesy Gilroy Museum.)

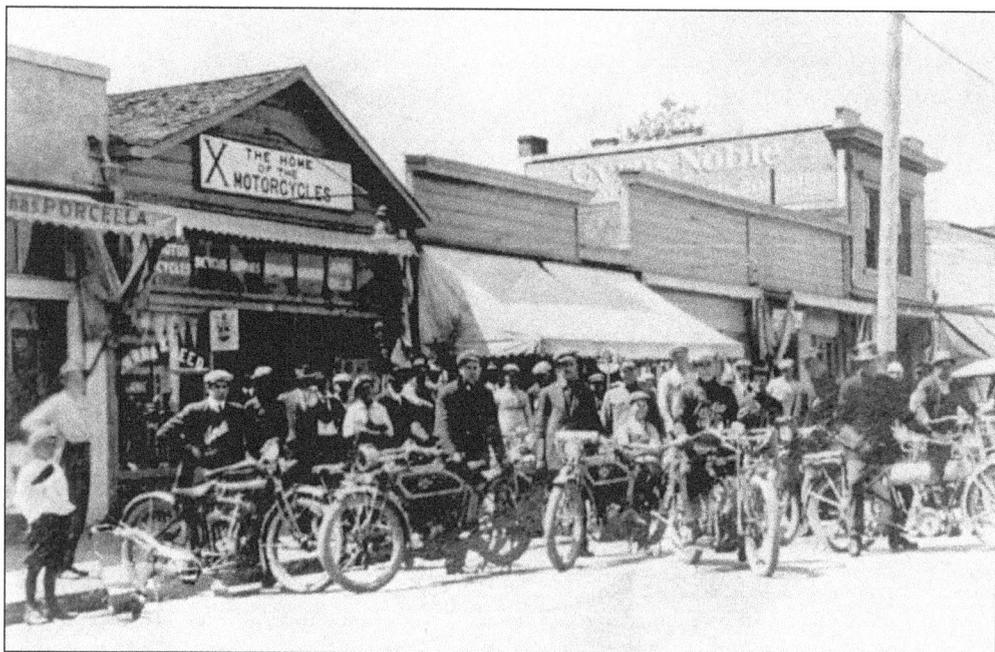

Motorcycles were all the rage by 1915, and the Parra and Reed Cyclery carried the latest models and also sold bicycles and parts. Perhaps Charles Porcella's clothiers, right next door, was where one could purchase the stylish caps many of these lads are sporting. (Courtesy Gilroy Museum.)

When nurse Mildred Hersman Quale came to Gilroy in 1925, Dr. Roland Prien approached her about establishing a local maternity home since the Private Hospital had closed. That next year she opened the Quale Maternity Home, which she operated for 15 years, caring for some elderly patients there as well. Nurse Quale assisted with over 200 births and then cared for patients at Wheeler Hospital for another 34 years. (Courtesy Gilroy Museum.)

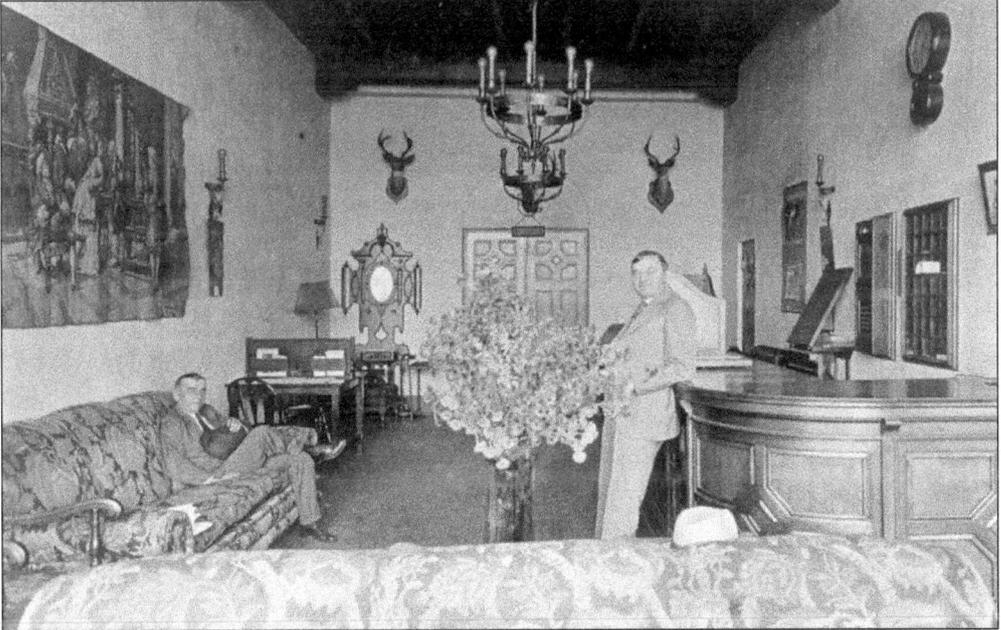

The Louis Hotel and Café, located between Sixth and Seventh on Monterey Street, opened in 1921. The lobby, pictured here, exhibits fine woodwork and upholstered furniture with an eclectic assortment of wall décor. There was a large room in back that many civic and social clubs utilized for meetings and private banquets over the years. Owner Louis Cupich is on the right. (Courtesy Gilroy Museum.)

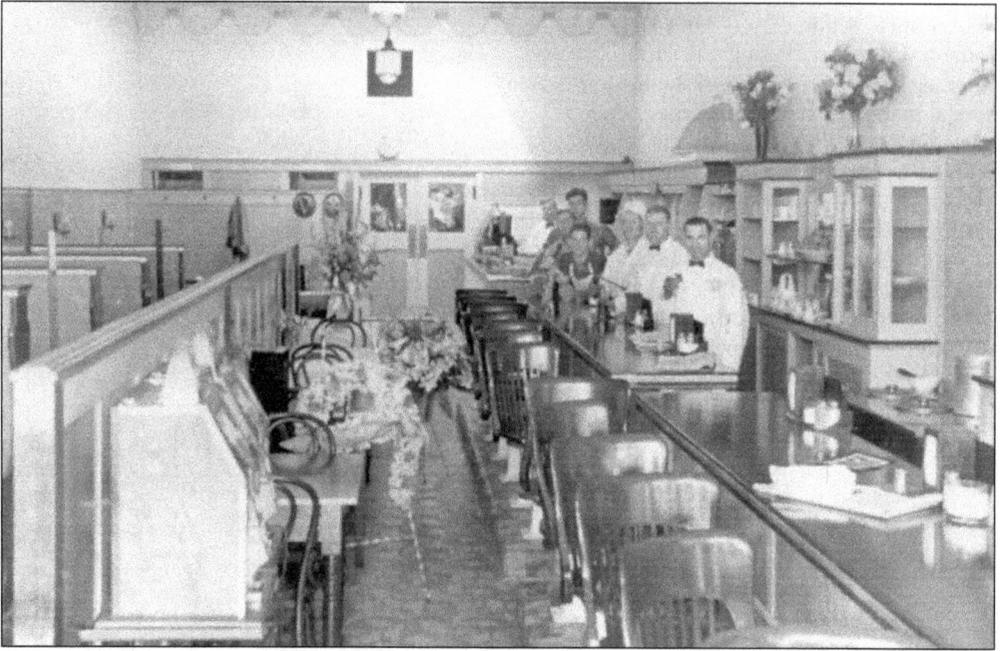

Frank Matulich owned and operated the Lily Café for many years in more than one downtown location. The café was a popular place to meet and eat whether for business or pleasure. Matulich is in front on the right in this, his second café. (Courtesy Gilroy Museum.)

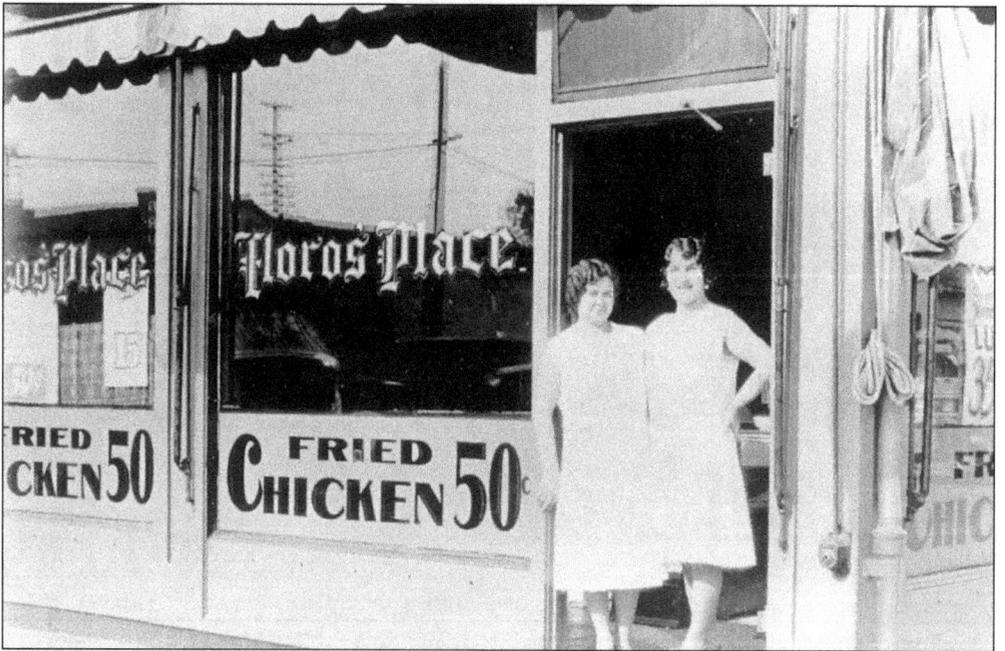

Floro's Place Café on the northeast corner of Martin and Monterey Streets was another favorite. Notice their sign, to the right, advertising a 35¢ lunch for merchants. Both Josephine Flores and waitress Bella Koulous, pictured here, c.1925, have mighty fetching bob cuts and finger-wave hairdos as well. (Courtesy Gilroy Museum.)

One of the hot entertainment spots of the Roaring Twenties was the Mill Road Park, a dance pavilion located off Bodfish Mill Road (later renamed Hecker Pass highway) about three miles west of town. Harry Learnard, son of Tracy of the Live Oak Creamery, established the facility. Learnard's broadcasting connections enabled him to book acts from San Francisco like The Three Boys, KGO live-radio regulars, advertised on this sign at the entrance. Businesses often used complimentary passes like the one here as sales promotions. During Prohibition, and because the park was outside the city limits, local officials weren't rigid about enforcing the no-alcohol law. Legend has it that on certain nights a fair amount of bootleg liquor was peddled in the pavilion's parking lot. (Courtesy Harry Learnard.)

DANCING

MILL ROAD PARK, GILROY

COMPLIMENTARY PASS

Saturday Night,, 193......

Signed, ..

Manager

Present at Box Office Federal Tax, 10%
 of Admission

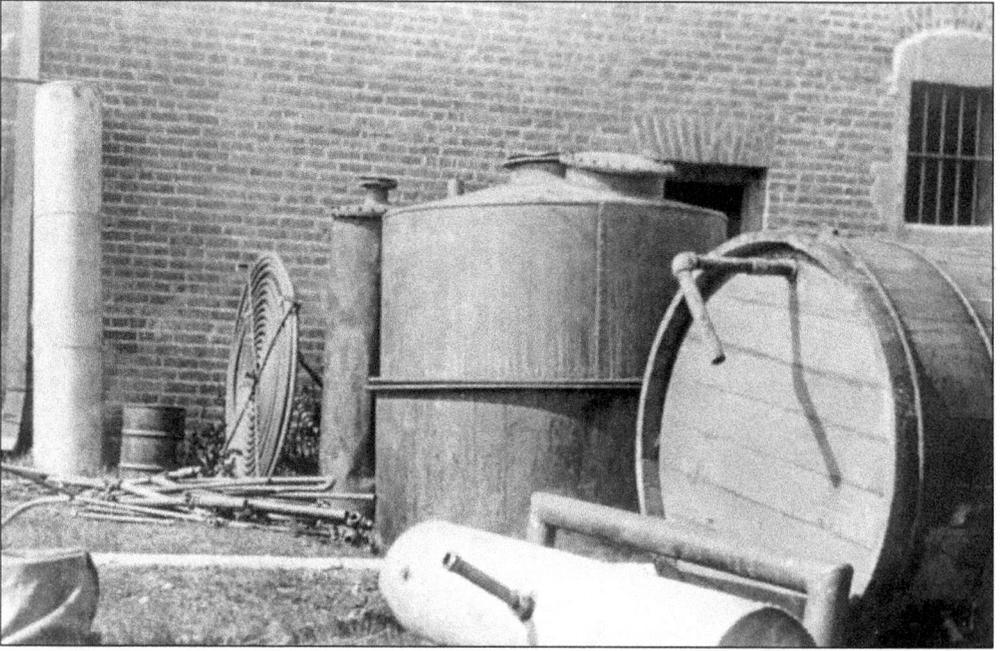

Where there's a will, there's a way. The Prohibition era's restrictions brought out the "creative" side of many an individual—and Gilroy was no exception. This large whiskey still, c. 1929, was seized in a raid by local officers and stored behind the jailhouse at the back of the City Hall until the case came to trial. (Courtesy Gilroy Museum.)

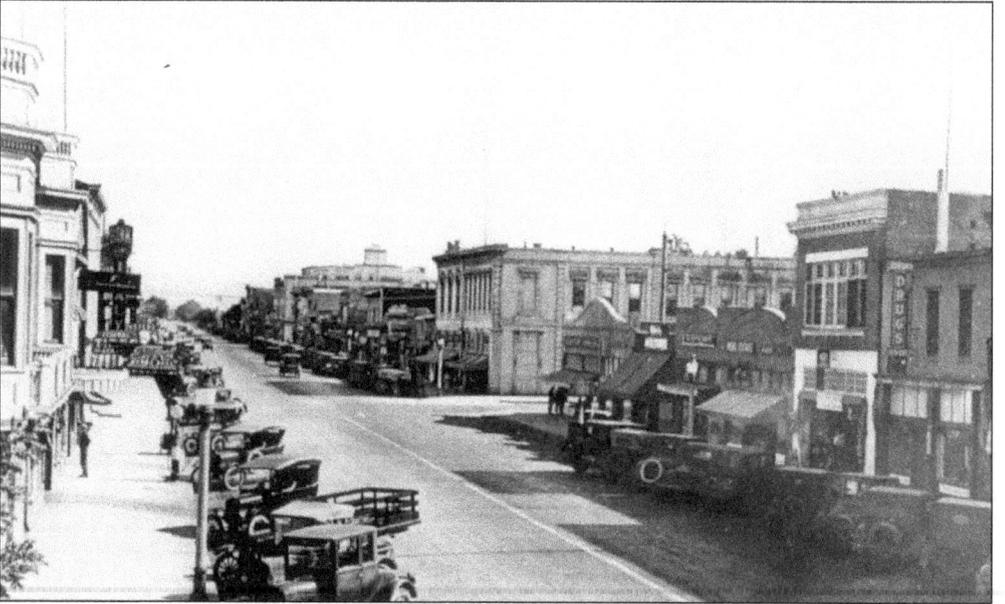

This photo was taken atop the entry arc of the Strand Theatre, looking south, c. 1923. By then diagonal parking had come to Gilroy's Monterey Street. (Courtesy Gilroy Museum.)

Members of the Kiwanis Club post their new meeting sign along the entrance to the downtown. Clockwise from left, are Ed Towner, Oliver Pierce, Maurice Byers, Harold Anderson, Pym Rhodes, and Irvin Hollister, c. 1940. (Courtesy Gilroy Museum.)

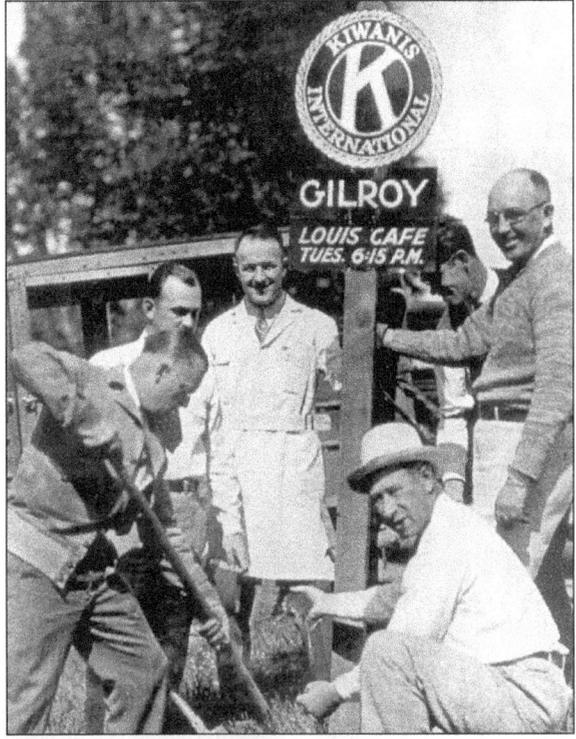

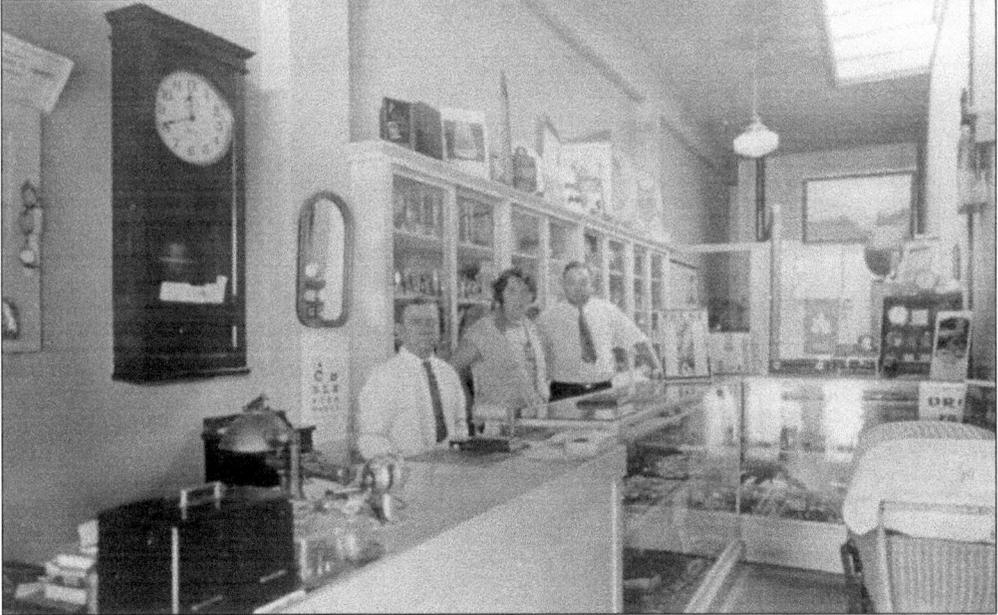

Lawton's Jewelers was a popular shop on Monterey Street for much of the 20th century. George L. Lawton, right, and his wife Betty, pictured here with employee W.B. Moran, sold a variety of fine jewelry, clocks, watches, and other gifts. Mr. Lawton was a skilled artisan who offered custom designs and engraving. Their son, Phil, in the baby carriage to the right, learned the business as well and made the tradition of Lawton excellence available to the community for many more years. (Courtesy Gilroy Museum.)

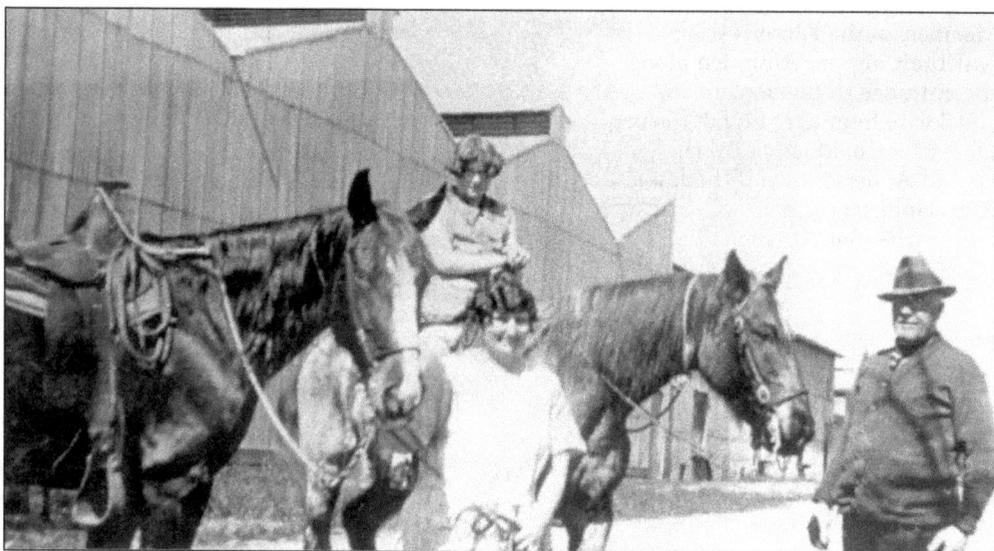

John E. White was another transported Englishman who endeared himself to Gilroyans for his many contributions to the community. Arriving in 1873 he first worked on the Ellis ranch. Later he learned cheese making as an employee of James Rea's dairy ranch and went on to be a cheese maker on the Doan ranch for 20 years. He was elected constable of Gilroy Township in 1898 and served nine straight terms. He was widely known all over California for his fairness in the job. His grandson, George White, was an exceptionally knowledgeable local historian. The Constable is pictured here with his daughter-in-law, Mrs. Walter White, and granddaughter, Grace. (Courtesy Gilroy Museum.)

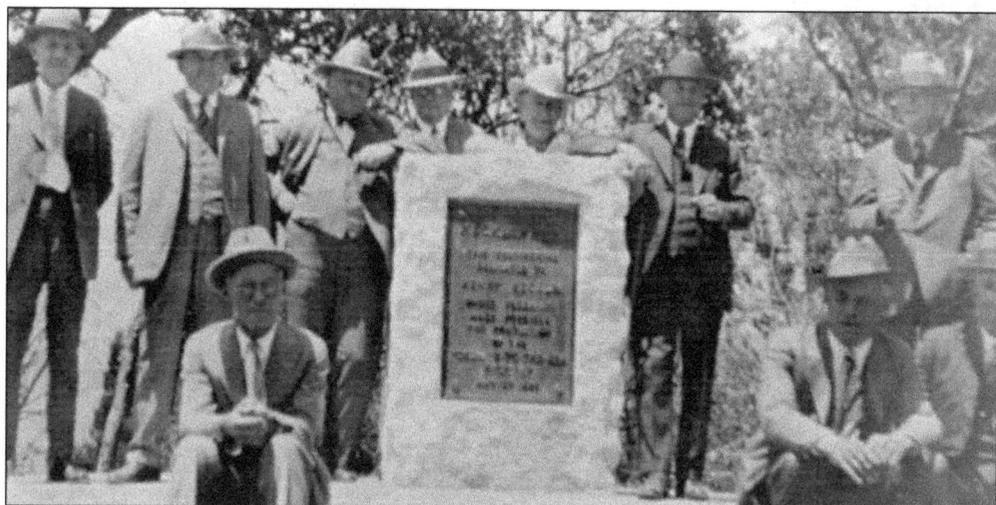

Henry Hecker arrived in Gilroy in 1883 at age 22. He owned a grocery store and also served as city treasurer. Later he was president of the Bank of Gilroy and was elected to the county Board of Supervisors. His main focus was improvement of the roads and bridges, most notably the road between Gilroy and Watsonville. When completed in 1928, it was named for him. Pictured at the dedication ceremony, left to right, are: (sitting) Joe Bordenave, Louie Sturla, and Nick Bordenave; (standing) Alfred Rea, Louis Cupich, Arnie Cox, Tracy Learnard, Alex Sturla, Walt Moore, and Henry Hecker. Hecker was also instrumental in the county's purchase of Henry Miller's Mount Madonna estate for use as a county park. (Courtesy Gilroy Museum.)

Perhaps on their way to a business luncheon are Hazel Martin, the *Evening Dispatch* Society Editor and Effie Weldon, owner of the Star Millinery and Juvenile Shop, *c.* 1929. (Courtesy Gilroy Museum.)

Enrico Conrotto's barbershop was on Monterey Street between Fourth and Fifth Streets. Here, *c.*1934, Enrico gives his brother, Giancinto, a haircut. (Courtesy Gilroy Museum.)

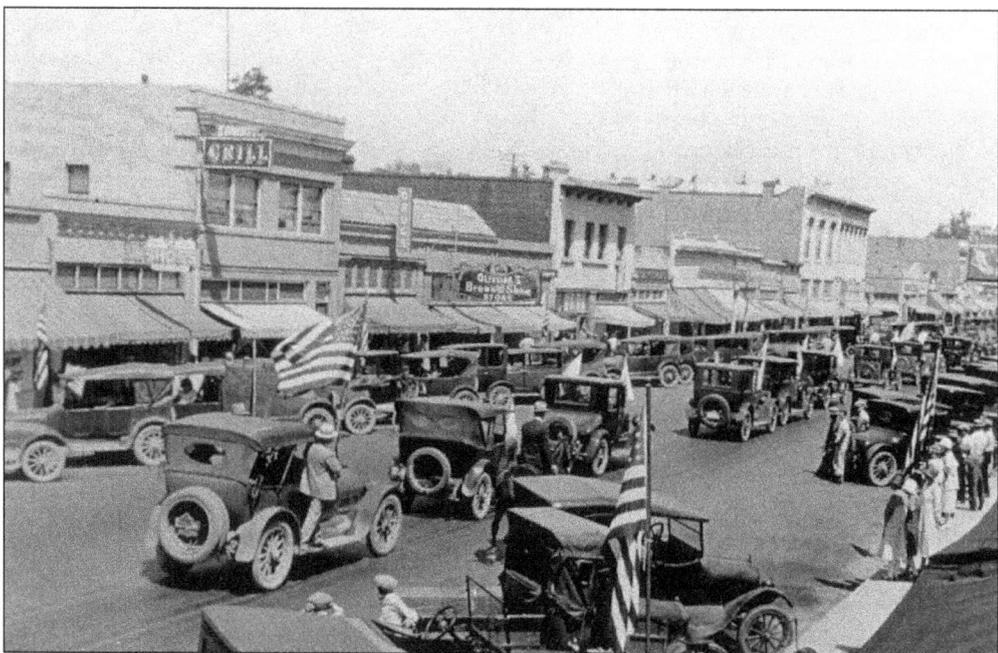

This Memorial Day observance, c. 1925, seems to have featured a new kind of unit. By then, most people had "motor cars," and here they are—on parade. (Courtesy Gilroy Museum.)

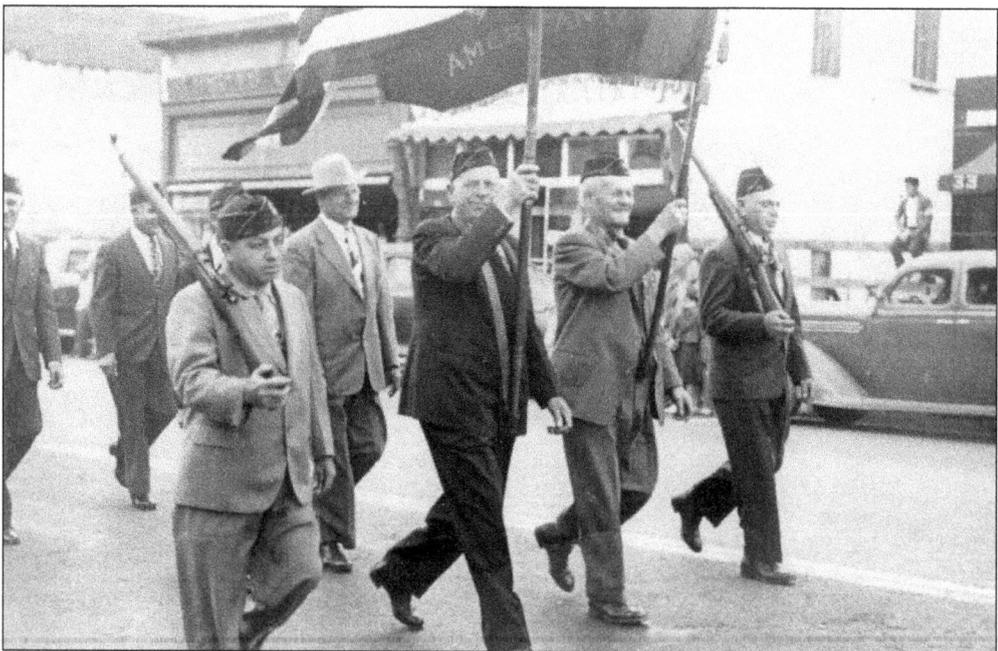

American Legion Post 217 members proudly participate—all in step—in a Memorial Day parade of the early 1940s. (Courtesy Gilroy Museum.)

Garlands made from fresh-cut redwood branches were strung from lampposts as downtown holiday decor for many years. Pictured Chamber of Commerce members, from left to right, are Irvin Hollister, Bill Blaettler, Dr. John Clark, Mayor James Princevalle (who served six consecutive terms), unidentified, and Linwood Wheeler. (Courtesy Gilroy Museum.)

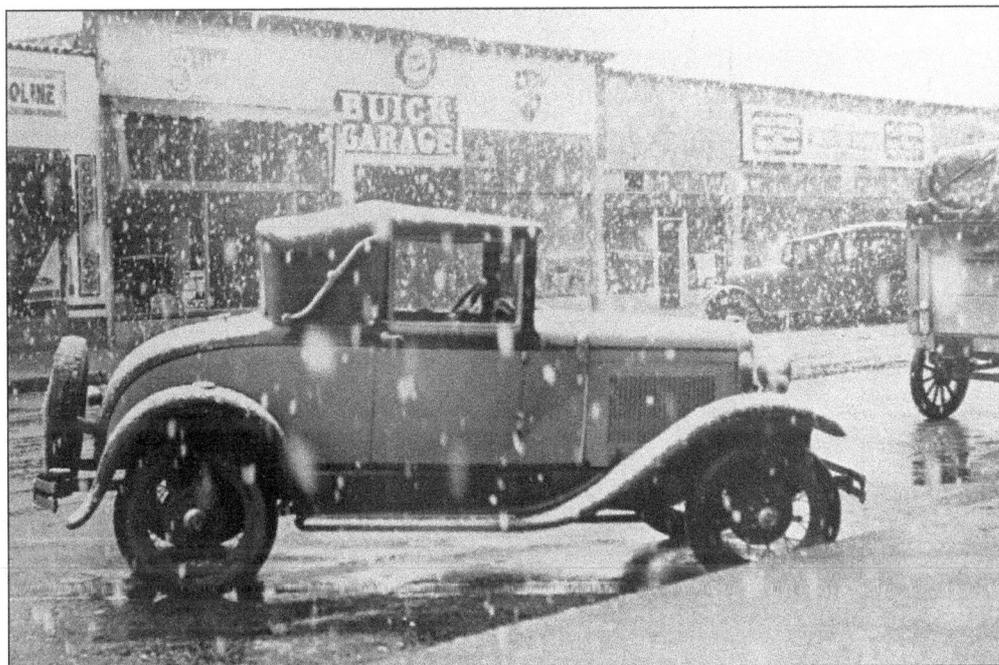

Snow—in Gilroy? Rarely, true. But every now and then it *does* happen. This snowfall along Monterey Street was recorded in 1932. (Courtesy Gilroy Museum.)

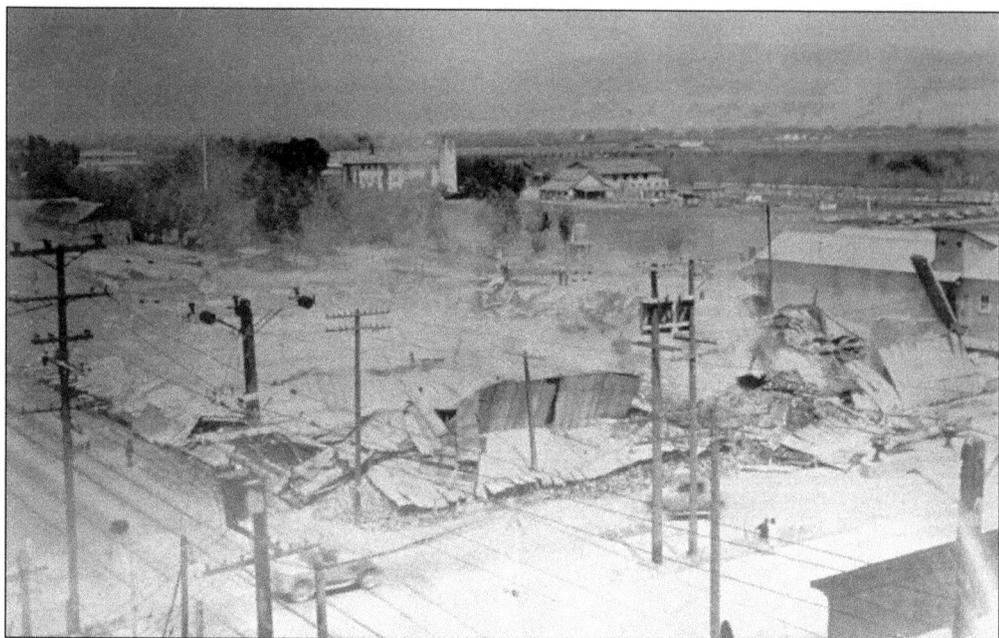

Not everything happening in and out of Gilroy was positive. In 1931, when the Depression had already made the economy so unstable, fire swept through the Filice & Perrelli cannery. The entire facility was destroyed, despite the valiant efforts of several fire-fighting units, and over 1,000 employees were left jobless until the company could rebuild. (Courtesy Gilroy Museum.)

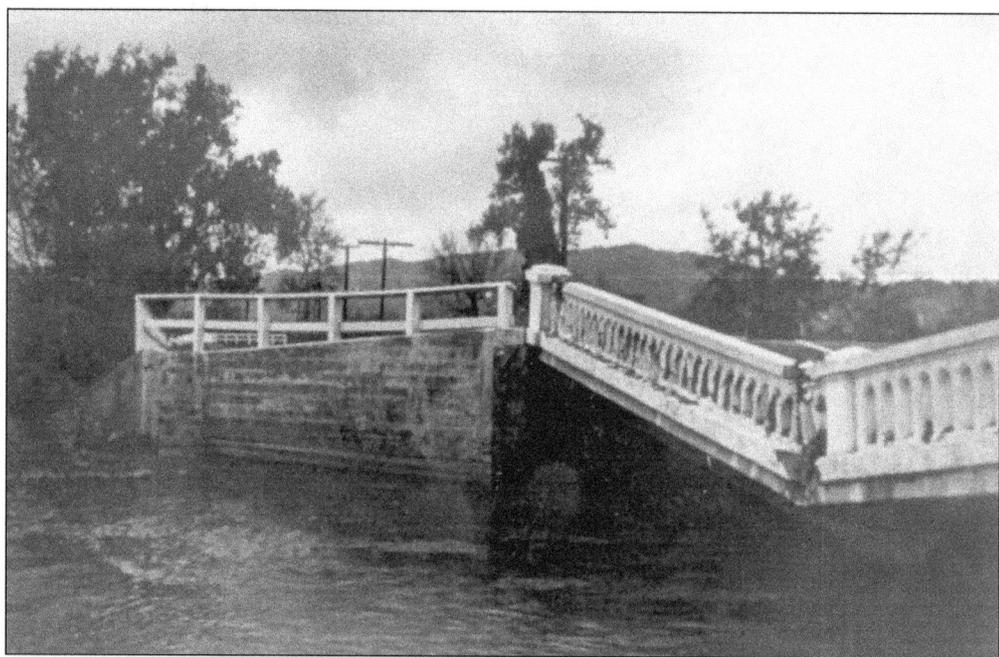

The opening of Hecker Pass highway between Gilroy and Watsonville in 1928 was a real boon for Gilroy. However, several severe winters in the next decade resulted in massive flooding of both the Uvas and Bodfish Creeks. The resultant collapse of one of the twin bridges put a real crimp in the "short drive over the hill." (Courtesy Gilroy Museum.)

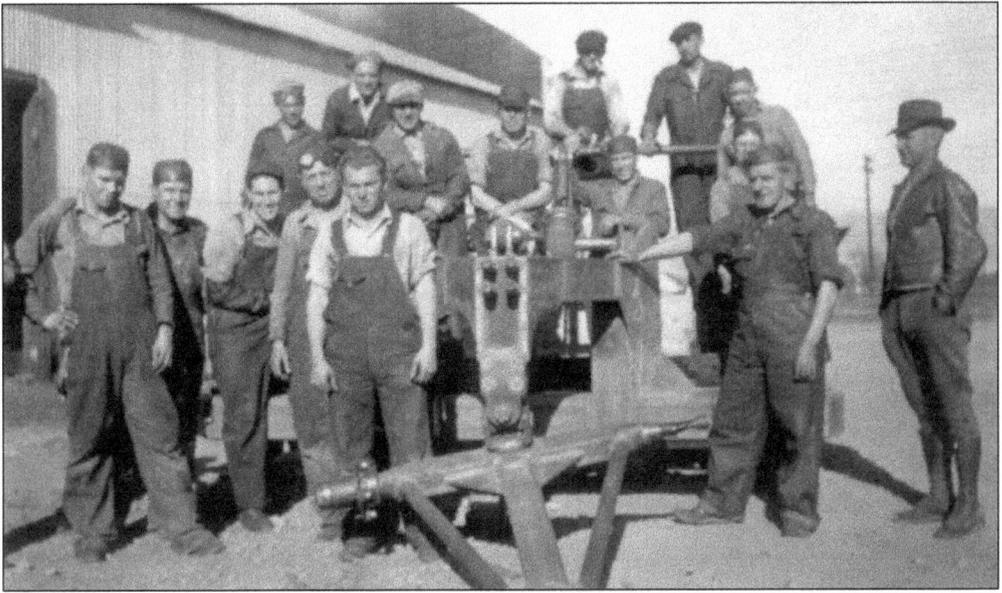

Another solid industry in town began as the Gilroy Welding and Machine Shop, owned by J.A. Bussert and Henry D. Peters. Albert Gurries bought out Peters, and the new partners changed their business name to Be-Ge Manufacturing Company. Mr. Gurries developed a hydraulic pump and they made earthmovers, land scrapers, and levelers and loaders that utilized Gurries' pump. During WWII Be-Ge built ship engine parts and 76 mm guns. After they sold out in 1952, Gurries went into real estate development and was also very active in civic affairs. Be-Ge employees are pictured in 1937 at the plant near Leavesley and Monterey Streets. (Courtesy the Alfred Tomey collection.)

The Byers Brothers enterprise was a busy one, handling the sales of Associated gas and oil and also serving as a Ford/Lincoln dealership. Pictured, from left to right, are Ray Brown, Justin Byers, Maurice Byers, and Junior Wilson, c. 1940. (Courtesy Gilroy Museum.)

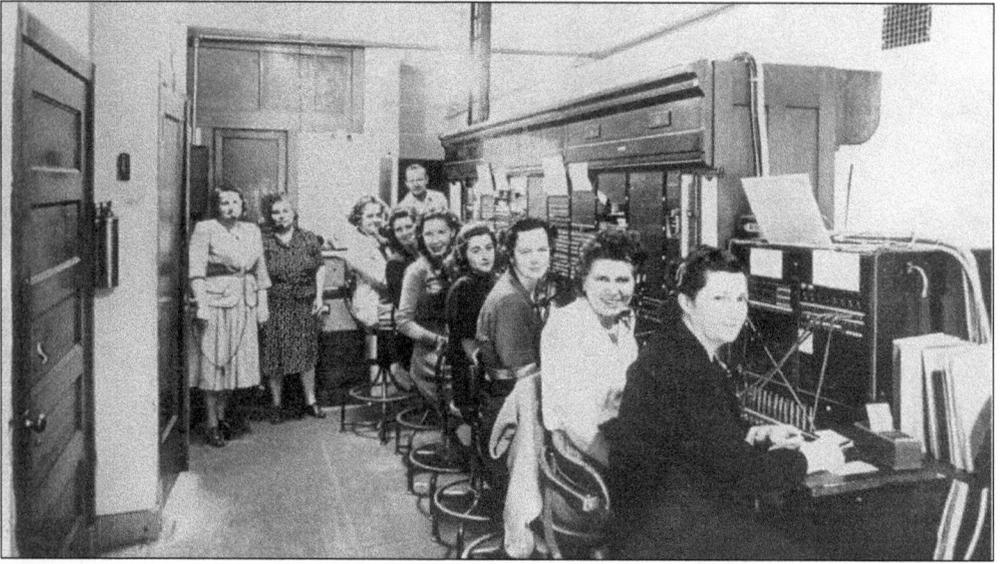

"What's the buzz?" From their second-story office on Monterey Street between Fourth and Fifth Streets, these Gilroy Telephone Company operators kept the townspeople connected by way of their switchboard during the 1940s. Pictured, from left to right, are: (standing) Fanny Holloway and Maud Miller, (sitting) Florence Miller, Minerva Brock, Claudine Davis, Lena Castro, Loretta Gwinn, Alice Rossi, and Eunice Curtis. Baldwin Peterson, switchman, stands in far rear. (Courtesy Gilroy Museum.)

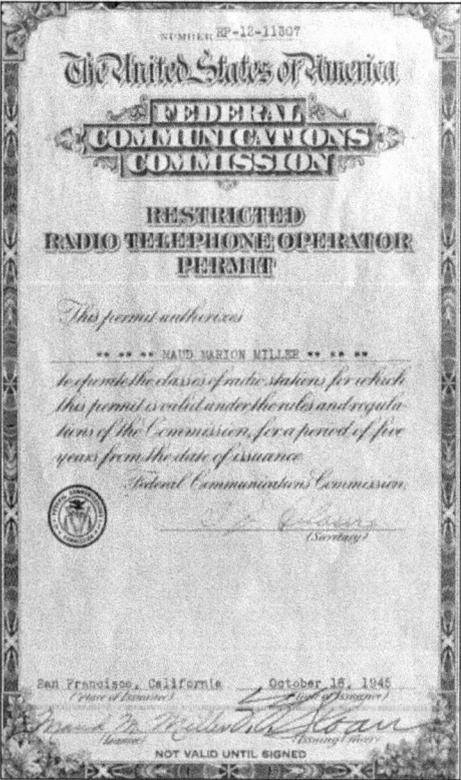

The telephone operators went through extensive training and earned FCC permits that were renewable every five years as indicated on Maud Miller's 1945 paperwork pictured here. (Courtesy Gilroy Museum.)

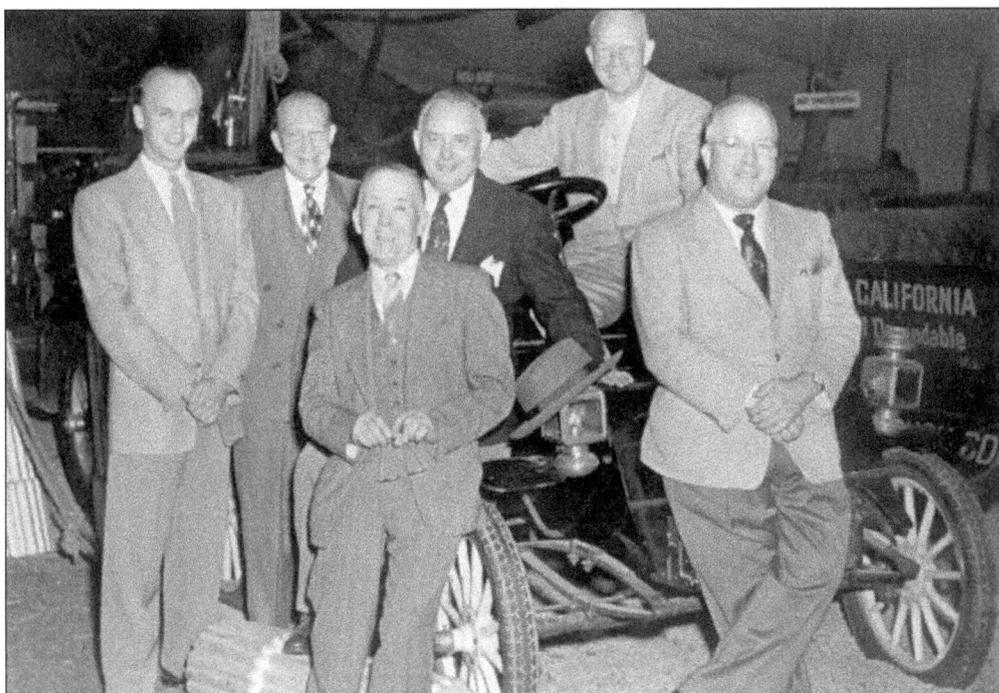

If you need to buy a new vehicle in Santa Clara County, our local dealerships' motto likely rings in your ears: "Drive a little and save a lot in the friendly town of Gilroy." Here, c. 1950, this gathering of auto row dealers, from left to right, includes Jack Ronald (whose daughter, Elizabeth Barratt, writes a fine local history column for *The Pinnacle*), Whitey Ackerson, Bill Wirthrich, Larry Larsen, Justin Byers, and Ken Graves. (Courtesy Gilroy Museum.)

Highway 101 went right through the middle of Gilroy until the bypass was completed in the early 1980s. So to be out cruising on Monterey Street, day or night in the 1950s, was to be where it was all happening. (Courtesy Gilroy Museum.)

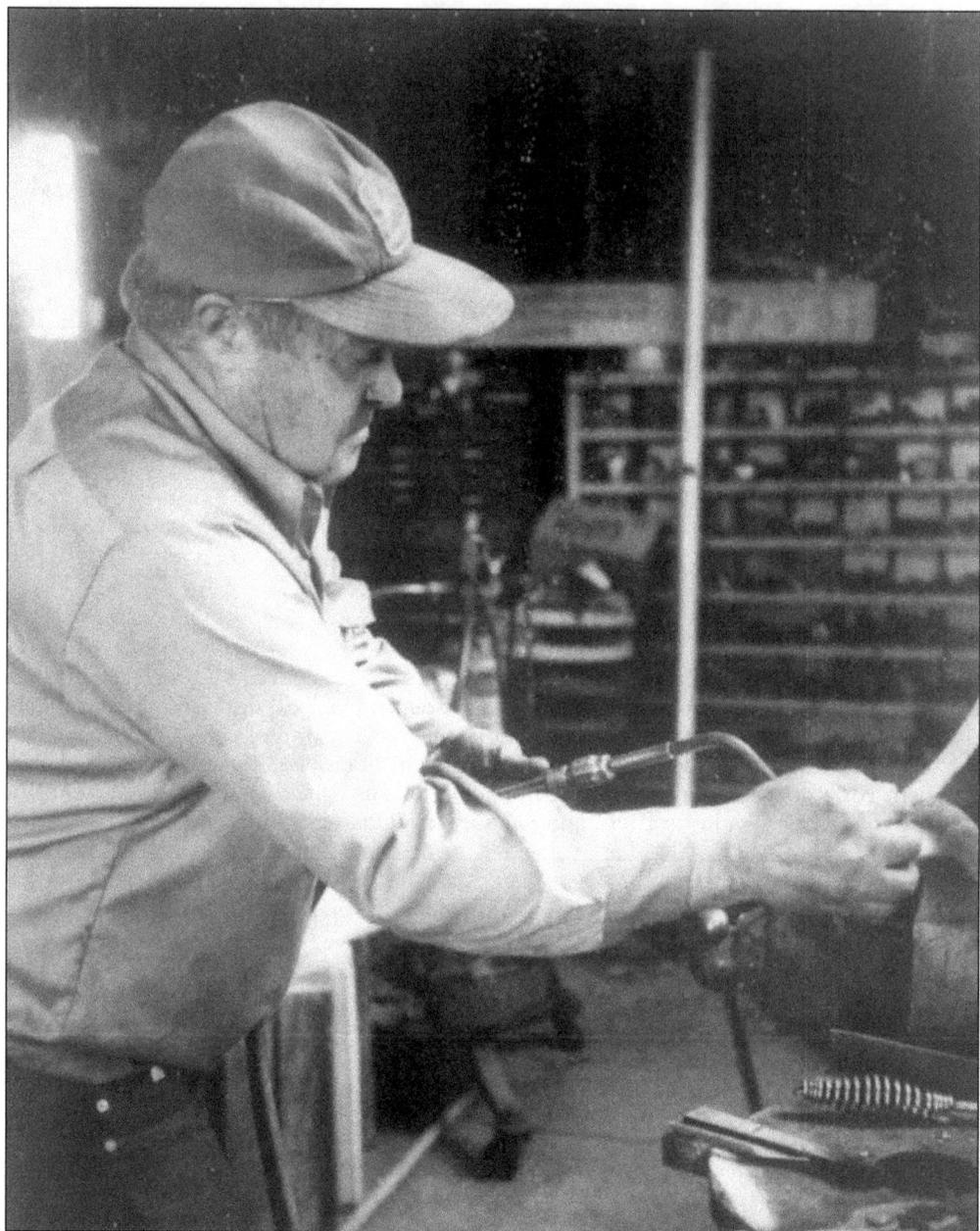

Alfred Tomey, pictured here shortly before his death in 1977, was known for his exceptional fabrication skills and, at that time, was one of a handful of remaining blacksmiths in Gilroy. Semi-retired by then, he was still making branding irons for cattle ranchers in the area or fashioning replacement parts for farm machinery. Early in his career, Tomey worked for the Southern Pacific Railroad where he enhanced the welding skills he'd learned in his high school shop classes. He spent 24 years with Be-Ge Manufacturing (he's the second from left in the picture on page 101), and was a foreman for 12 years. Clearly, his design skills were passed down to his daughter, Carol Peters, who spent her educational career teaching drawing and painting to thousands of Gilroy High School students and who did much of the special artwork for this book. (Courtesy *The Dispatch*.)

Nine

BUILDING
COMMUNITY SPIRIT

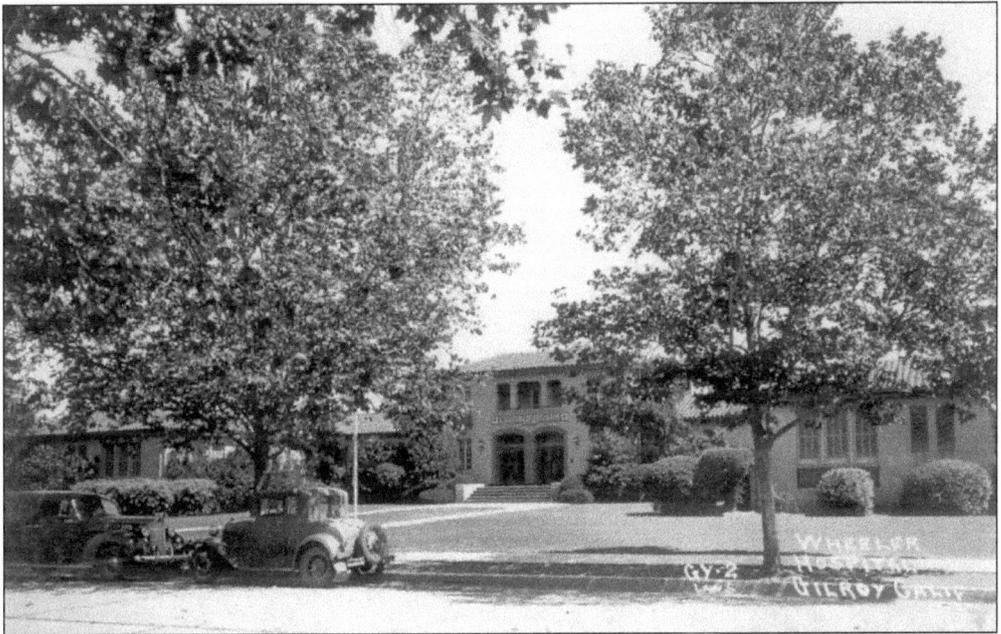

A panoply of people and events have built Gilroy's civic pride. This chapter will commence with remembering an individual whose generous early 20th century contributions set a precedent. When Dr. Clark's small hospital closed in the early 1920s, Gilroy's need for an acute-care facility was a pressing concern. Numerous medical personnel had lobbied for the cause, and fundraisers were many, but it was Linwood Wheeler who supplied the last of the monetary momentum needed to make it happen. Wheeler Hospital, pictured here, opened its doors in 1929. Mr. Wheeler's fine black sedan is pictured in the left foreground—there was such regard for Mr. Wheeler around town that the local authorities let him park with impunity in whichever direction he chose. (Courtesy Al Gagliardi.)

Philanthropist Linwood Wheeler was born in New York, learned the seed business in the Chicago area, and came west in 1907. In addition to his Pieters-Wheeler seed enterprise, he served as president of the Chamber of Commerce and was a charter member of the Elks Lodge. He donated funds for the purchase of city fire equipment and for the construction of a civic auditorium at Sixth and Church Streets, which is named in his honor. Mr. and Mrs. Wheeler were tragically lost in an auto accident in 1944. Although he shunned recognition, after his passing many small-business owners shared that Wheeler, without solicitation, had quietly subsidized them during the Depression years, keeping their enterprises afloat until the economy improved. (Courtesy Gilroy Museum.)

The Gymkhana came to life in 1929, thanks to George C. Milias. The event paid tribute to the city's ranch-life beginnings, and it brought the community together. Based on a Wild West theme, Gymkhana Days featured a marvelous parade and a full-fledged rodeo. (Courtesy Gilroy Museum.)

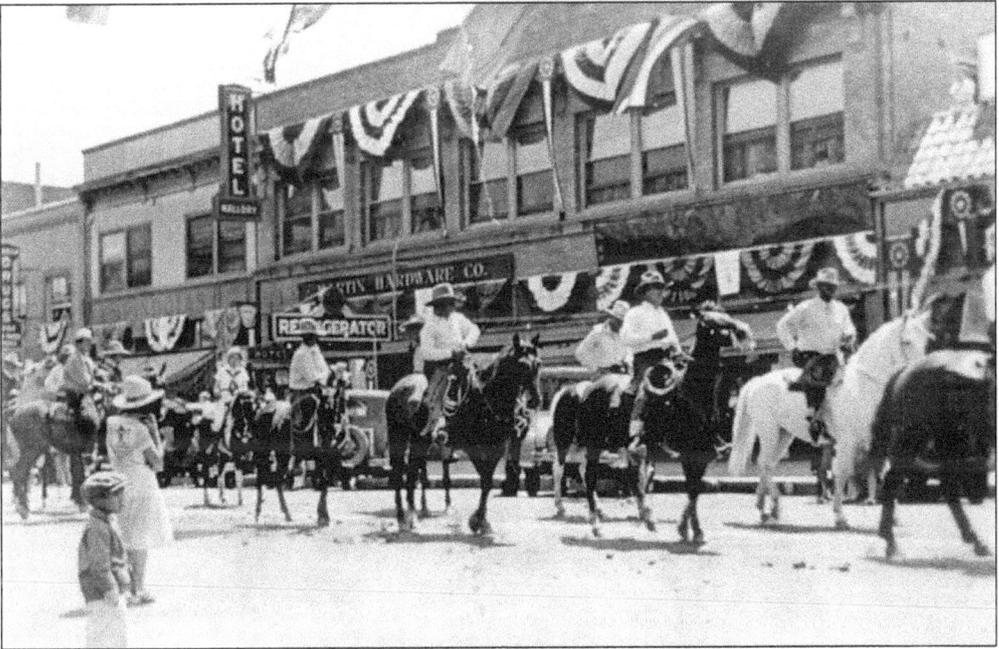

Horses participated in abundance, and, as can be seen in this photo of the 1937 parade, the natural result of that was considerable fallout. However, the annual two-day celebration so enriched the city's coffers that the additional work for the street-sweeping department was considered worth it. (Courtesy Gilroy Museum.)

The Gymkhana Song
(Lyrics by Vivian Moore Barshinger Head)

There's a town at the end of the valley
Where the sun shines so brightly all day.
And the folks are so friendly and jolly,
That they drive all your troubles away.

Oh each year there they have a Gymkhana,
And the folks come from miles all around
For there's ridin' and ropin' and dancin'
Down in Gilroy, the Gymkhana town.

Just to be once again in that valley,
Where the prunes and the apricots grow,
Where the blue hills are softened by shadows
And the cool ocean breeze lightly blows.

Get your chaps and your saddle and blanket,
For you'll soon be a ridin' along.
When it's Gymkhana time down in Gilroy,
That's the place where the cowboy belongs.

Vivian Moore Barshinger Head, mentioned earlier, was born in Gilroy in 1892 and was a music teacher in the Gilroy schools for 28 years. In the early 1930s she wrote these lyrics (to the tune of another famous cowboy song about a valley) and for years, in the weeks prior to the event, the children sang this song to rustle up their Gymkhana spirit. (Artwork by Carol Peters.)

The community got into the Gymkhana spirit many days before the weekend event as evidenced by these Bank of America employees, c. 1939, who donned their denims. Showing their Wild West spirit from left to right, are: (front row) Manager Jack Fabbri, Elmer Steinmetz, unidentified, Lucille Martin, Vic Monino, Eddie Weicander, Duncan Harrison, and Eddie Masini; (back row) Jack Clark and Ken Peterson.

Gilroy's Gymkhana was well known up and down the coast, its events a delight to spectators of all ages. Here, in the fresh-flower tradition of Pasadena's famous New Year's parade, a float makes its way down Monterey Street in the late 1940s. (Courtesy Gilroy Museum.)

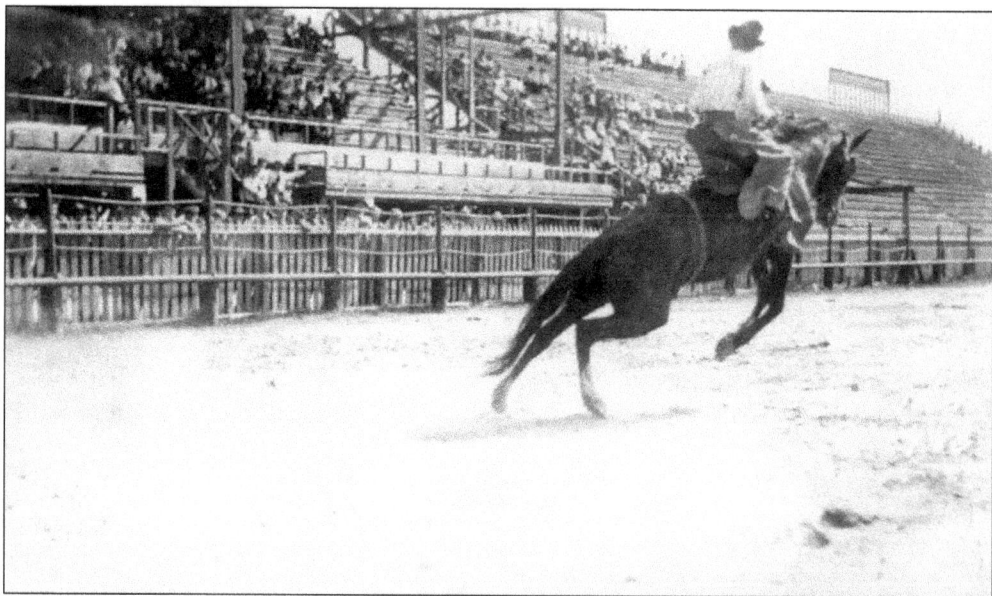

The land for the rodeo grounds was near the Pieters-Wheeler seed company, east of the railroad tracks and about a block south of Leavesley Road. Lin Wheeler gave the city use of the land for this event and provided bleachers that could seat 5,000 onlookers. Here a bronco rider entertains the crowd in 1935. (Courtesy the Alfred Tomey collection.)

110

In the spirit of good fun a hoosegow was set up along Monterey Street on Gymkhana weekend for the purpose of incarcerating those guilty of not wearing western garb. This little cowboy must have slipped through the bars just for the novelty of it. (Courtesy Gilroy Museum.)

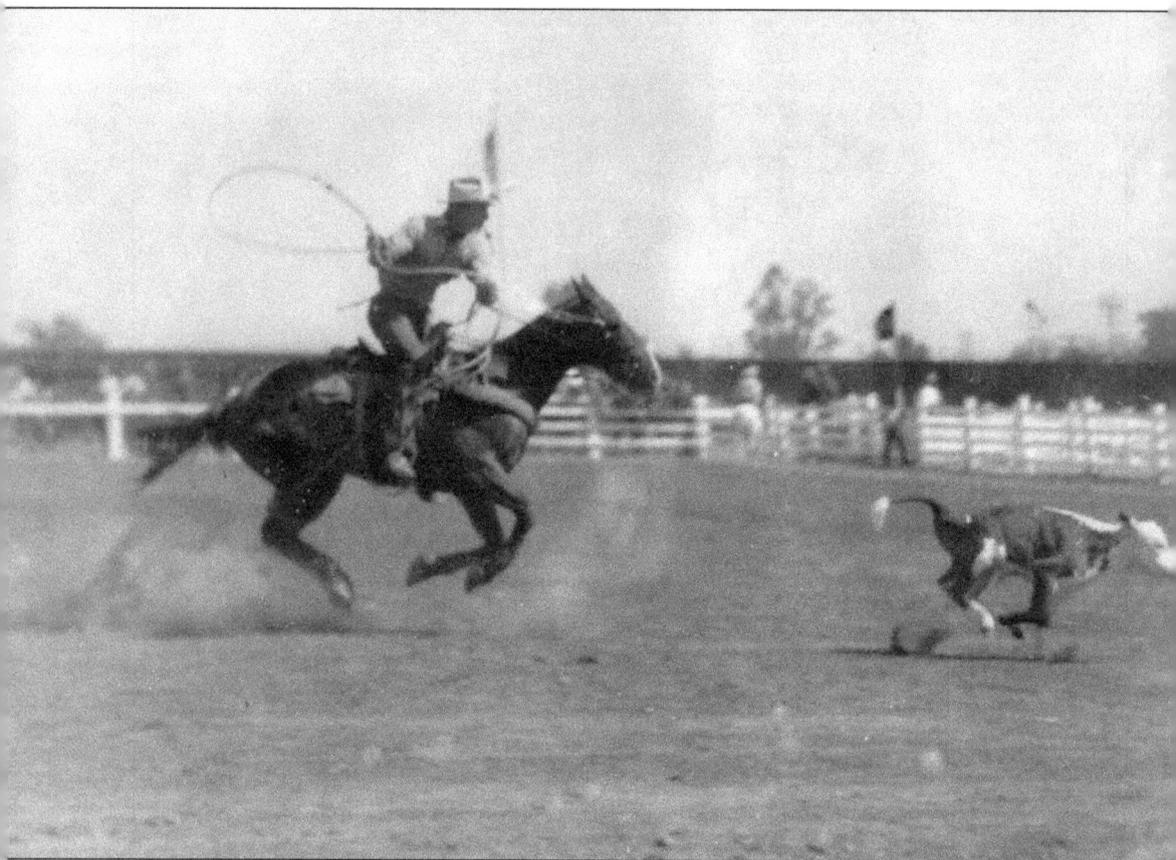

As a well-respected cattleman, George C. Milias made an ideal president and manager of the Gymkhana because he was networked with other big ranchers who traveled the state and chose his hotel as their stopping place. The result was that Gilroy's event drew entrants for both the parade and rodeo from all the western states. Here, cowboy Budd Rogerts moves in on a little dogie during the calf-roping event, *c.* late 1930s. (Courtesy the Alfred Tomey collection.)

Mrs. Lee Berta created another dynamic group, which generated tremendous civic pride in the mid 20th century—a precision drill team known as Las Senoritas. This 20-member troupe and their director spent countless hours practicing choreographed routines and competed all across the country. Berta's scrapbook contains numerous heart-warming telegrams from local citizens sent to these young women while they were on the road and winning many a trophy as they represented Gilroy. In this photo, c. 1958, Lee Berta pictured center, is flanked by her outstanding team. (Courtesy Gilroy Museum.)

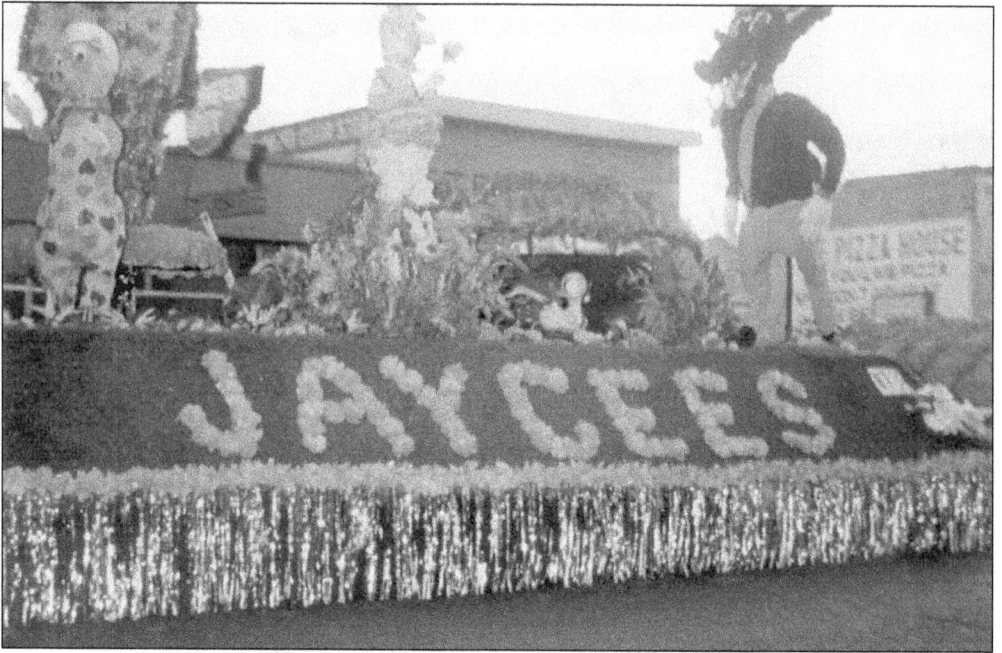

The last Gymkhana was held in 1956, followed by a long period with no unifying community events. In 1966, Lee Berta had a new idea, and with George Milias's help and an enthusiastic committee, Bonanza Days debuted in 1967. There was no rodeo, but like its predecessor, the spectacular parade each year drew entries from all over the state. Floats, such as this one from 1972, were fabulous in their design and in their meticulous, often humorous, detail. (Courtesy Gilroy Museum.)

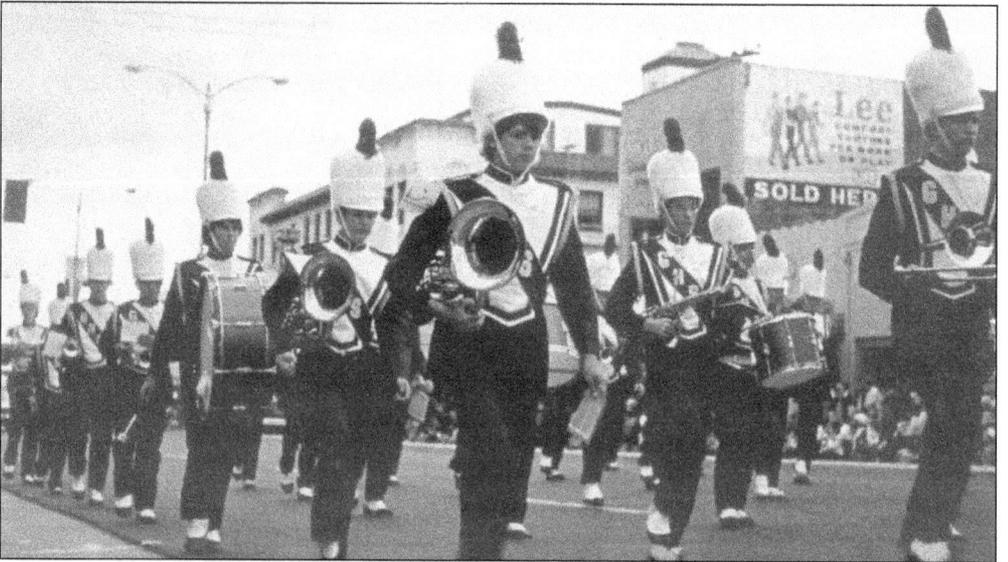

Marching bands from near and far looked forward to participating in the Bonanza Days parade. In the early years it was a nighttime gala, but once traffic patterns on Monterey Street were altered, the parade became a daytime event on First Street. Pictured here are members of the 1973 Gilroy High Marching Band. (Courtesy Gilroy Museum.)

114

Gilroy gratefully recognizes those who made successes of the Gymkhana and Bonanza Days events and demonstrated that boundless benefits result when the volunteer spirit of a community is tapped. This notion is a guiding principle of the Gilroy Garlic Festival. The co-founders, pictured from left to right, are Don Christopher, Dr. Rudy Melone, and Val Filice. Having read about an annual tribute to garlic in Arleux, France, Dr. Melone, then president of our Gavilan Community College, wrote Arleux's mayor to ask about their organization. Gloria Melone recalls that Rudy received a very gracious reply. In 1978, the three men spearheaded a tribute to garlic at a Rotary Club luncheon, held at Christopher's ranch and utilizing Filice's talents as a chef. The celebration blossomed into the first festival the following year. After expenses, each year's profits go to build community programs—charities, schools, civic clubs, recreation programs, churches, etc. as volunteers designate their donated hours for specific causes. (Courtesy Bill Strange and Gilroy Garlic Festival Association.)

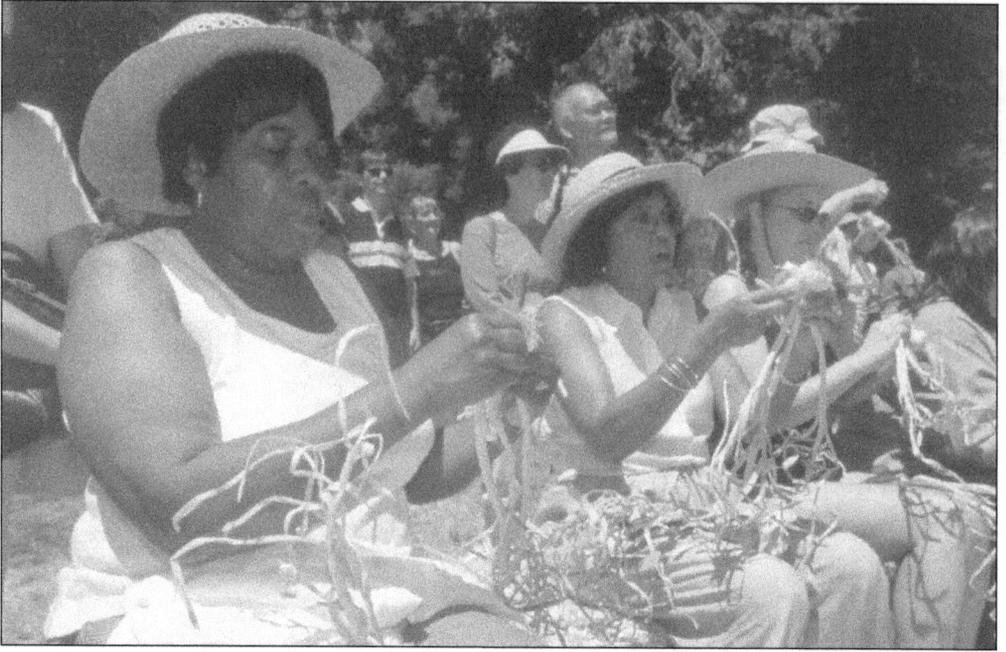

The festival moved to the city's Christmas Hill Park the next year, and there it has stayed with garlic, garlic everywhere. For guests interested in learning how to make their own garlic braids, there are mini-workshops that include the kind of hands-on practice session pictured here. (Courtesy Bill Strange & Gilroy Garlic Festival Association.)

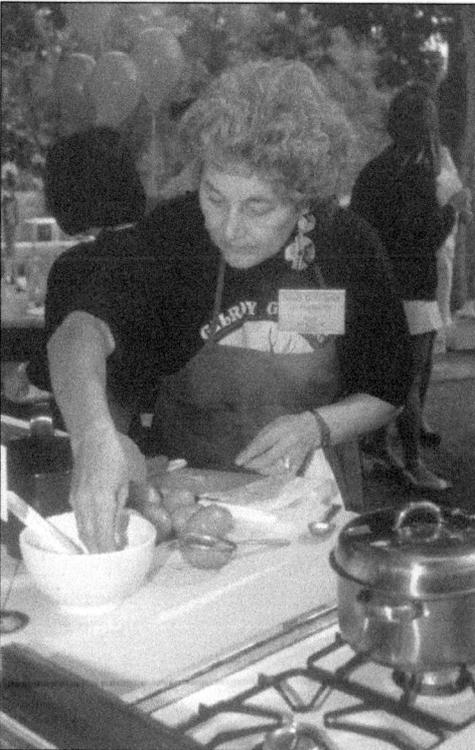

The Festival's "Cook-off" competition brings fabulous chefs to town from around the world. Here a finalist prepares her dish for the judges, featuring fresh tomatoes and, among other ingredients, a generous amount of garlic—the magic in every entry. (Courtesy Bill Strange and Gilroy Garlic Festival Association.)

Organizers realized early on that the festival had potential as a springboard for cultural and educational exchanges. In 1981, an article about our event appeared in the local paper in Monticelli D'Ongina, a small "garlic city" in northern Italy. Their city officials contacted our Chamber of Commerce about becoming sister cities. Some months later, Melone, serving as our ambassador, traveled there. Pictured here, Dr. Melone, right, shakes hands with Monticelli's mayor after presenting the sister-cities charter, shown center, to the city's officials. (Photo courtesy the late Dr. Rudy Melone; artwork by Carol Peters.)

The sister-city concept stretched across the Pacific as well as the Atlantic when Takko-Machi, Japan, another garlic producing area, formed this type of bond with Gilroy. Pictured here at the 1992 festival are Mr. Garlic, Gerry Foisy, Takko's Garlic Lady, and a city official of Takko. (Courtesy Bill Strange and Gilroy Garlic Festival Association.)

Another festival tradition is the amphitheater appearance of the Bay Area's own "SHA-BOOM," whose members specialize not only in Oldies music but in the moves of those tunes. Here two band members get the crowd to join them doing the Jerk—and there's the Twist, the Swim, and the crazy Hand-Jive too. (Courtesy Bill Strange and Gilroy Garlic Festival Association.)

118

A central feature of the annual festival is Gourmet Alley, where many mouth-watering, garlicky dishes are prepared for visitors. A crowd gathers every time one of the volunteer chefs handles a calamari flame-up. (Courtesy Bill Strange and Gilroy Garlic Festival Association.)

After the flames calmed down, the 2001 Garlic Festival queen, Lindsay Smith, took a turn at stirring the tantalizing calamari. To her left is Princess Melissa Noto, queen for 2003. During their year-long reign, the young women of the Garlic Festival Court have numerous opportunities to represent our community at a variety of events, sometimes over seas. (Courtesy Bill Strange and Gilroy Garlic Festival Association.)

It's an unofficial requirement that Garlic Festival attendees bring their appetites with them. The family pictured here enjoy another of Gourmet Alley's specialties, pasta con pesto. (Courtesy Bill Strange and Gilroy Garlic Festival Association.)

Ten

PRESERVING OUR PAST

Carl Bolfing has a bird's eye view of the downtown area in more ways than one. Largely due to his efforts, the Gilroy Historical Society was founded in 1966. One of its first aims was to preserve Old City Hall. In 1965, when the city government had vacated this facility, the building was slated for demolition to create a parking lot. Another who spoke eloquently on the building's behalf was Society member George Porcella, son of Charles Porcella. This landmark, believed to be the only building left in the state with the classification "early American with Flemish influence," was spared. As for the stuffed owl, it was hoped he would discourage the pigeons from using the building's rooftop as a launch pad. (Courtesy Gilroy Museum.)

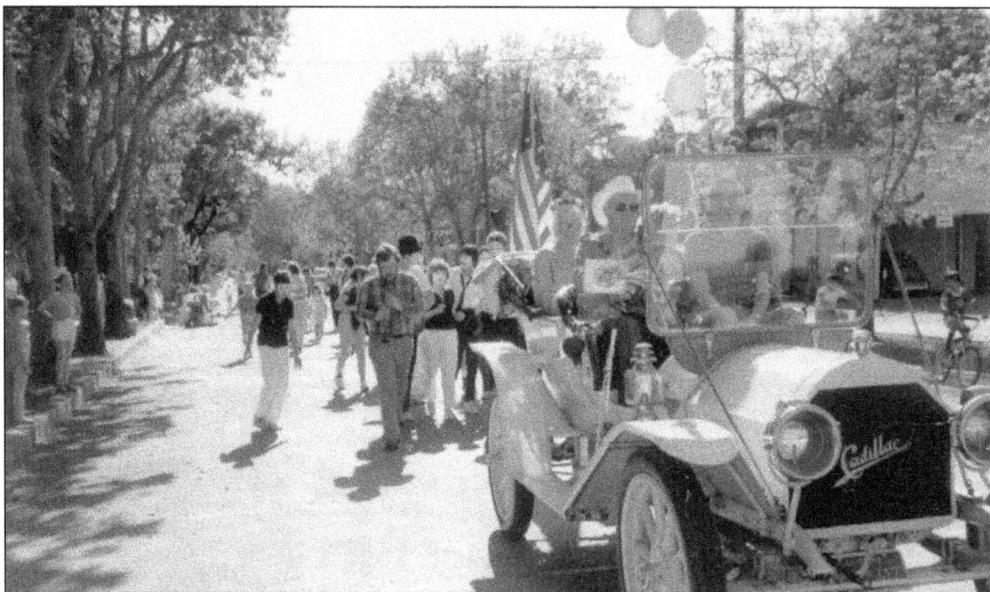

By 1985 there had been many more ups and downs concerning Old City Hall. A new committee chaired by Dr. James Williams, then of Gavilan College, was formed to work closely with the city on preserving the building. The committee held a ceremony on April 27th to declare their dedication to this task. Pictured in the foreground of the parade portion of that event is Bill Kuring, driving his antique Cadillac, with Councilman Jack Pate beside him. In the backseat, left, is Mary Prien, longtime director of the Gilroy Museum, and, at right, Sue Pate. Following the car is city planner Chuck Myer on clarinet, accompanied by members of the Gilroy High School mime troupe. (Courtesy Chuck Myer.)

Our 1918 train depot, pictured here c. 1980, was a much grander facility than its predecessor, and in true Gilroy style its opening was greeted with considerable fanfare. The depot served the city well for much of the 20th century, but when passenger service was cancelled in the late 1970s, the once-pristine building fell into disrepair. Commuter service finally began anew in 1992 after considerable pressure from several local groups, and in the late 1990s, as part of a lease agreement with the Valley Transportation Authority, the city funded the restoration of the facility. (Courtesy Kai Lai.)

122

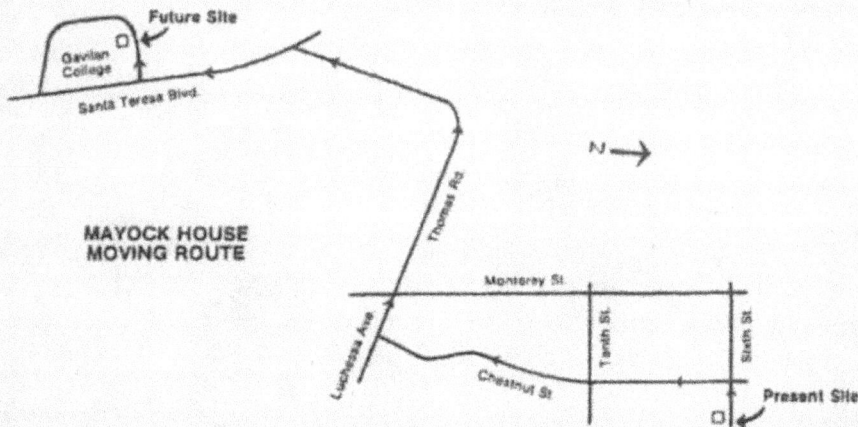

The Gilroy Historical
Society Presents

A HOUSE MOVING EXPERIENCE

What an exciting opportunity! The historic "Mayock House" located at the east end of Sixth Street has been made available to the Gilroy Historical Society for relocation and rehabilitation! We would like to move the house to a new site at Gavilan College, which is donating a site, and we need your help.

We need money for moving costs and are now accepting private and commercial donations! Join the Gavilan Faculty Association, California State Office of Historic Preservation, and the Garlic Festival Committee in this marvelous effort to preserve the historic "Mayock House."

JOIN OUR "BUY A FOOT OF HISTORY" CAMPAIGN!

To move the Mayock House 15,000 feet, we're selling these historical feet at $1.00 each. Buy as many as you can—there's NO LIMIT!

MAYOCK HOUSE MOVING ROUTE

The Michael Mayock family came west from Georgia in 1874. Mayock, who worked for Miller & Lux, purchased acreage on Sixth Street, east of town, and with help from his four sons constructed this home in 1886. Son Henry had the Fashion Stables in town and operated one of the stage lines to the Hot Springs Hotel. Son Ephraim "Stoney" Stonewall was a salesman, a barber, postmaster, and proprietor of the Central Hotel for 15 years. Son Levi was a successful cattleman, and son Robert served as manager of Henry Hecker's general store for many years. There was too much history here for the wrecking ball. (Artwork by Robin McGinnis.)

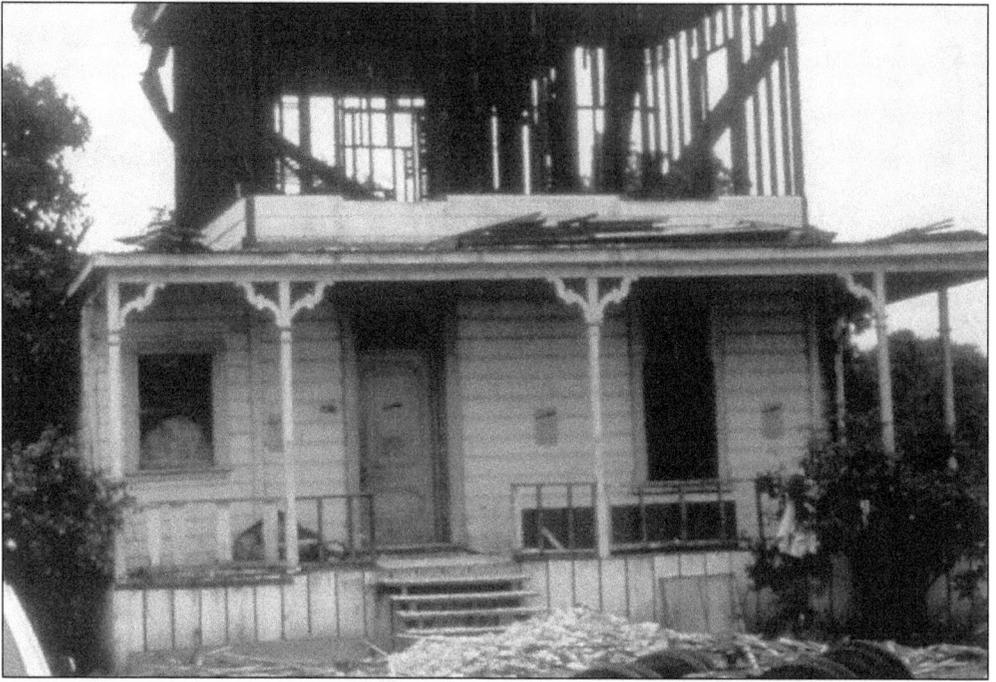

Early on the morning of June 12, 1982, a team of volunteers began to carefully dismantle the second story of the Mayock House, labeling each local redwood board as it was removed. When this photo was taken late that afternoon, only the skeleton of the upstairs area remained; these timbers were removed the following morning before the movers conveyed the building to its new site on the Gavilan College campus. (Courtesy Patricia Baldwin Escamilla.)

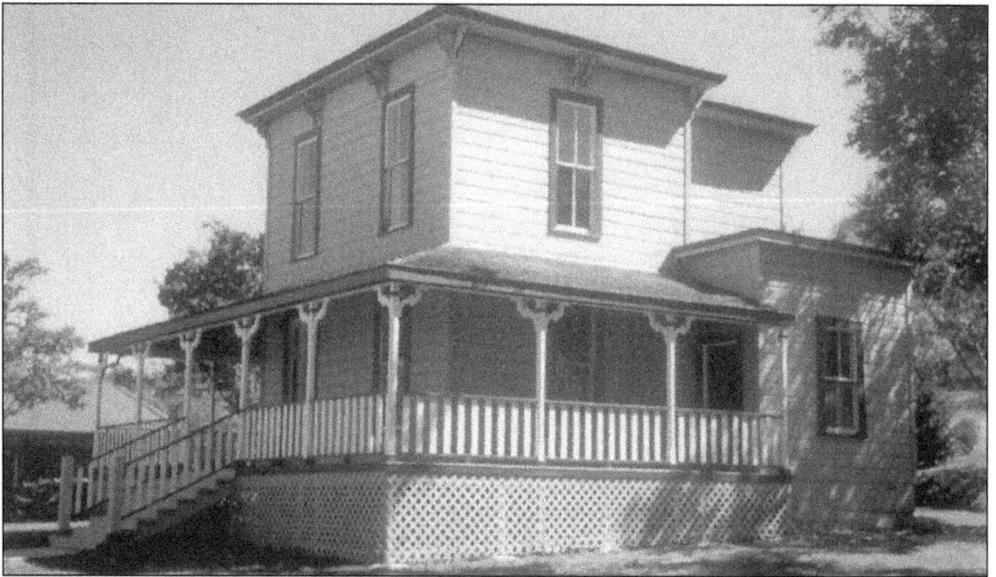

The marvelous transformation the Mayock House underwent is apparent, thanks to students at the college who enrolled in a course on renovating historic structures taught by Hal Dromensk. The Mayock House project provided them with invaluable hands-on experience. The building is used for faculty offices and there is meeting space as well. (Courtesy the author.)

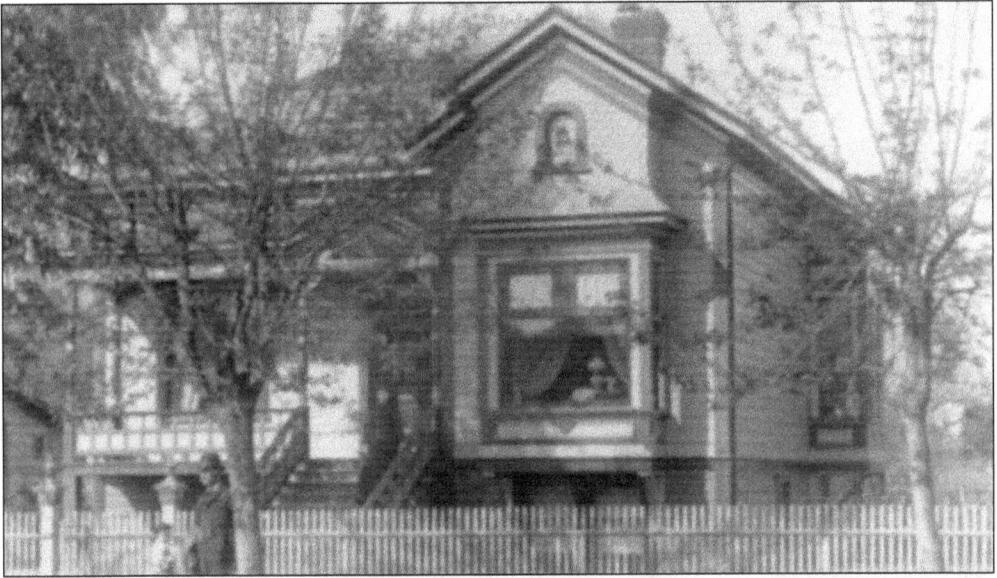

This stately Queen Anne-style residence on Church Street, between Fourth and Fifth Streets, was the first home built by Dr. H.R. Chesbro and his wife Emma and was completed in 1890. Dr. Heverland Rogers Chesbro was a graduate of the Harvard Homeopathic Medical College in Ohio, and he opened his Gilroy practice in 1885. The doctor is pictured, c. 1893, with their son Arthur outside the picket fence, and Mrs. Chesbro is on the front steps. The Chesbro house has remained in the family; presently the doctor's great-granddaughter and her husband operate a charming bed & breakfast at this historic location. (Courtesy Elizabeth Barratt.)

Dr. H.R. Chesbro served as a councilman and was mayor from 1898–1904. Here he stands in front of the last home he owned, constructed in 1928, just down the block from the first house he had built. This Church Street residence features strong horizontal lines, the trademark of the Prairie School style of architect Frank Lloyd Wright. (Courtesy Gilroy Museum.)

Mildred Moore, originally of San Jose, came to Gilroy in 1956 after her marriage to Walter Hanna Sr. Years later she began organizing trips for senior citizens to historic spots in California. When our venerable Wheeler Hospital was threatened, she championed its renovation as a housing complex for seniors. In this 1991 photo, frail in body but still strong in conviction, Mildred Moore Hanna joins others in toasting the success of that reclamation endeavor. (Courtesy *The Dispatch*.)

In 1960, overseen by Armand White of the Library and Culture Commission, a Pioneer Days exhibit was created, involving many local pioneer families. The event was so well received that talk of a formal museum ensued. Mr. White willingly cataloged the many donated items and arranged showcases for their display in the basement community room of the Carnegie Library. He is thus credited with being the Gilroy Museum's founder, and he served as City Historian from 1963–1976. After the library moved to Rosanna Street and renovations for museum usage were completed, a dedication ceremony for the facility was held on January 11, 1976. Retired nurse Mary Frasetti Prien, widow of Dr. Roland Prien, served as its director until 1989. (Courtesy Gilroy Museum.)

A bell tower was centered in the roofline of the old Severance Elementary School (page 26). When that building was demolished, the bell that had called Gilroy's children to classes for many decades was saved, and it became the district's official logo. For years the bell was mounted, as seen here, on decorative cinderblock in front of the old district office at Third and Church Streets. When the district's headquarters moved to Arroyo Circle, the decision was made to preserve the bell inside that facility to prevent further abuse from the elements. (Courtesy of author.)

This little Festival attendee seems pensive. Perhaps she's thinking, "Did I *really* agree to this garlic ice cream?" Her flavor choice aside, this child epitomizes a community's prime motivation for working hard, for putting down roots, and for holding on to what is precious from the past. We do it with the hope of securing a positive future for the generations that will follow, for their imprint is the history that is yet to be created. (Courtesy Bill Strange and Gilroy Garlic Festival Association.)

Visit us at
arcadiapublishing.com